RALLI QUILTS

Traditional Textiles from Pakistan and India

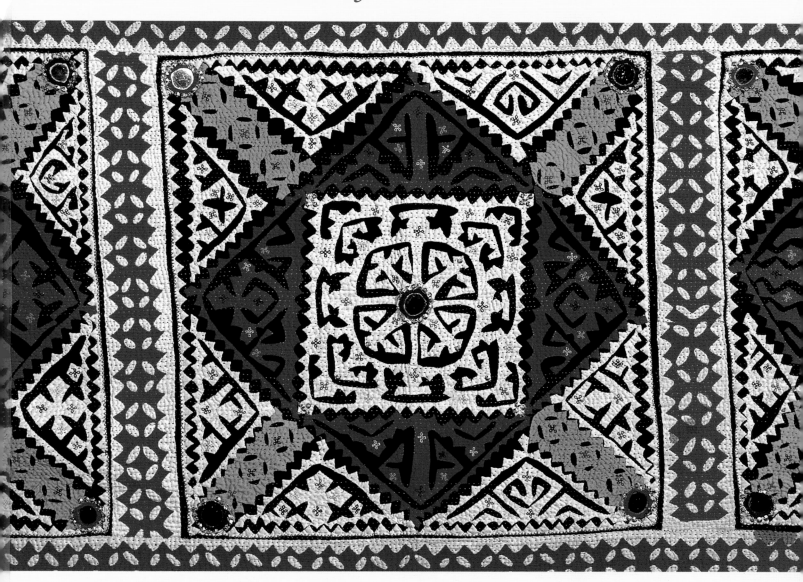

Patricia Ormsby Stoddard

Schiffer
Publishing Ltd

4880 Lower Valley Road, Atglen, PA 19310 USA

Published by Schiffer Publishing Ltd.
4880 Lower Valley Road
Atglen, PA 19310
Phone: (610) 593-1777; Fax: (610) 593-2002
E-mail: Info@schifferbooks.com

Please visit our web site catalog at **www.schifferbooks.com**
We are always looking for people to write books on new and related subjects. If you have an idea for a book please contact us at the above address.

This book may be purchased from the publisher.
Include $3.95 for shipping.
Please try your bookstore first.
You may write for a free catalog.

In Europe, Schiffer books are distributed by
Bushwood Books
6 Marksbury Ave.
Kew Gardens
Surrey TW9 4JF England
Phone: 44 (0)20-8392-8585
Fax: 44 (0)20-8392-9876
E-mail: Bushwd@aol.com
Free postage in the UK. Europe: air mail at cost

Cover and book designed by Bruce Waters
Type set in Bernhard Modern BT/Souvenir Lt BT

The ralli studio photographs were taken by Sajid Munir. The maps were done by Sara Matthews. All other photos and drawings, unless otherwise acknowledged, were done by the author.

ISBN: 0-7643-1697-4
Printed in Hong Kong

Title page caption:
This quilt block is from a ralli made in Badin District, lower Sindh.

Dedication

To my wonderful husband and children.

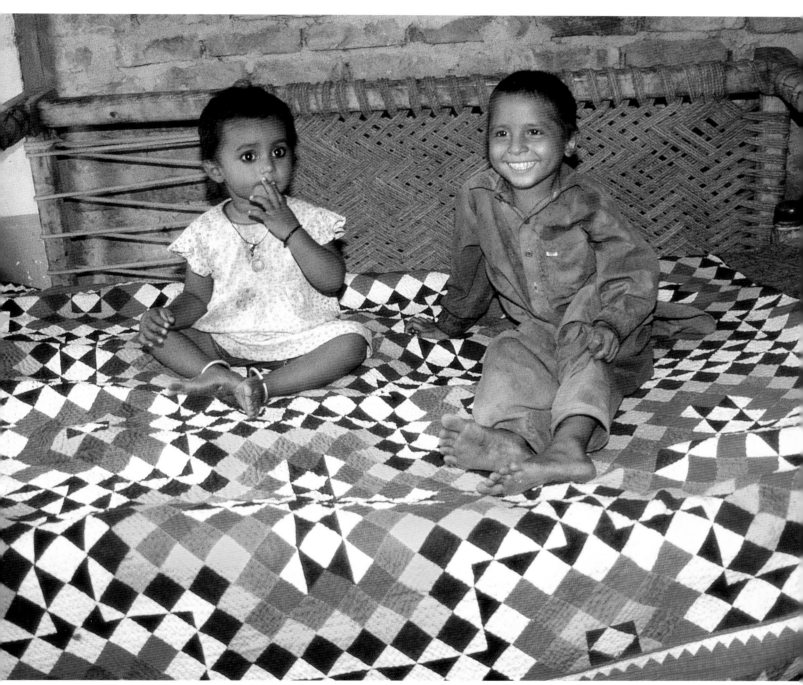

Hindu children from Mirpur Khas, middle Sindh, are sitting on a patchwork ralli on their wooden sleeping cot.

Acknowledgments

This book is the result of the efforts of many people. I want to first thank some people who may not even be aware of this book. Thanks go to the wonderful women of the ralli region who have spent countless days of their lives producing beautiful textiles. Thanks also go to the many archaeologists and scholars who have devoted their lives to uncovering artifacts and learning more about the ancient peoples of the Indus region. They may be surprised to find their research proved to be so important in a book about quilts.

I sincerely thank all those people who helped, and supported me in writing this book. Many, many people kindly answered my questions and gave me clues as to what to pursue next. Others went searching for quilts for me. Others gave me quilts. Others helped in countless ways. I would like to thank (in alphabetical order) Doug and Clair Archard, Nasreen Askari, Mehnaz Akber Aziz, Colette Bryant, Razia Salim Bugti, Robert Dyson, Mary Ann Fitzgerald, Kathy Gannon, Joss Graham, Asif Farrukh, Yasmine Jamin and others at the Sindh Museum, Khalid Javaid and others at the Lok Virsa Museum, Jotindra Jain, Mark Kenoyer, Ashok and Oam Kumar and family, Gotham Kumar and family, Ann Lewis, Aftab Nazimani, Uzma Rizvi, Dan Rolfe, Clare Rose, Dr. Pardeep and Mrs. Ranjana Shardha and family, Mark Smith, and Ann Wilcox. Special thanks to those who gave me great direction with the book: Ruth Brasher, Judy Frater, Rehana Kazmi, Susan Rugh, and Brian Spooner.

I would like to especially thank the quilters who answered my questions and showed me their work at the Lok Virsa Museum, in Hyderabad, Mirpur Khas, Umarkot, Thatta, and Kutch. My great gratitude goes to my friends who joined me in my travels and were always supportive: Peggy Simons and Kathleen Tanham. I particularly want to thank the government officials and others who arranged meetings with quilters on my first trip to Sindh – a wonderful eye-opening experience. Special thanks to Anika Jehangir for her help in many ways. I would like to thank those who showed me their own rallis and answered my unending questions: Anita Gulam Ali, Dr. Nabi Baloch, Noorjehan Bilgrami, and Dr. Harchand Rai.

I greatly appreciate the National Library of Pakistan, University of Pennsylvania Museum Library, and the Brigham Young University Library for their assistance. Thanks to others who have done so much to add beauty to the book, Sara Matthews, Sajid Munir for the studio photographs, and Asif Javaid Shahjehan. My thanks go to my editors, Tina Skinner and Jeff Snyder, for their great interest.

Personally, I thank my family and friends, who patiently supported me as this project grew larger and longer. My parents and siblings always offered moral support. My children exhibited great patience and interest in the book. My greatest thanks goes to my husband, Herb, who supports me in every way and learned to love rallis too.

Finally, I apologize for any mistakes or shortcomings in this book. I hope that research on this wonderful and beautiful tradition of rallis will continue and more information will arise over the years.

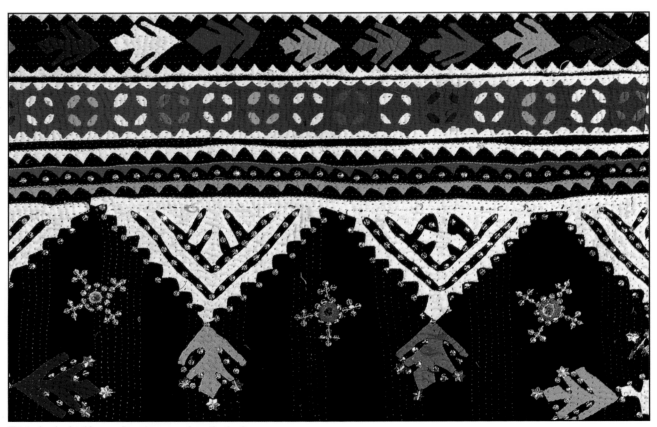

This is a border detail from a ralli used as a cover for a pile of quilts.

Contents

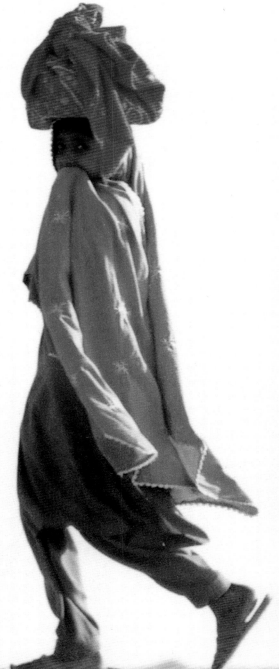

A village girl is walking along the bank of the Indus River north of Multan.

Preface

This book is designed to be both a tribute and an adventure. The tribute is to the women of the nomadic tribes, small villages, and towns of the Indus region who carry on the traditions of their mothers, other women, and their cultures. These women, despite the seeming hardship of their lives, have a wonderful love of life and great creativity. They create beautiful textiles through their skill in embroidery, quilting, and other needlework. The adventure of this book is to enter a wonderful realm of color, pattern, and form found in the quilts of Pakistan and India. It is a world of rich culture, tradition, and humanity.

As long as I could remember, I have been drawn to textiles. I studied Home Economics Education including textiles and sewing in college. In my doctoral studies, I expanded into International Development using the skills found in the home as a way of improving quality of life in developing areas of the world. With this background, I traveled to many poor areas of the world for research or development projects. As I worked around the world, I saw many interesting textile traditions. I loved exploring the fabric markets in Mali and the shops in the back alleys of Hong Kong. I returned home with textiles including hand woven and embroidered pieces from the mountains of Guatemala, embroidery from Mexico and the Philippines, old woolen blankets from Bolivia, appliqué from Thailand and Egypt, and wonderful old embroidery from China. As I saw various cultures, I found wonderful textile craftsmanship, colors, and methods of manufacture.

I was not expecting to find the amazingly rich heritage of textiles that I saw when I moved to Islamabad, Pakistan, in 1996 accompanying my husband on a military assignment. There were patterned carpets, pillows, tablecloths, and tents not to mention the wonderful variety of colors, pattern, and textures in women's clothing and shawls. Shortly after I arrived in Pakistan, I encountered my first ralli. At the very bottom of a stack of textiles at a local handicrafts store was an intriguing quilt made of boldly colored square blocks with a simple tag "Ralli quilt, Matli, Badin." It reminded me of traditional American Amish quilts with bold geometric patterns and bold color. After enjoying it for a week, my curiosity grew and I returned to the nearby store and asked if there were more "rallis." After some searching, a second one was found. It was different from the first, and aroused my interest. I returned the following week and found a third, appliquéd and totally different from the first two quilts. Now I was totally intrigued. I started asking questions, reading, and asking for more rallis at the local handicraft stores selling new and old textiles. At one of the largest stores, the owner commented that they would have to go to the villages and ask for rallis. They did not keep them in the store. He said there was one man very interested in quilts in the 1970s and I was the next one!

Over the next few years, I developed an undying enthusiasm for rallis. I sought them out at every opportunity and probably saw thousands of them. I was always somewhat partial to the ones that were obviously worn, perhaps smelling of camels or cooking fires. I would imagine them in their natu-

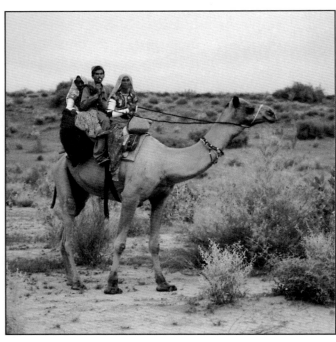

Two women and a man head to a celebration of the anniversary of a Saint in the Thar desert. *Courtesy of Margaret Q. Simons*

ral setting. Anyone I met who came from a ralli producing area I asked about the quilts. I found it was very much a feature of the rural, poor, traditional people. Most well-to-do urban women were familiar with the quilts but considered them quaint and not sophisticated. Many had received them as wedding gifts but never used them. I was perhaps perceived as unusual in having such an interest in them. I explained that America also had a wonderful quilting tradition. The urban women were pleased with the similarity, as was I.

I took several trips to areas where the rallis are made. On various trips, I went to Sindh including Hyderabad, Mirpur Khas, Umarkot, Mithi, and Thatta. I went to Gujurat and visited Bhuj, Banni, Dhamadka in Kutch, and Ahmedabad. I also took a trip in a traditional boat down the Indus and found rallis there. These trips were fascinating in every way but are not for a timid traveler. In fact, tourist travel in lower Sindh has been discouraged for several years due to the possibility of personal harm. I traveled with a friend from the Embassy, Peggy Simons, also a textile enthusiast. We were accompanied by Pakistani friends and a police escort. I'm sure our arrival was quite an occasion in some of the small villages where we stopped. In one place, a woman asked, through a translator, where we were from. I answered "America," and she asked "What's that?" Later, I thought maybe I should have said Islamabad or just a city north of here. With little transportation or knowledge of the outside, her world was only the limited area she knew. As night fell and the road ended, we happened upon a celebration of the anniversary of a saint at a shrine in the desert. We joined the people from the area arriving on their camels. On a later trip

to Bhuj and Kutch in Gujarat, India, we were grateful to be guided by Judy Frater, an American expert in the textiles of the area. With her assistance we met more wonderful women quilters in their villages.

As I traveled throughout the ralli region, I, a stranger, was greeted warmly by the women. Their willingness to share their quilting tradition and handiwork was obvious. Their smiles came quickly. Their flair for color is obvious in their work. They painstakingly continue the textile crafts that have been handed down for generations. They carefully form patterns and symbols from cloth, some simple and some complex. The women making these quilts rely on their own memories and the memories of their mothers and older women to teach them the patterns. They do not use paper or any tools to make their patterns. I remember on one occasion giving a woman a pencil so she could draw a picture of a pattern she was trying to explain. She apparently had never used a pencil and just made a big circle on the paper. The ralli compositions are in the women's minds and memories and they execute them with great skill in needlework.

Over time, I developed a collection of quilts. Some I got from the handicrafts stores, coming from a variety of areas. Some I was able to collect from quilters themselves. I was especially happy to meet the women who created these wonderful quilts. Some of the rallis were gifts from people who knew of my great appreciation for them. I have presented many of these rallis in this book. I have tried to show examples of some of the simplest, and most humble of the rallis. Often times these were truly made of patches of different fabrics. It was obvious with a close examination of the front and the back of the quilt. On the other hand, I have tried to show examples of some of the finest rallis also. The craftsmanship on these is amazing. I labeled the rallis according to my certainty of their origin. If I knew the area where they were made, I labeled them "from" an area. If I was fairly certain, I said "attributed to" or "probably from" an area. If I only knew generally then I would only include the name of a region, such as lower Sindh. Some regions have particular patterns where one could say with a degree of certainty that a ralli is from a certain area. However, one thing I learned on my travels is that there could be a great variety of patterns and styles of rallis even in a small village or community. The women have a large "mental portfolio" of quilt patterns they have made, known or have seen. They often describe them historically as "old patterns" or "new patterns." The age of a ralli is also hard to determine. With daily wear, a quilt could show signs of wear in just a few years. However, if the ralli was kept in the family stack for use by guests, it could last many years. The majority of rallis presented in this book are all cotton with no synthetic fabrics. Synthetic fabrics have become very popular in the last decade. Cotton fabric could indicate that a ralli was made before that time.

My training in family life helped me to think about the ecology of the ralli tradition. In what context are the quilts made, what resources are used, what interactions take place, and what significance do they have? The original objectives of this book were two fold. The first was to document the lives of the women who make the quilts. The creative spirit is obvious in their work. I wanted to present other aspects of their lives. The second objective was to document the quilts themselves

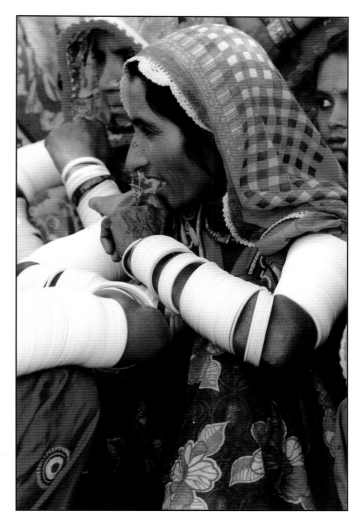

Women from Mithi, lower Sindh, are participating in a women's meeting. *Courtesy of Mehnaz Akber Aziz.*

including how they are made, their uses, and the variety of patterns found in the ralli quilts. There are many traditional patterns that are repeated in different colors with various borders. Each is unique within the parameters of the set design. I tried to represent in this book the range of patterns, from simple geometric designs to highly complicated appliqué. The complex appliquéd patterns are the ones most likely to be found in museum collections due to their beauty and the intricacy of the work but the simpler quilts, used daily on the sleeping cots of the people, also have a story to tell.

A third objective evolved as I tried to understand the patterns of the quilts. I entered a world of historical documents and remains of ancient civilizations as I traced the motifs found on the rallis to their earliest appearance. I discovered a real-life "quest" incorporating a lifelong interest in ancient civilizations and archaeology. I felt like a detective as I searched through reports of ancient artifacts from the civilizations that flourished in the same region of the ralli quilts over six thousand years ago. I was thrilled as I found first one and two and then dozens of motifs that are similar on both the ancient artifacts and the rallis of today. Many of the similar motifs are the geometric patterns on the simpler rallis, made in the same designs, year after year.

I hope the tradition of ralli making will never disappear. With the conditions of today, however, it is difficult to predict what may happen. Over twenty years ago, Bunting wrote that the traditional methods of decorating textiles were disappearing. She noticed the increased use of machines in production and the waning of family apprenticeships teaching the production of crafts. In textiles, the traditional appliqué zigzag snake design was being replaced by rickrack braid and sewing mirrors on fabric with holding stitches and blanket stitches was being replaced by plastic mirrors in plastic cases that can be easily sewn on. Tribal intermarriages and settlement into an urban environment were also causing changes in handmade textiles. (Bunting, 1980, 64-65) I have noticed that natural disasters such as drought and earthquakes have caused some in the ralli area to migrate and find new homes and jobs. Political unrest has caused changes in some areas. Perhaps more change will result from technology. I tried to find quilts made from traditional cotton to include in this book. However, many of the clothes of the women are now made of synthetic fabrics. Interestingly, in the region where cotton is produced and families work in the cotton industry, it is less expensive for them to buy synthetic fabric compared to cotton. Some women prefer the vivid colors and patterns of the synthetic fabric. They now make their quilts from scraps of these fabrics. Bright floral prints replace the hand dyed traditional colors of the past.

There is much about ralli quilts that is waiting to be discovered. Often as I found the answer to one question, two more questions arise waiting for answers. There are many rural quilters with wonderful stories and memories yet unrecorded. In this little studied part of the world, there are many creative processes unknown to the outside. The rallis, as part of the diverse material culture from this corner of the world, have great value. I sincerely hope that this book will open the door to a greater appreciation of the rallis and the wonderful talents and creative spirits of the women of the Indus region.

Saida from Haji Kheeda Bukah Khaskheli, middle Sindh, sits with her ralli. *Courtesy of Margaret Q. Simons.*

This young girl is from the Thar Desert. *Courtesy of Mehnaz Akber Aziz.*

Introduction

Every ralli quilt tells a story. It tells of the natural creativity and love of color and design of the women who create them. Every ralli tells the story of the strength of tradition. The basic designs and motifs of rallis have been passed from mother to daughter and woman-to-woman for maybe thousands of years. Continued migrations of new cultural groups into the area have not erased the love for or the creation of these compelling designs.

Examining a ralli closer can give clues to the life of the woman who made it. Was the back made with an old shawl that perhaps indicates she was from a farming group? Did she use the favorite colors of her community on the front pattern thus helping to preserve her community identity? Did she make a small ralli for a child from scraps of other rallis because she knew her child would be outgrowing it in a few years? Did she use sequins, beads, and tassels to make a special ralli for an important person or event such as a wedding? Each ralli illustrates part of the story of the woman who made it.

The ralli is a humble craft, made of worn out clothing and other discarded fabric. It is not usually bought or sold but made by women for use in their family. Rallis have never had much attention other than by the people who used and needed a quilt to make life more comfortable and colorful. Yet to those people the ralli is extremely important as a way to stay warm at night and make their string cot more comfortable, and also as a symbol of their culture and community identity.

For those not of the community of ralli makers, rallis can be windows to help us understand a little more of their lives, thoughts, and creativity. Besides creating amazing designs with color and shapes and movement, they have developed a craft with universal appeal, touching the senses of those beyond their community and culture.

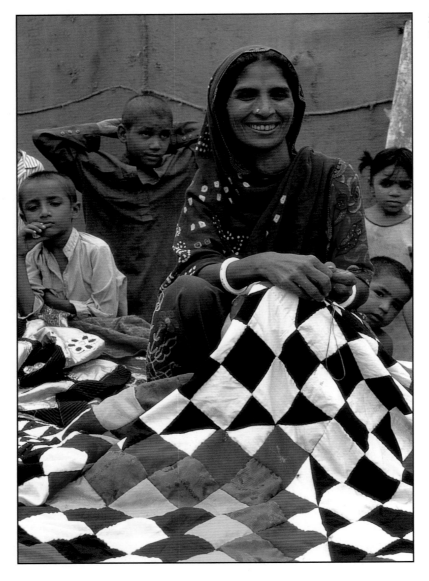

A Meghwar Hindu woman from Thatta takes a break from making her patchwork ralli.

Chapter 1:
The People of the Ralli

Women from the region of the southern portion of the Indus River in the Indian subcontinent make colorful indigenous quilts. They are commonly called ralli but are also called rilli or gindi or other names. In Pakistan, rallis are made extensively in the provinces of Sindh, in Baluchistan close to the Indus River, and in the desert area of Cholistan in the southern Punjab. Rallis are also made in the Indian states of Rajasthan, and Gujarat that border Sindh and western Punjab. This chapter will introduce some of the people of the ralli region, including their history, cultures, and lifestyles.

The Ralli Region

Sindh, the central geographical area where the quilts are made, can be considered the "heart" of the ralli producing region. Sindh, located in the southeastern part of Pakistan, has a long and colorful history, going back many thousand years BC. The province is named after the Indus River, locally called Sindhu, that runs the length of Sindh. Presently Sindh is mostly a rural, agricultural area with the exception of the major city of Karachi and a few other urban areas. Sindh is populated with hundreds of different tribes and ethnic groups. Many of these groups have related tribes in Baluchistan, Punjab, Rajasthan, and Gujarat. The characteristics and traditions of the tribes differ greatly. The groups are known by their occupation such as farmers, herders, merchants, landlords, entertainers, leatherworkers, or craftsmen. They are also distinguished by religion; most are Muslim or Hindu. Examples of the Muslim groups are the Chauhan carters located in Badin, the Jat cattle breeders, and the Sayyed religious leaders. The Hindu groups include the Jogis who are known as snake collectors, the Meghwar who are leather workers, and the Rabari who are pastoralists and farmers in Sindh, Gujarat, and Rajasthan. The Bhil, who are farmers in Sindh, Cholistan, and Rajasthan, are considered both Hindu and tribal. Many different local languages are spoken in the various communities. Some of the tribes have their own special styles and characteristics of quilts; others share styles with other communities.[1]

A first impression of the people of the ralli region may be their love of color. Some think color is a balance to the lack of variety in their environment. The color of the desert areas is generally drab, broken by the green plants that appear with the monsoon rains, the colors of the sunsets and the blue and purple of the hills. In contrast, their clothing, embroidery, and quilts as well as wooden objects, pottery, and tiles are stunning in bright red, yellow, orange, green, blue, pink, and purple. Designs for many crafts are taken from objects in the environment such as flowers, clouds, trees, butterflies, and birds. Decorative motifs are also derived from fruits such as almonds, dates, and the lotus seedpod. Daily objects such as a milk churning stick, a child's rattle, a game board or a cat are seen on textiles, pottery, lacquer work, tiles, leather, boats, and tombstones. The basic art of Sindh and the surrounding areas has survived since ancient times, and in spite of continued migration into the area, has retained its originality and identity. Instead of creating works of grandeur, the art of the region is focused on decorating everyday objects that are used by the common people. Geometric patterns and floral designs are the basis of the art of the region.[2]

A Hindu woman from Umarkot holds her baby. The white bangles on her arms are a tradition continuing from before the time of the Indus Valley Civilization.

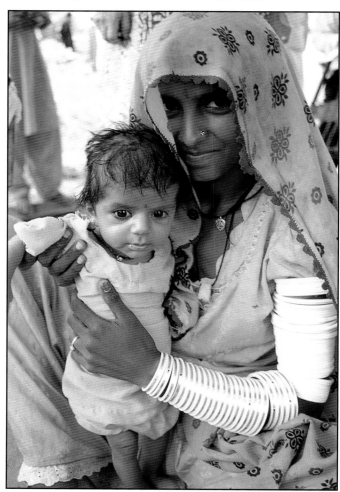

There are many arts and crafts produced in Sindh and surrounding regions today. The craftsmen follow traditions set by their community, the force of conservatism, and habit.[3] The craftsmen still use primitive tools and in many cases use the same techniques found in the Indus Valley Civilization thousands of years ago. They use traditional patterns, color combinations, and motifs, none of which is easy to alter. They are usually patient and painstaking in their craft following what has been done for generations and only produce a limited number of objects.[4] Likewise, women follow centuries old traditions in creating their rallis, textiles, and embroideries.

The ralli region is famous for great variety in its textile arts and traditions. Starting at the east, Baluchistan is the most sparsely populated area with a combination of mountains and arid plains but is rich in ancient history. Textiles from Baluchistan are famous for mirror work and precise tiny patterns in geometric embroidery. Punjab in the north of the ralli region is densely populated and is known for woven fabrics, block printing and embroidery. Sindh is famous for textile arts and traditions in all areas. The northern area (Siro Sindh) bordering Punjab is a plains region known for gold thread embroidery. The middle area (Vicholo Sindh) is irrigated for farming and also has fishing. In textiles it is known for dying, weaving, and printing. The southern or lower area (Lar Sindh) is in the lowlands bordering the Arabian Sea. The ancient capital of Thatta, the large metropolis of Karachi, as well as deserts and small towns are located in Lar. The area has been famous for centuries for the production of fine textiles for trading as well as a wide variety of folk embroidery. In addition to the three major latitudinal divisions in Sindh are some smaller physically distinct areas. The area to the west of the Indus bordering the Lakhi and Kirthar mountains in Baluchistan is called the Katcho Plains. Kohistan is in the Kirthar Mountains

on Sindh's northwestern border. The textiles here include intricate embroidery and mirror work. The eastern third of Sindh is the great Thar Desert. The desert is a significant part of the geography of the area and it extends from southern Punjab, northwest Rajasthan down through Sindh and Kutch in Gujarat. Bordering Kutch is a peninsula called Saurashtra (formerly known as Kathiwar) also known for its textiles and quilts. Cholistan, in the Punjab, known for very fine lined appliqué, is part of the Thar Desert. The people of Thar distinguish themselves from the rest of the region by their language, culture, and geography. The area of Thar Parkar is known for its bold textile design, often inspired by flowers, dunes, and peacocks.[5] The terrain of western Rajasthan and Gujarat is dry desert, given color only with the monsoon rains. The regions in the Thar Desert are the world's richest source of folk embroidery. They are known for the marriage and dowry clothing, textile decorations for home and animals, and a variety of bags and other objects all enhanced with shells, shiny sequins, buttons, and mirrors.[6]

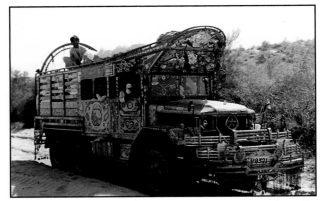

This colorful desert public transportation, called a kekra or crab, is actually an old military truck. In this truck traveling near Mithi, lower Sindh, women sit in the front. *Courtesy of Mehnaz Akber Aziz.*

The love of color and decoration is evident on the wall of a rural home in Banni Kutch, Gujarat. These designs are also used on the ralli quilts.

Map of the Ralli Region of Pakistan and India.

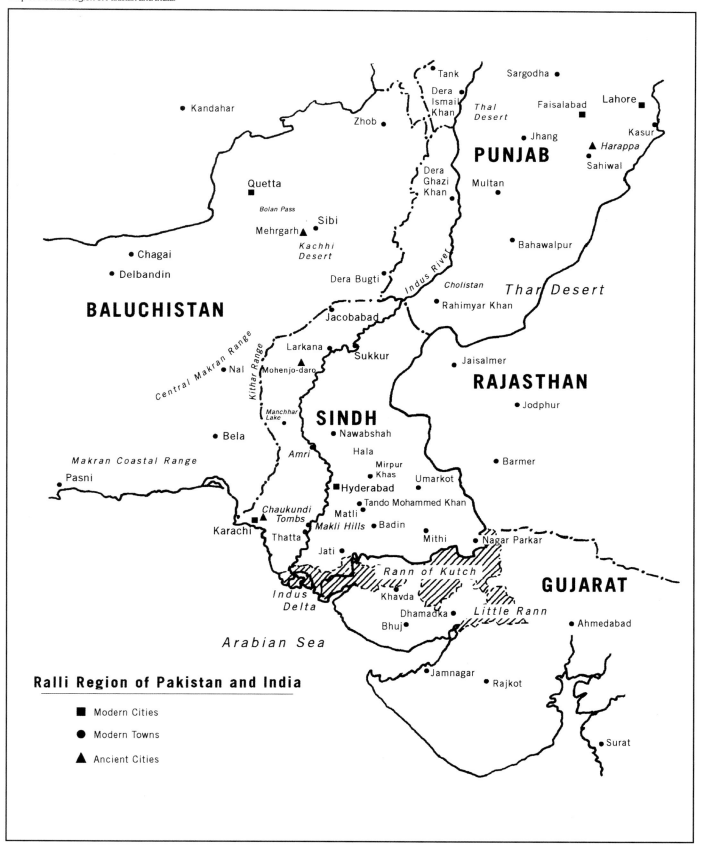

Ralli Region of Pakistan and India

- ■ Modern Cities
- ● Modern Towns
- ▲ Ancient Cities

Life of the Ralli Makers

The women who make rallis come from lives determined by their environment and their traditions. Many are born, marry, and die in the same community. Most of the women live in rural areas. Some live in permanent communities in homes of concrete or mud brick with thatching while others live in a large town or city. Some are completely nomadic, traveling with their animals or live on flat-bottomed boats on the rivers or lakes.[7] The nomadic lifestyle has been a tradition in the ralli region since ancient times. The people who are settled in communities may refer to nomads by a term meaning "house on shoulder," even though the nomads do not refer to themselves by that term.[8] Many nomads are pastoral nomads who travel in search of pasture for their animals, including cattle and buffalo, camels, goats and sheep, and horses. Some are settled part of the year as farmers or combine raising animals with various occupations including making pottery and metal work, charcoal makers, woodcutters, peddlers, entertainers, and smugglers.[9]

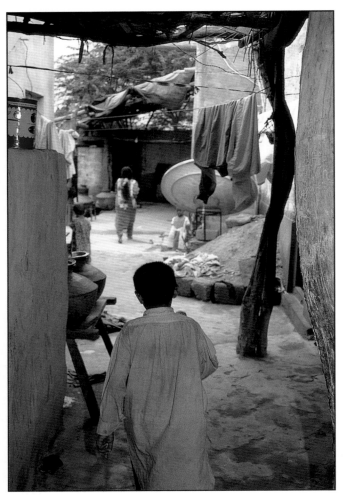

The view entering the courtyard of an urban house in Thatta opens to many household activities including, at times, quilting.

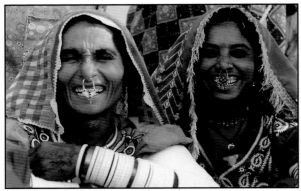

Two Hindu women from Mithi are enjoying a light moment.
Courtesy of Mehnaz Akber Aziz.

A group of village women are walking across a field in Doh Kallah Yar, the barrage irrigated area of western Sindh.
Courtesy of Mehnaz Akber Aziz.

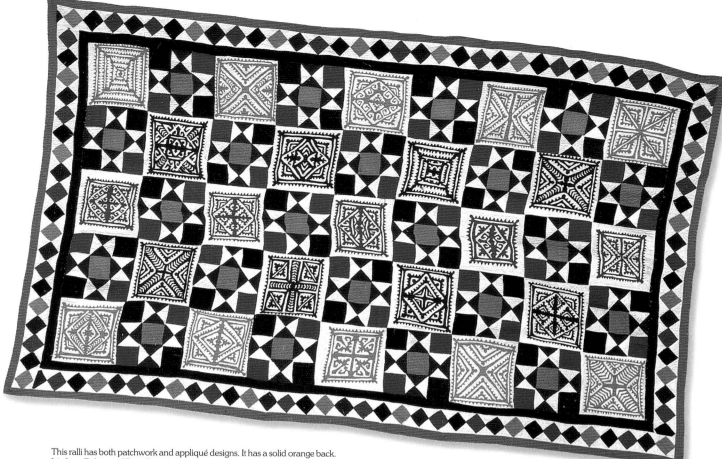

This ralli has both patchwork and appliqué designs. It has a solid orange back. It is from Rahimyar Khan, Punjab, late twentieth century, 73" x 46", all cotton.

Even today, the lifestyle of women who make rallis may be little different from their ancestors. An account of Baluchistan villagers in 1908 is similar to what can be seen today. At that time, a man who owned land had a large house with furniture, and a large number of cooking utensils, blankets, rugs, quilts, felts, and saddlebags. In addition, he wore fine quality clothes, a waistcoat, and had a thick coat. An ordinary farmer had only one or two metal or earthen pots, two to three bowls, a tripod made of iron, and "a few ragged quilts." The farmer's wife wore a "wrapper, a shift, wide drawers, and shoes."[10] The isolated desert and hill areas of the ralli region continue on with the simple life they have known for centuries. The area impacted by the development and extension of the irrigation of the Indus River is now changing. The nomadic life there is becoming less common and those who are settled are becoming greatly varied in their origin, customs, and past residences.[11]

The women of the ralli region, from almost every group, are distinctive in their appearance. For those familiar with the cultural meanings of the clothing, a woman's appearance announces her tribal group, her marital status, and her religion. Usually glittering with silver and gold colored jewelry, some are in full skirts and highly embroidered bodices, others in colorful long tunics and full trousers, and others are covered in long capes. The nomadic women may distinguish themselves by appearance, using items such as jewelry, tattoos, and make-up.[12]

Sindhi folktales and literature are filled with stories of great romance and love. Seven love stories told by the bard of Sindh, Shah Abdul Latif (1689-1752), and other poets form the basis of Sindhi literature.[13] These folktales also describe the lifestyles of the people. For example, one common covering for cold weather in Sindh is a hand loomed rough woolen blanket called a kathos. It has been said that both the kathos and the ralli are symbols of dignified poverty. In one story, Marui, wrapped in her kathos, is taken away by Umer Sumro and kept in Umarkot. This account illustrates how deeply people are attached to traditional ways.

O Sumro, how can I stop the thoughts
That dwell with my herding men?
Since I saw the huts and herding men
The days are passed and fled.
Not for the herdsmen's wives at all
Are clothes that are made of silk.
When they dye in lac (red) their coarse rough cloth
They're finer than clad in shawls.
Better than wool and fine striped cloth
Better than velvet too,
Better than rich broadcloth do I think
My coarse rough blanket to be,
Better, O Sumro than gorgeous clothes.
I should die of shame if I doffed
The blanket I had of my father's folk.[14]

Religion, Dowry, and Marriage

One of the important facets of life in the ralli region is religion. The majority of people of Pakistan are Muslim. The beliefs of Islam include a single omnipotent God (Allah) and the teachings of the Prophet Mohammed, and the sacredness of the scriptures (Quran). Muslims pray five times a day and refrain from eating pork or drinking alcohol. The month of Ramadan consists of thirty days of fasting during daylight hours. At least once in a lifetime, a believer should make a pilgrimage to Mecca. The majority of the people in India are Hindu. They believe in a cycle of birth, death, and reincarnation that is repeated until salvation is achieved. Salvation is seen as joining the great world soul, or cosmic force. Salvation is possible through following the teachings of Krishna in the Bhagavad-Gita, proper actions, and offerings to the gods to break the wheel of life.

In the areas where rallis are made, Muslim and Hindu families often live together in the same community and have learned to consider each other's mores and traditions. The families define themselves as being part of a group or caste that is a particular religion and has a certain profession. The Hindu caste system evolved from the social hierarchy brought by the Aryan invaders in the second millennium BC. From the initial handful of groups, the caste system has evolved into a complex system of tens of thousands of subgroups called jati. These longstanding practices of separation are still part of society today (and have been adopted by some Muslims in the area) despite the fact the caste system was outlawed by the government of India in 1948.[15] There is a saying from the Thar area "that the earth grows a different type of human being every hundred miles."[16] This can appropriately describe the many castes that have developed over time from the different groups of people migrating into the Indus region.

Marriage is an extremely important event for both Muslims and Hindus. From the time a child is born, thoughts of potential marriage partners and preparations of textiles and other items are a part of life. It is hard to overemphasize the importance of marriage in these communities. Each group or caste has their own particular customs relating to marriage. The following are general descriptions.

Muslim and Hindu families both practice dowry systems with choice of partners set by tradition. In Muslim families, marriages are often preferred with first cousins, a custom that keeps family wealth intact. Bride price is a sum a man must pay to another family for a wife for his son. (A common price in the desert is about $1,000 per bride.) The bride price will return to the family in the dowry the bride brings with her. The Hindus look for a marriage match within the same caste. However, they do not exchange marriage partners in the same genealogical descent or same village. Instead, they arrange a marriage with another family in a neighboring village. This causes a great cultural exchange in Hindu communities. Every effort is made to give the bride as much dowry as possible, including such things as clothes, pots, silver and gold jewelry, and a quarter of the father's livestock.[17] Traditionally, the bride and the women of her family make beautifully embroidered clothing and textiles for the wedding. These include clothes for the bride and groom, and many decorations for the home and animals. These textiles will go with the bride to her new home with her husband's family. A display of the colorful items takes place at the wedding and at other religious festivals. These serve as a cultural indicator as each group or caste has its own favored colors, styles, and embroidery stitches.[18]

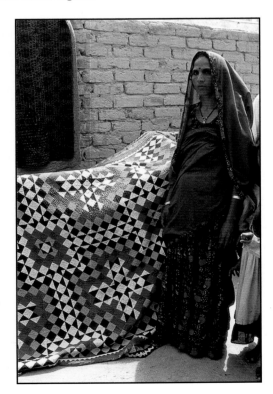

A Meghwar Hindu woman stands proudly beside a ralli she made. She lives in Mirpur Khas, middle Sindh.

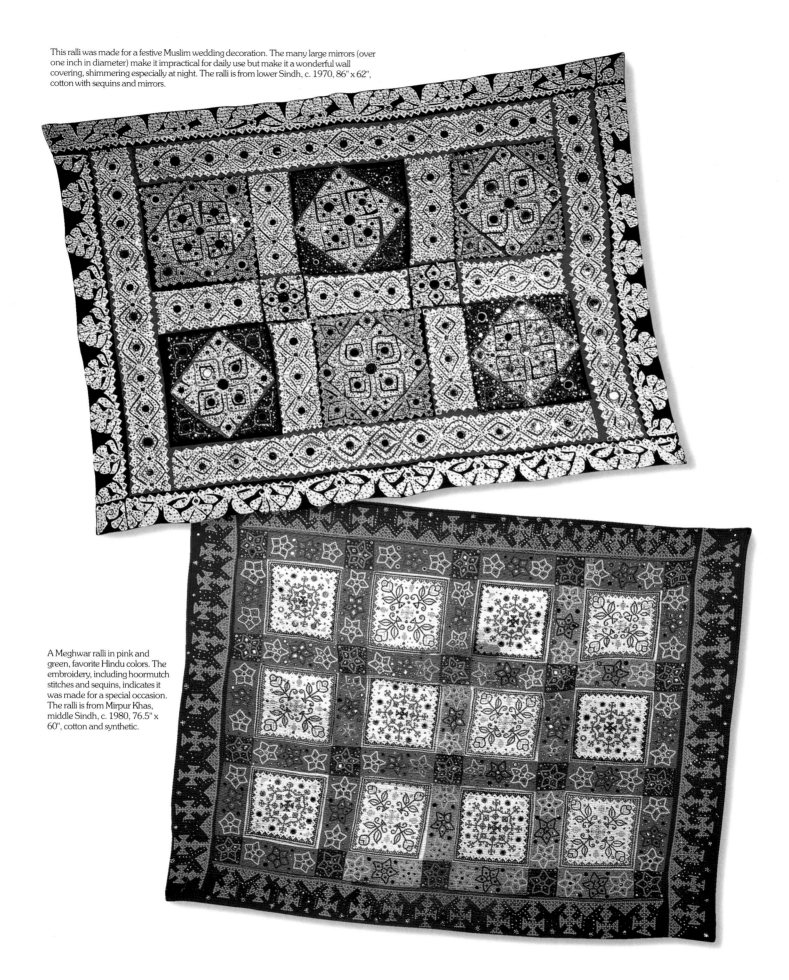

This ralli was made for a festive Muslim wedding decoration. The many large mirrors (over one inch in diameter) make it impractical for daily use but make it a wonderful wall covering, shimmering especially at night. The ralli is from lower Sindh, c. 1970, 86" x 62", cotton with sequins and mirrors.

A Meghwar ralli in pink and green, favorite Hindu colors. The embroidery, including hoormutch stitches and sequins, indicates it was made for a special occasion. The ralli is from Mirpur Khas, middle Sindh, c. 1980, 76.5" x 60", cotton and synthetic.

Rallis play a role in the wedding traditions of both Muslim and Hindu families. In Muslim tradition, an engagement takes place. The engagement period may last up to several years depending on the age of the bride or other factors. After the engagement, the man and woman cannot talk to each other until the marriage. The marriage ceremony takes place in the house of the bride. The couple and guests are dressed in fine clothes. The participants also have lacy patterns made from henna paste (mehndi) painted on their hands and feet. The bride and groom sit facing each other on a special ralli. The mother, sisters, and other relatives of the groom prepare this ralli. The ritual of the marriage includes the touching of the heads of the bride and groom seven times by close relatives of both sides. The mother of the bridegroom and sisters of both mates start the marriage ceremony. A cup of milk is served to the groom and bride. The groom takes the first sip and then the bride, repeated until the milk is finished. Touching heads and drinking milk represents the development of understanding, frankness, and love between them. The groom and bride then take some sugar and salt from one pot and put it in another pot representing the sharing of the sorrows and joys of life.[19]

The Muslim weddings in Gujarat are likewise filled with traditions. Female family and friends sing wedding songs a few weeks before the marriage. The bride and groom wear yellow the week before the wedding. During this time they perform have special activities to keep away evil. The wedding day is filled with a variety of activities including the receiving of the dowry gifts, painting hands with henna paste, a game where the bride tries to guess her groom's hands from a group of hands from underneath a curtain, and the bride showering rice on the groom's head. In the wedding, a representative of the bride and the groom meet. The groom accepts a small amount of money from him. After that, a sacred agreement for the marriage is read. All the guests wish the couple happiness and leave.[20]

The Hindu weddings are held on a day considered auspicious by the Brahman priest. The bride, dressed in a brightly colored wedding outfit, and groom sit on stools. The priest ties the corner of the groom's turban to the tie-dyed head covering worn by the bride and drapes a skein of mill-made thread over their shoulders. The bride and groom walk around a small ritual fire four or seven times as the Brahman chants and the family observes. On the first three times around the fire, the bride leads the groom and on the last, the groom leads and this ends the ceremony.[21] Customs may vary by community but rallis are used to seat the groom in Hindu weddings as well.

To fully appreciate the ralli tradition, it is important to understand the lives of the women who make the quilts. They come from varied backgrounds, traditions, and communities and it is not possible to describe every situation. However, some aspects of their lives are similar. Women have the responsibility for child rearing, food preparation, and housekeeping. They often have responsibility in the economics activities of the family as well. These descriptions of women's lives in the Thar Desert, Middle Sindh, and in Kutch in Gujarat illustrate some of the lifestyles of the ralli makers.

This highly decorated Hindu ralli is made with a multitude of sequins and gold and silver cords used to highlight the various appliqué shapes. Lace is used on the outside edge and the back is bright pink synthetic fabric. The quilt is from middle or lower Sindh, 103" x 89.5", mostly cotton top, and synthetic back.

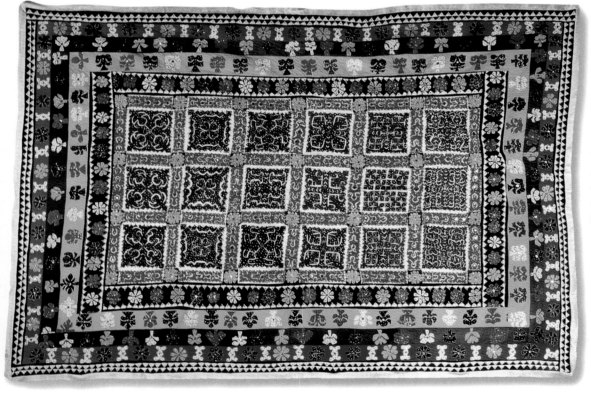

Life in the Thar Desert

The region of the Thar Desert, in the southeastern corner of Sindh, is an isolated region. The area is called Nagar Parkar, Parkar meaning "beyond the salt." It is separated from other areas by a salt river and on the south and east by the great salt flats of the Rann of Kutch.[22] Throughout history, it has proved to be a barrier isolating Sindh from the east. Only unpaved roads connect the small communities. Enormous sand dunes cover the landscape dotted with desert foliage. Life has changed little over time with most people relying on animals and their products, food and leather and wool, to live. Drought is one of the factors of life in the Thar. Wells, usually two to three hundred feet deep, do not dry up during the first year of drought but the effort of drawing water for both people and animals becomes a burden. Rounded beehive-shaped huts made from local small woods dot the landscape. A Sindhi proverb, "Drop by drop a pond," illustrates the importance of water and the endurance of the people.[23]

An example of one small village is Arniyaro named after a wild tree that grew at the local well. The Muslim groups in the village are Dohat, Mehar, Sangrasi, Boota, and Saand and the Hindus are Meghwar and Bhil. All the groups speak Datki, an unwritten language that seems to be related to Hindi and is considered imperfect by the villagers. Sindhi is considered a better language because it can be written. Life is based on animals, agriculture, and water. In the desert, most of the income is from livestock including cattle, goats, and camels. In dry years, families move throughout the region seeking water for their herds. In times of drought, the husband or the whole family may migrate to another area and return after eight months if the rain falls. The men frequently speak Sindhi or Urdu and can find work outside their village. The women often only speak their local language. Schools are not often available to the children and if they are usually only boys have the opportunity to attend.

The responsibilities of the women are to take care of the children, help build their houses – including the mud floors, wash clothes at home or at the well, bring water from the well to home, and collect dung and wood for fuel. They also help their spouses in cultivating the land. After wheat is separated from the grass, it is divided equally between the landowner and the farmer. Traditionally women and children pick the cotton. Cotton is picked in three stages. The last stage of picking can have up to seven picks so the women may spend considerable time in the fields. In the past, women also spun and wove the cotton cloth used in daily life. Now they buy a low grade, unbleached, and uncolored cloth and dye it as they desire. By tradition, and because of their home responsibilities, many women have not been outside their village.

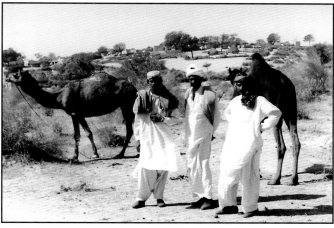

These three men with their camels, traveling between Nargar Parkar and Mithi, are wearing shalwar kameez, the national dress. When worn out, an outfit may yield up to twenty yards of fabric for a quilt. On their heads are the traditional cap (topi), a white turban, and a turban made from the printed ajrak cloth. *Courtesy of Mehnaz Akber Aziz.*

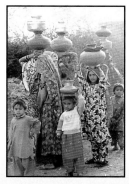

A Muslim group of women and girls from Nargar Parkar are carrying their pots in the traditional way. *Courtesy of Mehnaz Akber Aziz.*

This village in the Thar Desert of middle Sindh has traditional cone-shaped houses with a twig fence wall protecting the area.

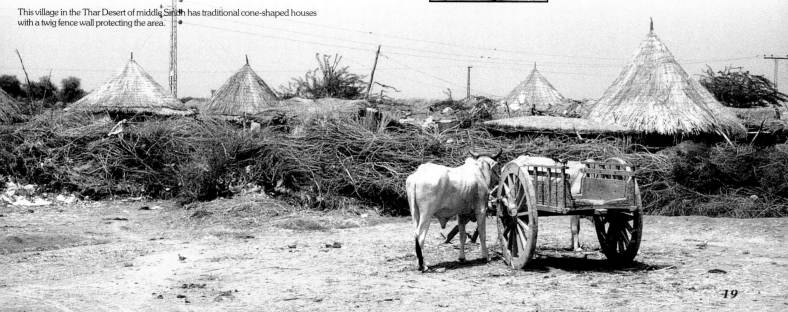

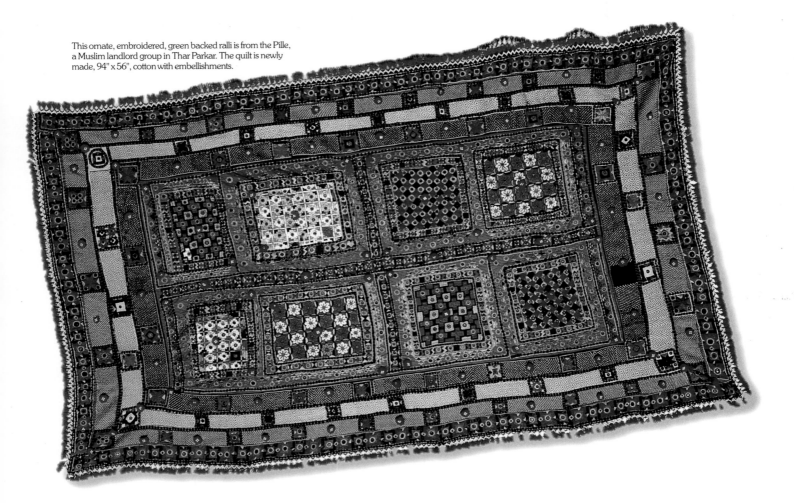

This ornate, embroidered, green backed ralli is from the Pille, a Muslim landlord group in Thar Parkar. The quilt is newly made, 94" x 56", cotton with embellishments.

The women grind wheat, and prepare meals. The two meals a day consist of tea, milk, buttermilk, yogurt, and flat bread. Vegetables may be available during the two months of the rainy season and legumes are eaten by the more well-to-do. Watermelon and other melons are available when there is rain. When grown on open land, the fruits belong to everyone. Women milk the animals with their husbands. Young girls learn these skills alongside their mothers.

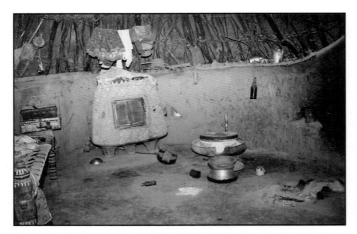

This is a simple kitchen area in the traditional cone-shaped roof, mud brick home in the Thar Parkar. *Courtesy of Mehnaz Akber Aziz.*

One occupation for women is birth attendant (dai). This is usually an elderly woman and the position is passed from generation to generation within her family. For the birth of a male child, she receives money, wheat, clothes, and sweets but for a female child she gets only money and wheat. The society is patriarchal, thus genealogy and family relationships are traced through the father's side. Men's work consists of herding cattle or livestock, building houses, and working in agriculture.

Women sew for the family. Much time and effort is spent in making beautiful clothes and preparing for the wedding dowry. The traditional women's clothing is decorated with intricate embroidery. Older women wear the blouse, skirt, and head covering of their community while younger women often wear the shalwar kameez (loose pants and long loose shirt). Women also make rallis, pillows, and bags. Those women fortunate enough to have a sewing machine may sew for others. Women's handicrafts are done at home during the free time between household and field jobs. Most handicrafts are made for family use but some are sold at nearby markets. Along with the traditional clothing, jewelry is an important part of a woman's dowry and identity. Gold jewelry is for the ears and nose, and silver for the neck.[24] Many white bangles are worn by unmarried women from wrist to elbow and by married women from shoulder to wrist. Wearing white bangles is a tradition in the area going back to ancient times.

Life in Middle Sindh

The description of the small town of Chiho in Nawabsha district, middle Sindh, is probably typical of other towns of the area. Chiho is east of the ancient city of Mohenjo-daro, across the Indus River. The majority of the households are Sindhi who are Muslim, with smaller number of families who are Hindu Marwari and Muslim Brahui. The Muslim households tend to be large, maybe fifteen or more people including the brothers of the household head.

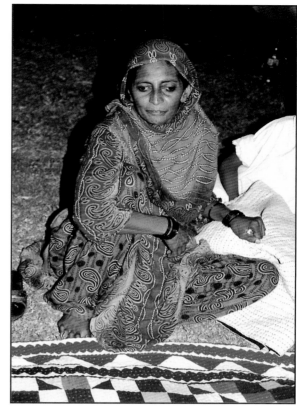

This is Haleema, a quilter, from middle Sindh.
Courtesy of Margaret Q. Simons.

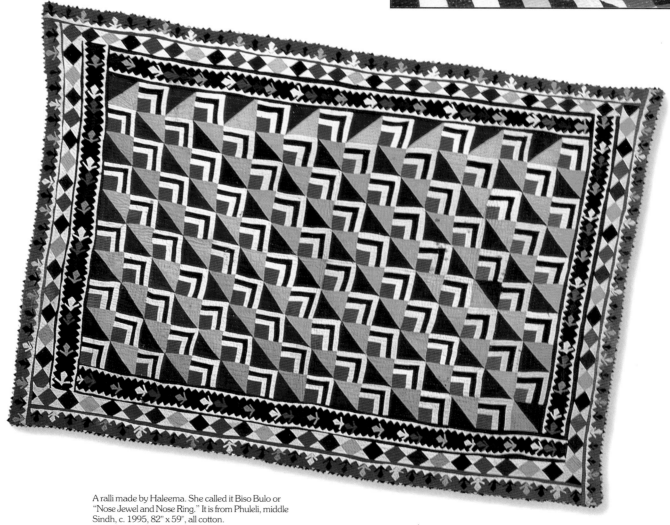

A ralli made by Haleema. She called it Biso Bulo or "Nose Jewel and Nose Ring." It is from Phuleli, middle Sindh, c. 1995, 82" x 59", all cotton.

Privacy is an important feature of the housing. A high fence of thorny brush protects the Marwaris, who live at the edge of the village. Other homes may use a mud brick wall. Within the wall are a courtyard and a home of mud brick with a roof of straw or bamboo. Shutters cover the windows. Houses range in size from one room to many rooms for the wealthy. The town is a series of winding alleys with little vegetation of any kind. Three quarters of the population of the village owns no land.

Women of the village prepare the food. They grind flour to make a round flat bread (chapatti) that is baked in a brick fireplace in the courtyard. Browned meat, rice, green vegetables, and buttermilk (lasi) are common foods. Food is seasoned with herbs and hot spices. Women wash clothes by pounding them with a large stick. Their clothing reveals who they are: the Sindhi women wear the shalwar kameez with a shawl, the Brahui women wear a black, full cotton coat, and the Marwari wear a short bodice with a low neckline, and a full skirt to the ankles. Jewelry is also heavily worn, with poorer women choosing silver alloy.

One of the pastimes of women is singing. Marwari women sing love songs in high-pitched and lusty tones with complicated rhythms. At the birth of a child, a drummer stands outside the door to signal the event and women visit and sing in the courtyard. Happy songs are sung for the birth of a son. However, a Marwari woman said that a daughter is also from God and women love daughters more because they will be separated from their mothers someday.

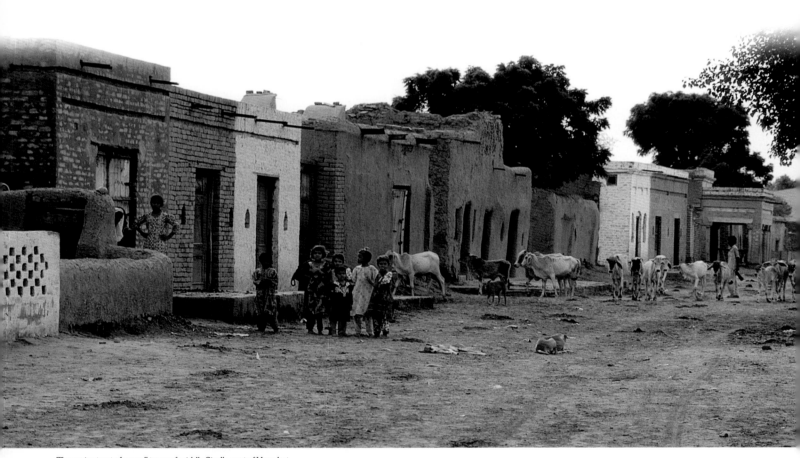

The main street of a small town of middle Sindh, east of Umarkot, is lined with mud brick houses.

Examples of Groups

There are thousands of groups, large and small, that live throughout the Indus region and make quilts.[36] They are all an important part of the societies in which they live. Lambrick describes "Those who find their place upon the land, there to rub shoulders with Sammas and Jats, Serais and Baluchis, will surely in the course of time fall under the age-old spell of Sind, which has made so many strangers, drawn to her from such diverse causes, feel themselves her true children."[37] The earliest inhabitants of Sindh were the pastoral Jats and the fishermen Meds. Early invaders include the Sakas, the Yuchchi, and the Huns. From these initial peoples, many of the ralli region are descended.[38] Some examples of interesting and well-known (though not necessarily the largest) groups known for making quilts are described below: Sayyed, Baluch, Jats, Bhils, and Jogis. In this part of the world, cultural heritage determines many of life's events and links the past and present.

The Sayyed group holds particular importance in Islamic culture as descendants of the Prophet Mohammed. Even though the Prophet himself said that "there are no genealogies in Islam," the Sayyeds are seen as a superior family.[39] The Sayyed families lived in Persia, Afghanistan, and Central Asia and over a period of perhaps a thousand years migrated to Sindh. They were instrumental in the conversion of many Hindus to Islam, particularly in the fourteenth to eighteenth centuries.[40] The murshid or pirs are usually from the Sayyed family and are considered especially spiritual. The holy men have families and children. Customs vary but in some very conservative Sayyed families, the women rarely go out of their household compound and, if they do, they are covered or concealed.[41] In the very traditional families, the women can only marry their first cousins. First cousin males can marry women other than first cousins. As a result, some Sayyed women remain unmarried throughout their lives. They spend their days in the compound talking, swinging, and discussing recipes. They often become expert quilters and spend much of their lives making beautiful rallis, pouring out their creative talents, ambitions, and desires into the quilts.

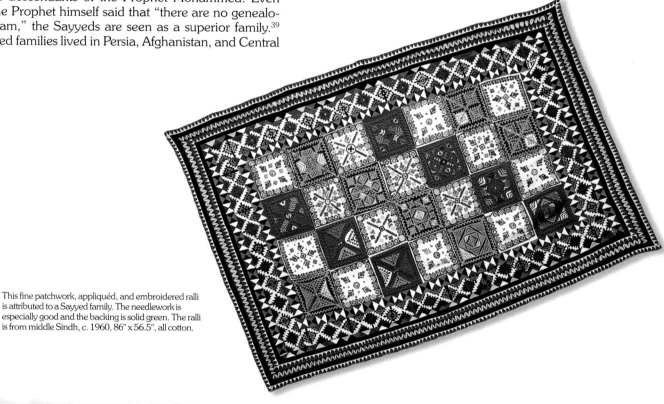

This fine patchwork, appliquéd, and embroidered ralli is attributed to a Sayyed family. The needlework is especially good and the backing is solid green. The ralli is from middle Sindh, c. 1960, 86" x 56.5", all cotton.

This is a typical nomadic Baluch dwelling near the road to Quetta, Baluchistan.

The numerous Baluch are an influential major tribe, subdivided into many groups, in the ralli region.[42] The Baluch tribes are known for defending their honor, being generous in their hospitality, and providing protection to guests. They live in the desolate desert regions extending from southwestern Afghanistan and southeastern Iran, in Baluchistan and on to Sindh in eastern Pakistan. Historically, the area has been a crossroads with Persians, Brahmins, and Arabs seeking control. However, the remote geography helped defend the area. As a local saying goes "the lofty heights are our comrades, the pathless gorges our friends."[43] The Baluch have a long history and there is much speculation about their origin. The Baluch were originally a diverse group of peoples from the Middle East (Syria) who formed a distinct group by the tenth century, slowly moving from south of the Caspian to their present location in the Indus region. Their sometimes violent nature caused them to be removed from some of the areas where they settled.[44] In the early thirteenth century the last ruler of entire Baluch tribe, Mir Jalal Khan, led the tribe to Kech Makran in Baluchistan. At his death, the tribe broke into four parts, following each of his sons, starting the many groups seen today.[45] Islam gradually spread to the Baluch groups but pre-Islamic ideals and practices continued. Muslim writers in the tenth century commented that the Baluch at that time were still only Muslims by name.[46]

The Baluch woman from Nagar Parkar is wearing a yellow shawl, a favorite color of the Baluchis. *Courtesy of Mehnaz Akber Aziz.*

By the sixteenth century, the Baluch had reached the land east of the Indus River under the leadership of the famous Mir Chakar Rind.[47] Thousands of stone-carved tombs of the Baluch are found throughout the deserts of Sindh and Baluchistan. Descriptions of the ancient Baluch are clear in their colorful descriptions of the war loving lifestyle of the nomadic tribes. Fiercely independent, they enjoyed their weapons, their horses, and the hookah pipe. They held women in high esteem. A common saying is "a Baluch warrior never died, he was always killed in battle or murdered."[48] The Baluch were happiest fighting and quarreled with neighbors over petty situations. A famous battle was started by a child's argument over a mongoose that had gone to the home of another Baluch faction. A thirty-year war between two Baluch tribes, the Rind and Lashar, started as a quarrel between the leaders, Mir Chakar Rind and Guhram Lashari, over a Jat camel-breeding woman.[49]

Over the years, a number of Baluch have moved permanently out of Baluchistan, particularly to neighboring Sindh in search of grazing grounds.[50] Some rulers encouraged the immigration because of Baluch ability as soldiers. Later, the tribal leaders became part of the military of the country.[51] Many modern Baluch have adapted to life without warfare and with scarce resources. However, the importance of strength and power has remained in their culture. Sayings such as "strong water can flow uphill" and "if your fortress is strong and your followers numerous, for you there shall be neither danger nor trouble" still survive.[52]

In the dry central portion of Baluchistan (with less than five inches of rain per year), the Baluch have turned to agriculture with date palms watered by oases or drought resistant grains. These Baluch prefer to marry cousins yet complications such as inheritance, land tenure and water rights cause almost three quarters of the marriages among agricultural families to be with non-kin. Pastoral nomads live in small egalitarian groups, herd sheep and goats and use camels for transport. Women water livestock and have other work roles in the camp. Females are not secluded until they are close to settled communities where they are protected by campmates. In the oasis community, women do not participate in the date cultivation and are sheltered behind the mud walls of their homes. The more sequestered the women of the household are, the higher the status of the family. Fishing is also a major occupation among some coastal Baluch.[53]

The Jats are one of the oldest groups to inhabit the ralli region. The scarce records indicate the indigenous people living in the area of Baluchistan before the eighth century were the Jats, Meds, and Afghans, who remain in the area today.[54] Likewise, records show the earliest inhabitants of Sindh were the Jats and Meds. Most Sindhis descend from the Jats, Rajputs (who may have been originally Jat), and Samma. Now the original distinction between the groups has faded. Tribes with Rajput names are often called Samma(t) in Sindh and Jat in the Punjab.[55] The Jats were most probably of Scythian descent. Darius the Great in 512 BC annexed the Indus Valley and fought against the Sakas or Scythians there. The Jats were later repressed by the Brahman kings and the Arabs who followed them. A tenth century geographer, Ibn Haukal, called the Jats breeders of camels.[56]

Herders are traversing the Rann of Kutch.

The Jats have become an integral part of the peoples of the region. Descendants of these herders continue to raise animals today and the name Jat often is used to refer to herders or agriculturalists or people with a certain social status. As the name Jat has some prestige in Punjab, many tribes go by that name and likewise in Sindh, many Jats and Samma(t)s go by the name of Baluch where Jat may mean a camel man or peasant. (Two pronunciations of the name Jat, with either short or long a sound, is attributed to the use of the name by several languages.) Many Jat tribes from the Punjab moved to northern Sindh under the name of "Sirai," meaning a man from the north. They speak a dialect known as Siraki (western Punjabi).[57] This group is known for intricate rallis.

The two groups of Jat herders are those who raise camels as breeders and those who raise cattle mainly for milk. Some of the Jats settled outside the Rann of Kutch and became farmers. Others became holy men studying the Quran and living a life of poverty. (Some Jats are also Hindu.) Usually, Jats do not marry outside their group and prefer to marry cousins from the father's side. A Jat woman's group identity is her long, black cotton caftan dress, an important part of her dowry. The dress is decorated with bodice panels that may take two months to three years to embroider and sometimes patchwork of red stripes on the back. They wear a head cover of dark brown or black and yellow dots. They are ornamented with ivory or imitation ivory bangles on their arms, thin silver anklets, and a large gold nose ring in the left nostril. The men usually wear black clothes: shirt, sarong, and turban with a printed blue and red (ajrak) shoulder cloth. Ajrak may also be used as the sarong and turban and European style shirts may be worn with their short hair, beard, and moustache. Quilting is also highly regarded by the Jats and they use the technique to make thick mattresses, quilts, and smaller bags.[58]

The Bhils live across a wide area including both India and Pakistan. They are the largest tribal population in India with almost four million. They are distinctive in appearance with a dark complexion, high cheekbones, large nostrils, and small stature. They are also known for tattooing, especially on the women. Girls, starting at age ten, will get tattoos at the weekly market on their face, including forehead, cheeks, and chin, and on their arms between the elbows and wrist. A person can choose their tattoo from numerous designs. Women also decorate themselves with silver-colored (made of nickel, aluminum or silver) or bronze earrings, necklaces, and bracelets or ivory bangles. The women usually dress in red and black with a full skirt (ghaghara), bodice (kanchli), and shawl (odhani).

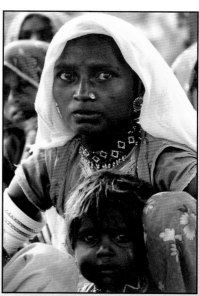

This Bhil woman and her baby are from Nagar Parkar. *Courtesy of Mehnaz Akber Aziz.*

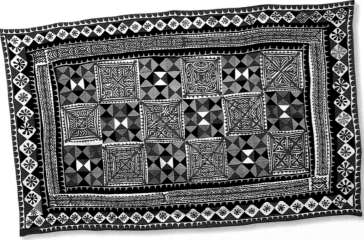

This ralli, from the Bhil community near Umarkot, illustrates fine patchwork and appliqué in the traditional Bhil colors of burgundy, green, and gold. This ralli is from middle Sindh, late twentieth century, 80" x 49", all cotton.

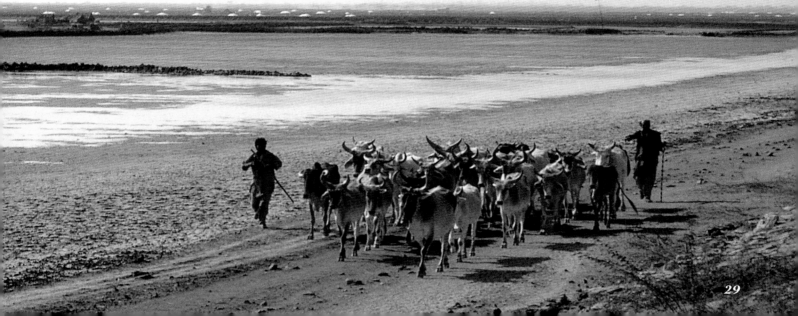

Bhils are known to be energetic and untiring, particularly in negotiating steep and rough paths in the hills. Their name is probably from the Dravidian word bhilla, meaning bow, a common Bhil weapon. It appears that the Bhil were the earliest settlers of India. An Aryan invasion drove the Bhils, who were then rulers of Jodhpur or Marwar, to the hills. The Rajputs oppressed the Bhils until the seventh to thirteenth centuries, known as a time of Bhil and Rajput cooperation. Bhils now make their living through agriculture with some other activities. The Bhil religion is Hindu but it is mixed with some aspects of ancient Bhil culture, including the worshipping of village deities and natural objects. Music and dance are important social parts of their lives. Marriage is undertaken only after a long series of ceremonies to select an appropriate partner and perform all the proper rituals. Songs accompany the different ceremonies of marriage including a song of invitation, which talks of preparing cots for guests to sit on with silken sheets.[59]

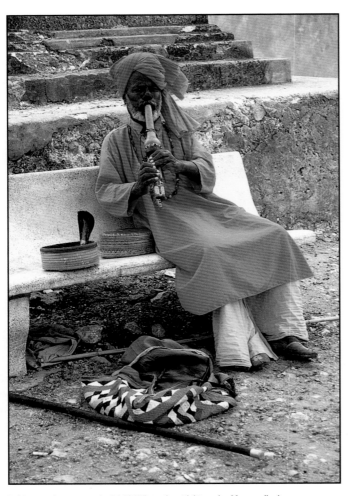

Lakhano, a Jogi, is seated at Makli Hills tombs with his snake. He proudly shows a letter explaining how the snakes are sent to the National Institute of Health to make anti-venom medication. His snake bag is made of patchwork.

Jogis, or snake charmers, are a group found on both sides of the Pakistan-India border. For thousands of years they have been nomadic. The Rig Veda mentions snake charmers, along with musicians, jugglers, and other entertainers. British accounts from 1938 noted that the Jogis traveled with their families, did not thieve, and were free to go as they wished. Some feared them. As nomads, they live in tents made of quilts and rags over a frame of wood. In India, they move about with donkeys loaded with bedding and belongings on string cots turned upside down. About the middle of this century, some Jogis gave up their nomadic lifestyle. The Kalbelia Jogi group of Rajasthan choose to live outside villages where they could work with agriculture. In addition, their talents gave them opportunity to meet others including low and high caste and foreign tourists who gave money and items such as watches. The Kalbelia are known for their medical or magical services. Women's work is usually focussed on childcare, preparation of food, washing clothes, milking the cows, taking the goats to graze, taking lunch to their husbands in the field, and maintaining their living area. They may be midwives to their own and other castes. They may also work with their husbands and children on road construction projects. The extreme heat of the Rajasthan desert causes the women to complain that they do nothing, only sit. In the hot season, food is only prepared in the early morning and later in the evening when fires can be lit for tea and other cooking. The Kabelia women also make quilts from rags. In the desert's cold season, every quilt will be used to keep warm at night. To make a quilt, washed rags are "stretched out on a frame, and sewn together with fancy stitches through several layers of cloth."[60] The Jogis of Sindh have a jholi or begging bag. The saying that goes with the bag is "barde meeree jholi" or God, please fill my bag. The Jogis are also known for their small square rallis used for carrying snakes as well as embroidered quilts.

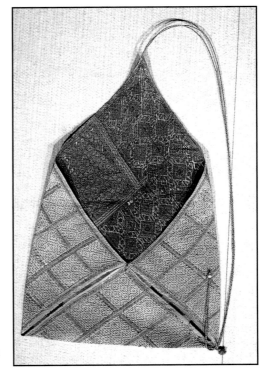

This is an old embroidered bag done in traditional Jogi stitches with a fine ajrak lining. It is from lower Sindh, early to mid-twentieth century, 26" x 16", all cotton.

Chapter 2:

The Ralli

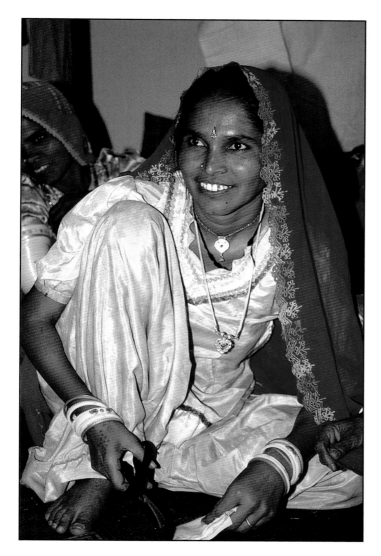

A Hindu quilter from Kutch, Gujarat, is forming an appliqué shape.

The back of this ralli from Matli, Badin, shows pieces of traditional ajrak block printed fabric patched together.

Ralli quilts are an integral part of the cultures where they are made. They are seen over doorways and walls, on sleeping cots and used as cushions for workers. A Sindhi folktale illustrates the importance of the ralli in the scheme of life. In the tale, the universe represents a complete whole in which both male and female live together and contribute to their mutual survival. The men make ajrak, a block printed textile in colors of crimson and indigo made in a long, intricate process. Ajrak is worn primarily by men as a turban on their heads and represents, according to the story, the sky. Women make rallis, which represent the earth as they are used on or near the ground or on a sleeping cot.[1]

The indigenous quilts of the Indus region are variously called ralli, rilli, relhi, rallee, rilly, as well as other spellings. The most accepted spelling of the name seems to be ralli.[2] (The northern part of Sindh prefers rilli.) There are several ideas on the derivation of the name. Most think the name comes from the infinitive "ralannu" which means to mix, to join, or to connect.[3] In Cholistan and Baluchistan, rallis are called gindi. Ralli is the name for quilts in Rajasthan and, in Gujarat, they are called dhadaki[4] and other local names. Small quilts for children are called rilka, ralka or ralko or relhico. A godri is a small square used for sitting.

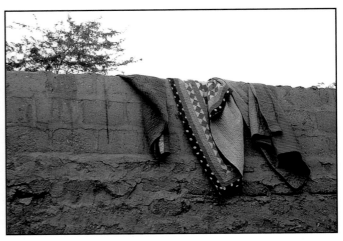

Ralli quilts are airing out on a mud wall in lower Sindh.

This quilt was made for a child. It has fifteen blocks that alternate in patchwork and appliqué. It is traditional that a child's ralli (called rilka) does not contain black. The quilt is probably from middle Sindh, mid- to late twentieth century, 54.5" x 38.5", all cotton.

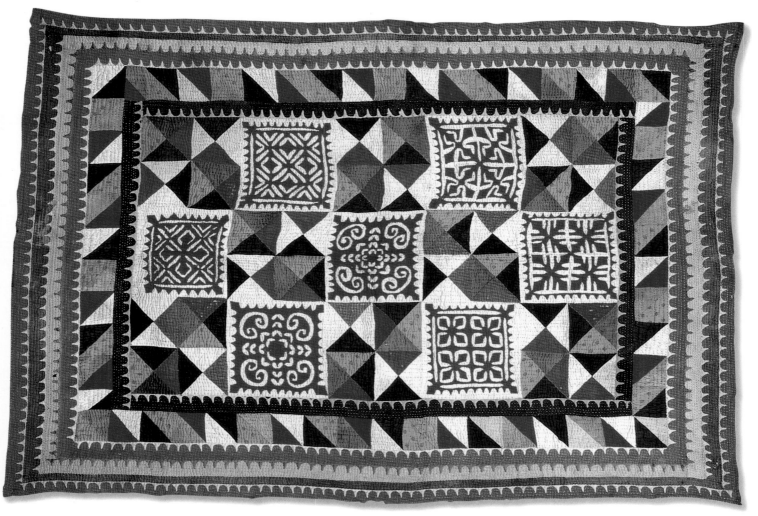

Uses for Rallis

Rallis have many uses. The majority of rallis are for everyday use but some have an important ceremonial purpose. Most commonly, rallis cover a wooden sleeping cot called a charpoy. Charpoy (meaning four-footed) is a woven surface suspended about a foot and a half above the ground between the four legs. For the poor, the legs are often simple wood and the ropes are grass or palm leaves. More expensive bed legs are shisam or lacquer patterned wood, brass, or are plated with gold or silver. The weaving is made of broad cotton tape. A charpoy is used to carry the dead to the graveyard.

Rallis are spread over the webbing of a charpoy as bed sheets and as a bed cover. In cooler weather and in more northern areas, two to three rallis are used as covers and in very cold weather, rallis are used as covers for the charpoy and wool covers are used on top. Each household normally has enough rallis for each member of the family as well as guests. Large stacks of twenty to fifty or more rallis are seen in village homes. Rallis are used in marriages, as gifts and as dowry. A couple receives between five to fifteen (or more) new rallis at their wedding, depending on their wealth. Rallis are borrowed from neighbors at wedding time to provide guests a comfortable place to sleep.

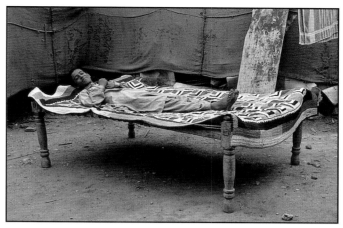

A charpoy sits in a family courtyard in Thatta, lower Sindh

Rallis are used to convey feelings of hospitality. When guests arrive, a ralli is spread over a bed as a show of respect. If a guest is welcome to stay a night or more, the ralli is kept at the foot end of the bed. If a guest has stayed too long, the host will fold up the ralli in the presence of the guest as a signal it is time to go. If the ralli is not placed on the bed, then the guest should know that they are only invited for a chat, dinner, cup of tea or buttermilk, and then should leave.

A charpoy and a shawl make a nice hammock for a baby in Umarkot, middle Sindh.

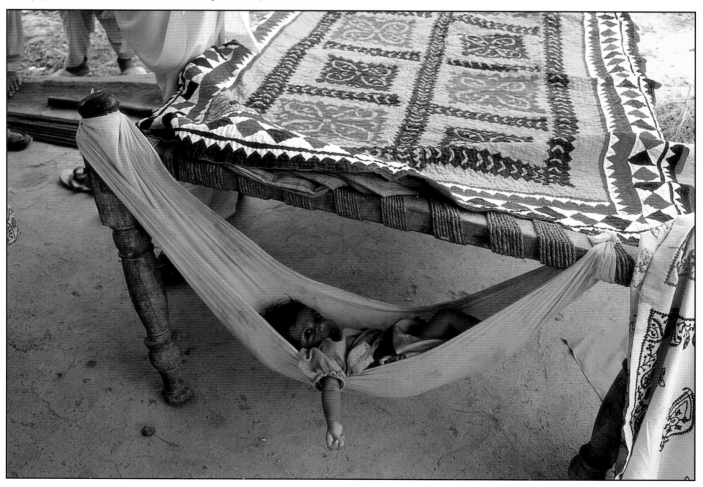

Rallis, in addition to bedding, have other sizes and uses. Rallis are used as a carrying cloth, sewed with a skirt as a table cover, as a baby cradle, and as a temporary wall or canopy. Rallis can be spread on the floor like a mat or can be made as a prayer rug. After a death, it is customary to go and sit respectfully in the household of the deceased and at the condolence place. Two rallis are collected from each village household, and close relatives spread these rallis on the ground for those paying their respects. In the past, rallis were also used as enormous fans. A ralli was connected to the roof of a home with the help of hangers, and a rope was connected to the center of the ralli. Pulling the ralli circulated fresh air. This cooling method is still used when electricity fails.[5]

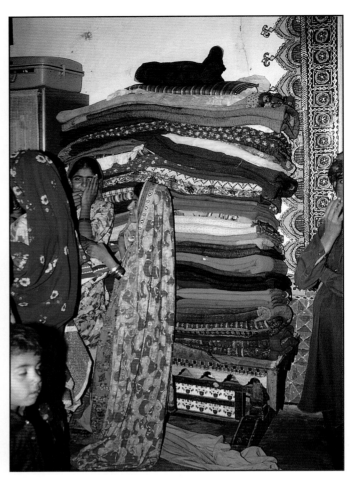

These quilts are stacked on a chest in a home in Banni, Kutch. They are often seen piled on a short table as well.

Small square quilted pieces are often made into storage bags. Wedding gifts such as jewelry or cosmetics are often presented in bags formed by folding a square in half and sewing up two sides (gothro). Another form of bag (bhujki or bushkiri) is made by folding three corners of a square quilt to the center. This kind of bag is also referred to as a Quran bag, an honored place for the Muslim scriptures.[6]

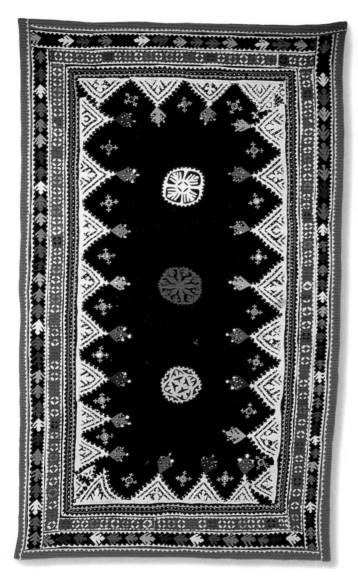

This quilt was made as a decorative cover for a pile of quilts as evidenced by the long narrow shape and decoration. It is from middle or lower Sindh, late twentieth century, 91" x 52", all cotton.

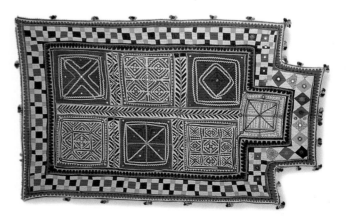

A ralli may be made in the shape of a prayer rug. This one is mid- to late twentieth century, 51" x 32", all cotton. *Courtesy Lok Virsa Museum, Islamabad.*

Making Rallis

In almost every rural household, the women know how to make rallis. They are normally not made for sale, but are made for use by the family. Traditionally rallis are made from layers of cotton cloth originally old clothing or sacks. Sometimes inexpensive, uncolored cloth called grey cloth or muslin is purchased to supplement the available fabrics. Muslin comes from a weaving unit at a town with power and is available in various weights. In the past, all rallis were made of cotton fabric. With the introduction of synthetic fabrics in clothing, old worn cloth is now synthetic and quilts can be found with combinations of cotton and nylon or all synthetic fabrics. Some women prefer to make quilts from synthetic fabric because it is easier to sew and their fingers no longer hurt after stitching. In addition, the colors are bright and do not fade or run. The women find the new pre-dyed cotton stiff and difficult to sew, so they wash it first with water and salt to soften and shrink it.

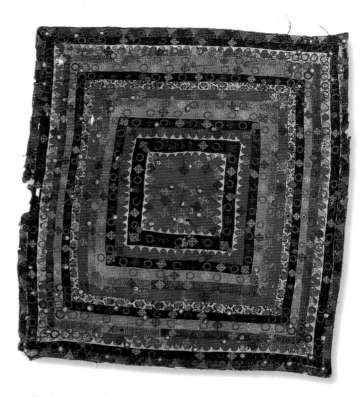

Few ralli quilts last long with constant use. This Jogi square is about one hundred years old, judging from the handwoven fabrics, block printing, and the natural dyes used in the coloring. At one time, the square was covered with small round mirrors embroidered in place with red. A few mirrors remain as well as a few pompoms embellished with clear beads. The ralli is from middle or lower Sindh, c. 1900, 39" x 34", all natural fibers.

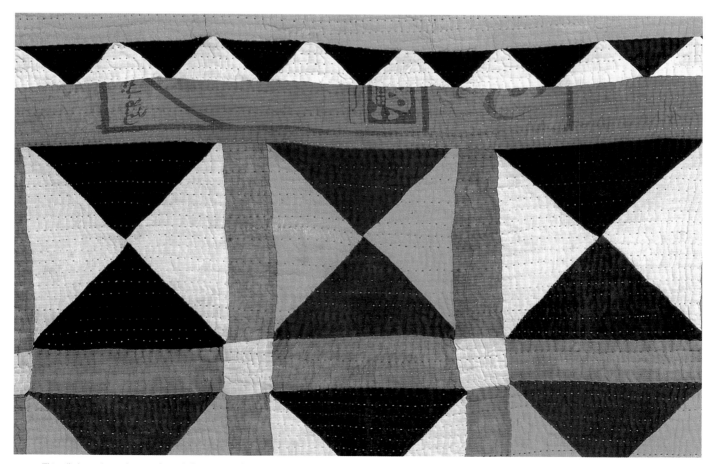

This ralli shows that quilts are truly made from scraps of different fabrics. Printed words and a skull and crossbones from the original printed sack are still visible on the red strip on the border of the quilt.

To get enough fabric for a ralli, the women of the household collect old clothing as it is worn out. The cloth is washed and saved.[9] Old head coverings (chaddars, dupattas, odhanis, abochhanis or chundaris) are particularly prized as they are large rectangular pieces of fabric that can cover almost an entire quilt back or front. A fabric collection is located in a specific area of the house. Some pieces are held for many years waiting for the "right" quilt. (In this way, it is difficult to "date" a quilt when the quilter is unknown. Often the age of the fabric on the front and back is not the same.) Certain traditional colors are preferred in quilts and women will dye the fabric to get these colors. In the nineteenth century, dying, especially in the rural areas, was done with natural dyes. Indigo was used for blue, madder root for red, the bark of the Babul resulted in a black red color, iron acetate for black, and yellow pomegranate skin created a maroon color.

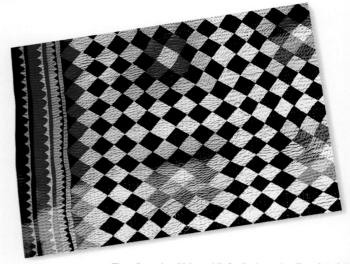

This ralli, made in Hala, middle Sindh, shows the effect of sun fading on the chemical dyes. The quilt was folded asymmetrically in a shop window so the exposed part faded to very pale colors and the covered areas are still vibrant. Some old quilts are faded to the point that the original colors can only be guessed.

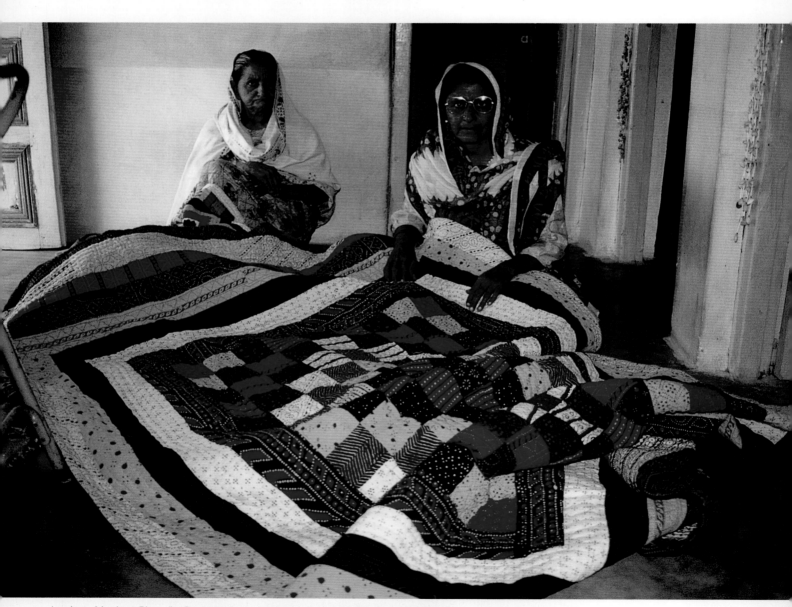

A mother and daughter in Dhamadka, Gujarat, sit with a patchwork quilt (called godri) made by the daughter. Safiya-Bai Hussain, and her mother, Jannat-Bai Majid, are Muslims from the Khatri group. Dhamadka, known for its block-printed fabric industry, was mostly destroyed in the earthquake of January 2001.

Starting in the middle of the nineteenth century, inexpensive European commercial dyes became available in the market. The commercial dyes were less time consuming to use compared to the collection and preparation of natural dyes. Women dying the fabric themselves at home started using commercial dyes to such an extent that by the turn of the century, natural dyes were rarely used, with the exception of indigo and madder. (Only a few dyers today are familiar with the natural dye process. Fortunately, there are individuals now striving to revive the old processes.) Women now dye one or two meter lengths of fabric with chemical dyes that are available in the market. The women heat the water in a large container or small drum, add the chemical dye, and then the fabric. The dyes are usually not very good and no mordant is used to set the color. As a result, colors are not fast and will fade over time. Sometimes moisture may cause the colors to bleed into one another.

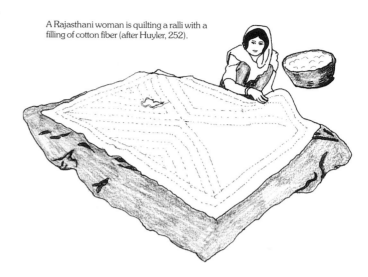

A Rajasthani woman is quilting a ralli with a filling of cotton fiber (after Huyler, 252).

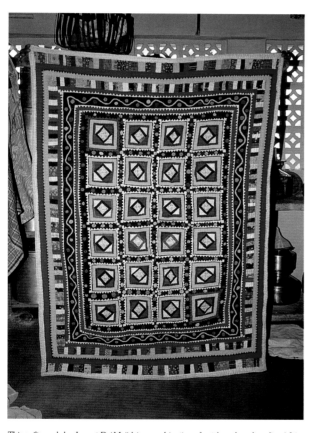

This quilt, made by Jannat-Bai Majid, is a combination of patchwork and appliqué. It is over fifty years old and was the inspiration to her daughter for her first quilt.

If a woman is making a quilt with a patterned top, she plans the pattern in her mind and starts working on the stitching of the pieces when she has time. Traditionally the patterns are done totally from memory and no paper designs are used. People who are illiterate often have amazing memories. From their early years, children of the subcontinent are taught to repeat stories, songs, and poems. Long dramas and dances are memorized and repeated as a source of entertainment as well as for cultural history.[10] Without the ability to record words and images on paper, these people use their minds to store important images. Singing memorized songs, often accompanying ralli making and other work, is another way of exercising memory.

Usually the stitching of the pieces of the quilt pattern together is the work of one woman. She often keeps all her cloth pieces together in a small bag as she works on them. The cloth for a geometric pattern is torn to the correct sizes and small needles are used to sew the pieces together. Traditionally, the entire quilt is stitched by hand without the use of a sewing machine. Usually rallis are made in leisure time that comes after breakfast until noon and in the evening. This can total three to four hours a day. Sewing is usually not done at night because the lighting is not adequate and causes eyestrain.[11]

A ralli is usually planned to be six to seven feet long and four to four and a half feet wide, large enough to cover a person on a charpoy. The quilt will have an upper and lower cloth layer called "purr." In between is a layer of stuffing called "laih."[12] The stuffing layer can be anywhere from two to seven layers of scraps laid out in layers to cover the bottom purr and tacked down with a long running stitch called "dogan".[13] For a warmer or thicker quilt, cotton fibers are put in the middle of the two purrs. The upper purr is the one that is usually seen and is therefore the patterned purr. Sometimes a full sheet of patterned fabric such as an ajrak or old chaddar is used on the top. A border is added to make the fabric piece larger and to add decoration.

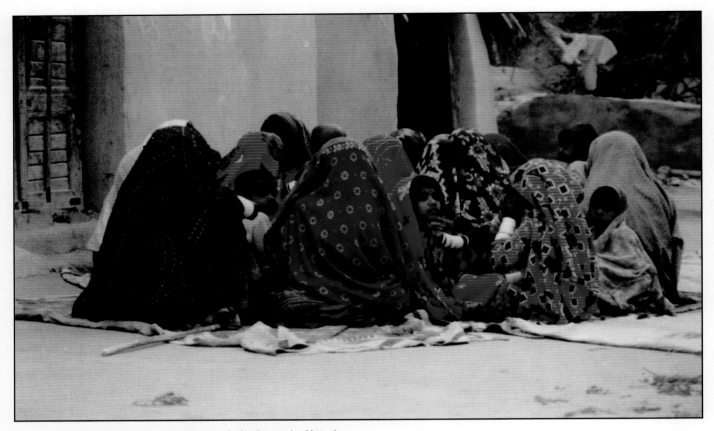

These women in Nagar Parkar are singing a wedding song for the photographer. Notice the variety of shawls used by the women. Once worn out, they are often used as the bottom layer of a ralli. *Courtesy of Mehnaz Akber Aziz.*

This rilka has a piece of an fine silk embroidered shawl (abbochnai) as the upper layer. The back has a dozen different scraps of fabric. The ralli is from middle or lower Sindh, late twentieth century, 46" x 32.5", with a variety of fabrics.

The lower purr or layer of the ralli is often very interesting. The fabric used for the bottom is usually a large piece of fabric especially saved to be used on a quilt. Most often the fabric is a used shawl that is tie-dyed, block printed or commercially printed. Sometimes this lower purr is pieced and then dyed red, blue, green or black to make the different fabrics seem to be one large piece of fabric. Solid green or black lower purrs usually indicate the ralli was intended to be a special piece.

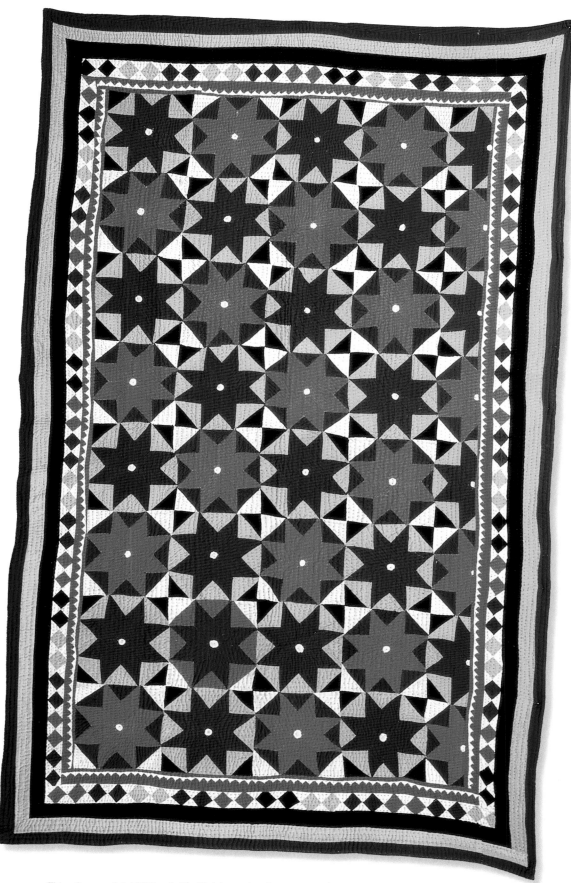

This quilt was made in Mithi for sale. The fabric is new, the colors are even and probably commercially dyed. The back is new fabric in solid green. The ralli is from lower Sindh, c. 1998, 98.5" x 56", all cotton.

Colors of Rallis

There are some traditional colors for rallis but these colors can vary according to the community where the quilt is made, the preferences of the quilter, and the colors of fabric available. Sindhis traditionally use a color palette called satrangi (or seven colors). It includes dark blue (or black), white, red, yellow, green, purple, and orange. Shocking pink is also used. This color tradition follows the colors of the ancient pottery of the Indus civilization including black, white, red, yellow, green, and blue. These are the colors that are made from the natural sources in the region. Fondness for color and the preferred colors make a common theme in the ballads, folklore, and classical literature of Sindh. Color is even added to village homes through paintings on the walls or mystical symbols.[23]

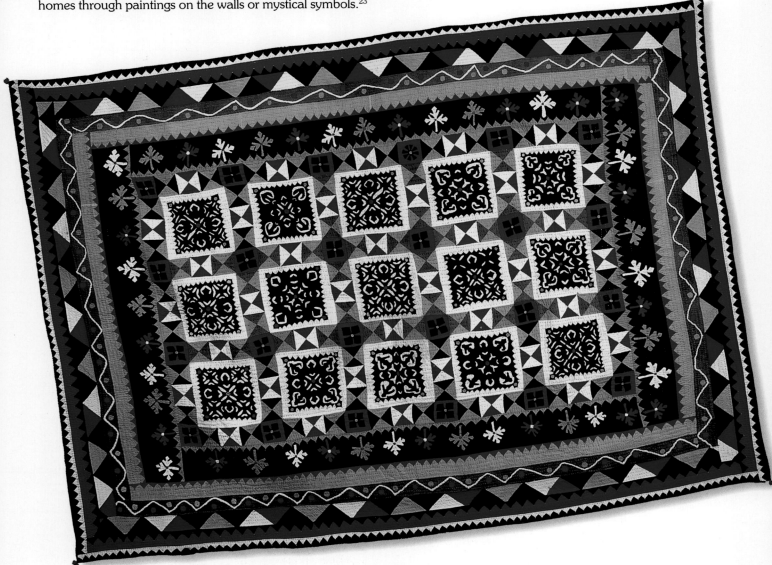

This fifteen block appliquéd ralli has various designs of purple appliqué on a white background in the "satrangi" colors. The borders around the center field are a combination of triangles and squares, a tree-like appliqué, a row of triangles, and a vine design. The ralli is from middle or lower Sindh, late twentieth century, 89" x 66", all cotton.

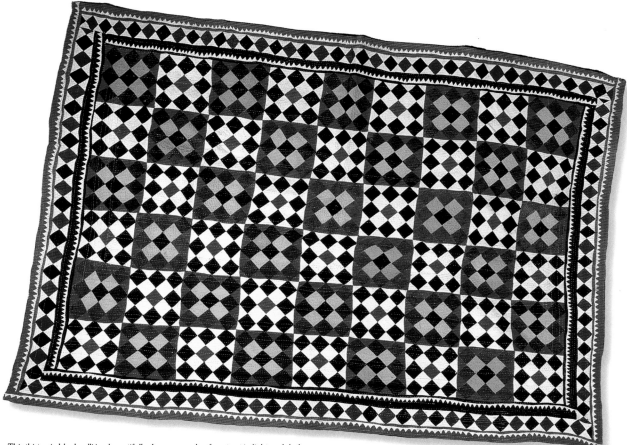

This thirty-six block ralli is a beautifully done example of contrast in light and dark blocks in a farsh pattern. The back has a reddish block print chaddar. The ralli is from lower Sindh, late twentieth century, 81.5" x 58", all cotton.

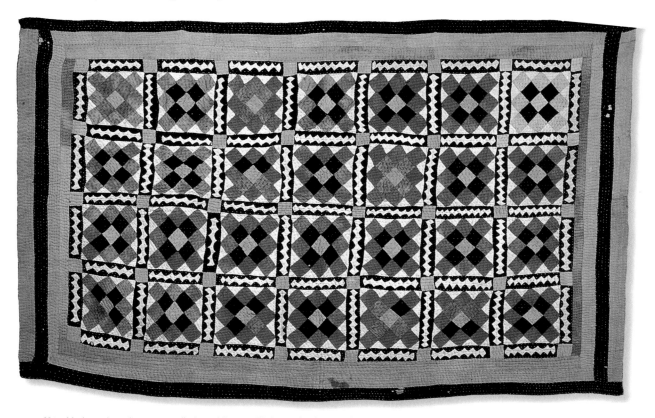

Using blocks similar to the previous ralli, this quilt has an added zigzag border around each block. The back of this ralli has a very old and worn block print and resist moon pattern. This ralli has twenty-eight blocks made of squares separated by a zigzag border, with plain borders of black, white, red gold, and olive green. This ralli is from lower Sindh, late twentieth century, 80" x 51", all cotton.

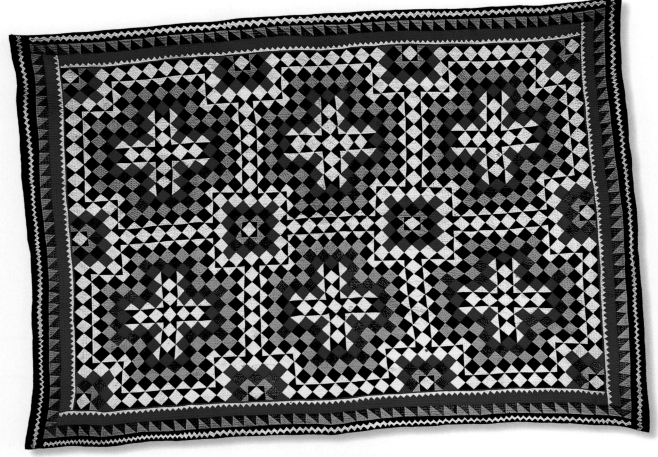

This large ralli, with six large crosses done in small square and triangular patches, is from the Meghwar community in Mirpur Khas. It is late twentieth century, 89" x 63", all cotton.

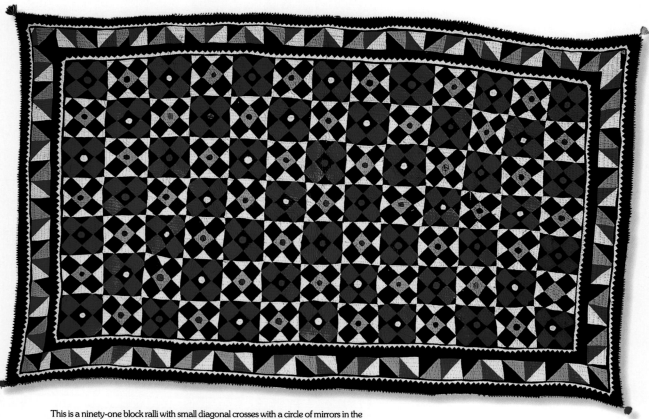

This is a ninety-one block ralli with small diagonal crosses with a circle of mirrors in the center. The quilt is from middle or lower Sindh, late twentieth century, 79" x 48.5", all cotton.

54

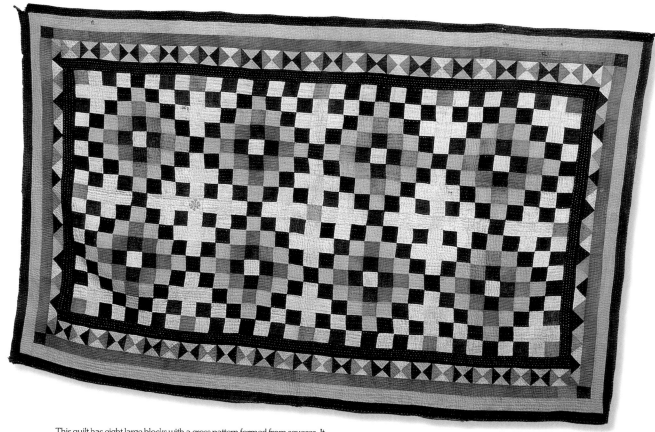

This quilt has eight large blocks with a cross pattern formed from squares. It is from lower Sindh, late twentieth century, 81.5" x 54", all cotton.

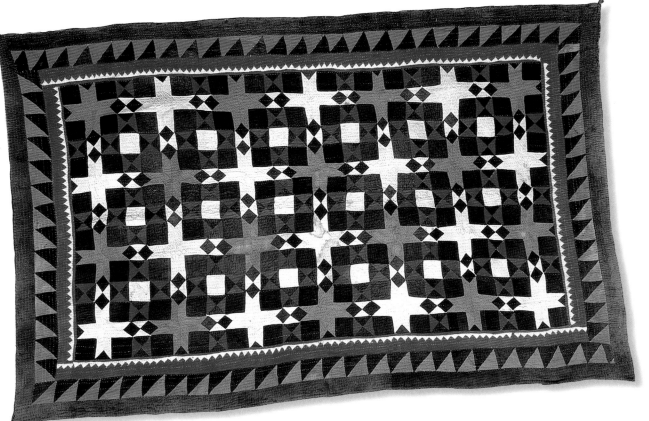

This ralli has a multi-dimensional pattern that can be viewed many ways. It has sixteen blocks of eight-pointed stars. Done in white, dark purple, orange, and subdued green, it has a fine ajrak in the kharak pattern on the back. The quilt is from middle or lower Sindh, late twentieth century, 84" x 55.5", all cotton.

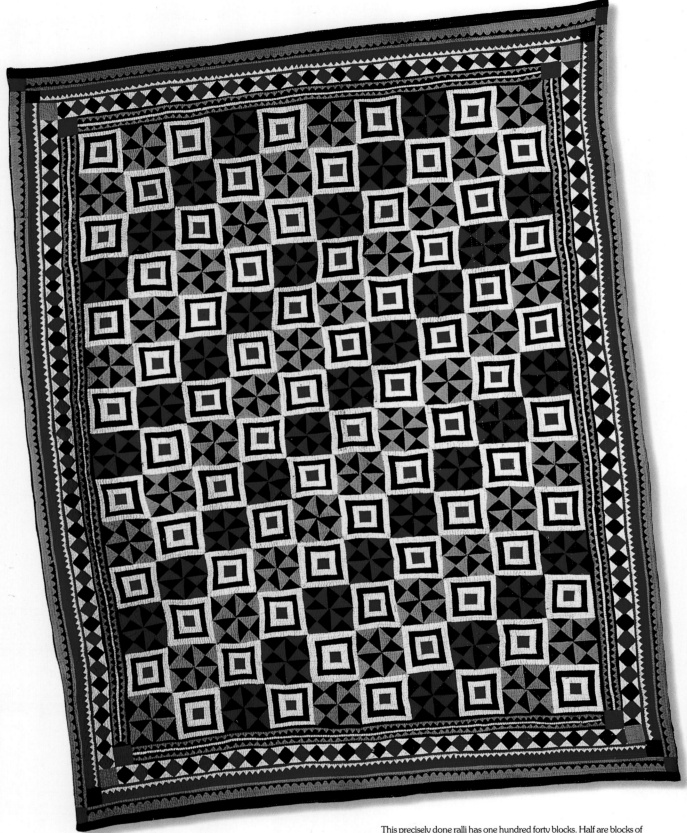

This precisely done ralli has one hundred forty blocks. Half are blocks of triangles and the others are the square within a square design. The back has two lengths of commercially embroidered shawls. The quilt is from middle or lower Sindh, late twentieth century, 81.75" x 62.5", all cotton.

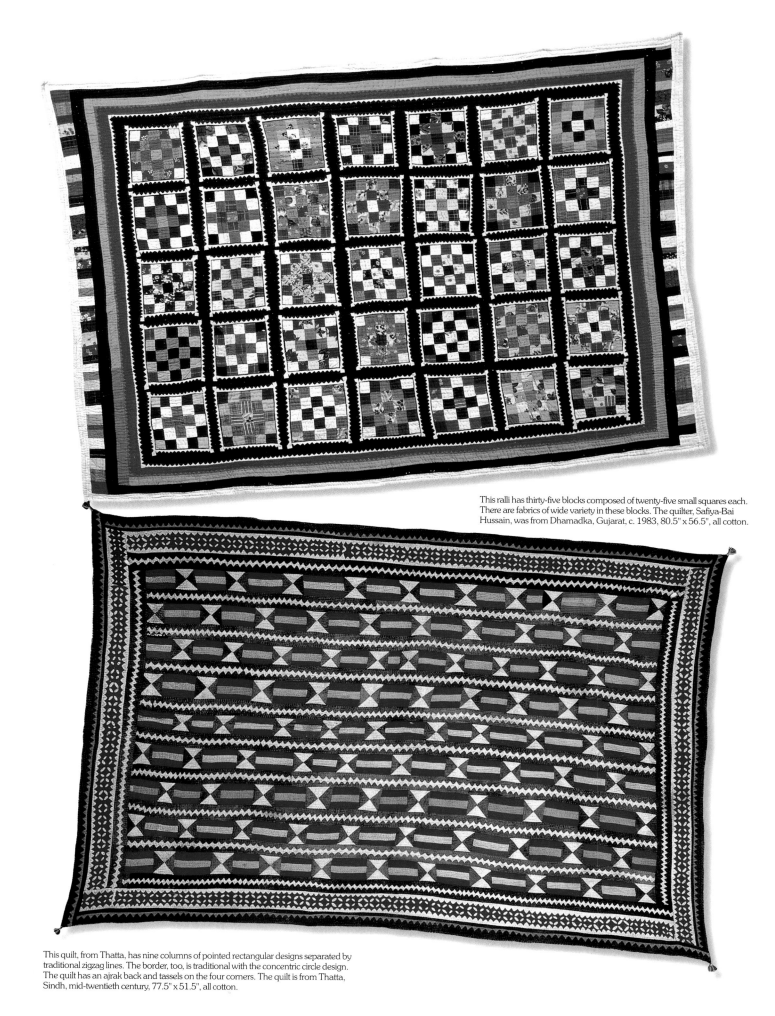

This ralli has thirty-five blocks composed of twenty-five small squares each. There are fabrics of wide variety in these blocks. The quilter, Safiya-Bai Hussain, was from Dhamadka, Gujarat, c. 1983, 80.5" x 56.5", all cotton.

This quilt, from Thatta, has nine columns of pointed rectangular designs separated by traditional zigzag lines. The border, too, is traditional with the concentric circle design. The quilt has an ajrak back and tassels on the four corners. The quilt is from Thatta, Sindh, mid-twentieth century, 77.5" x 51.5", all cotton.

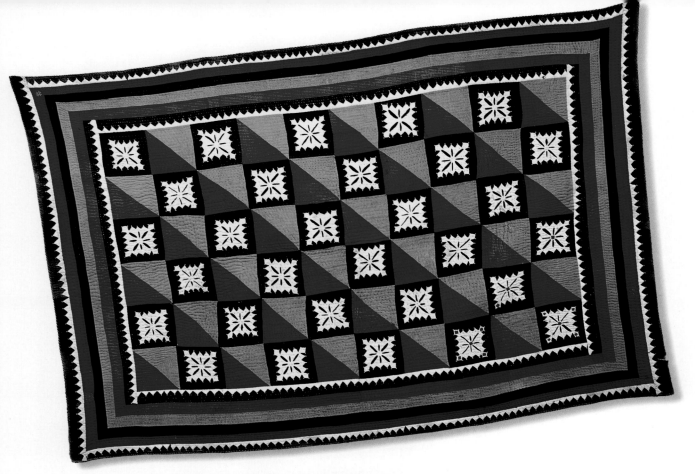

This ralli has fifteen black blocks with a white appliqué design placed between red and orange triangles. The back is a large red tie-dye shawl with yellow dots. The quilt is from middle or lower Sindh, late twentieth century, 84" x 57", all cotton.

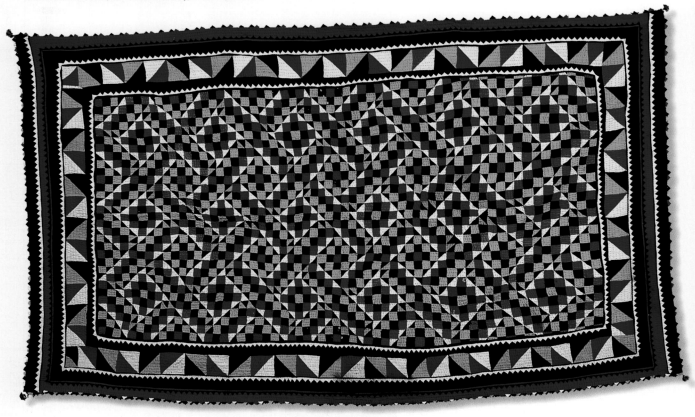

This design, produced from hundreds of tiny squares and triangles, formed twenty-eight cross-shaped patterns. The quilt has a commercially printed floral back in lavender, pink, and lime. The quilt is from middle or lower Sindh, late twentieth century, 76.5" x 47", all cotton.

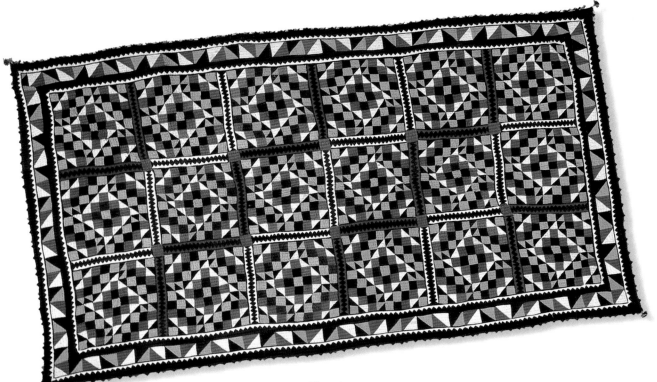

This quilt is the companion of the previous one, probably done by the same quilter. She has taken the original design and divided it into eighteen blocks without changing the original pattern. This quilt has a commercially printed peach colored floral backing with small lavender flowers. This quilt is from middle or lower Sindh, late twentieth century, 79" x 44", all cotton.

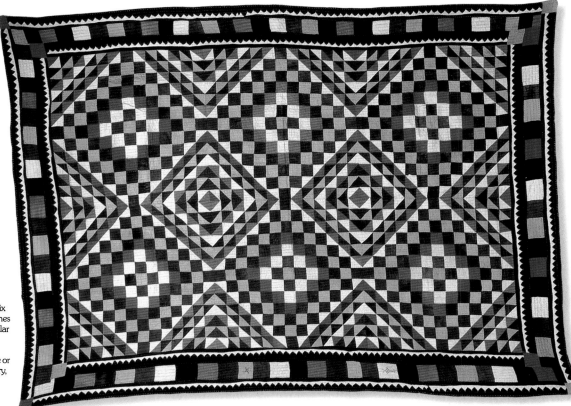

The movement in this design of six blocks formed from square patches and two center blocks of triangular pieces. The quilt has bright commercially printed fabrics on the back. The ralli is from middle or lower Sindh, late twentieth century, 78.5" x 58", all cotton.

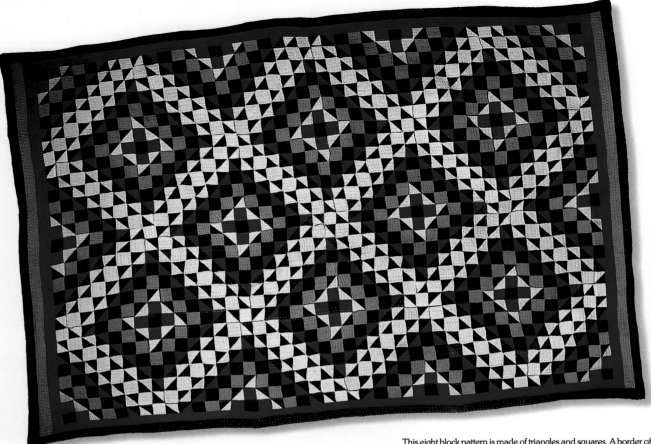

This eight block pattern is made of triangles and squares. A border of black and white triangles and squares frame the blocks. The quilt has a tie-dye shawl on the back. This ralli is from middle or lower Sindh, late twentieth century, 88" x 58", all cotton.

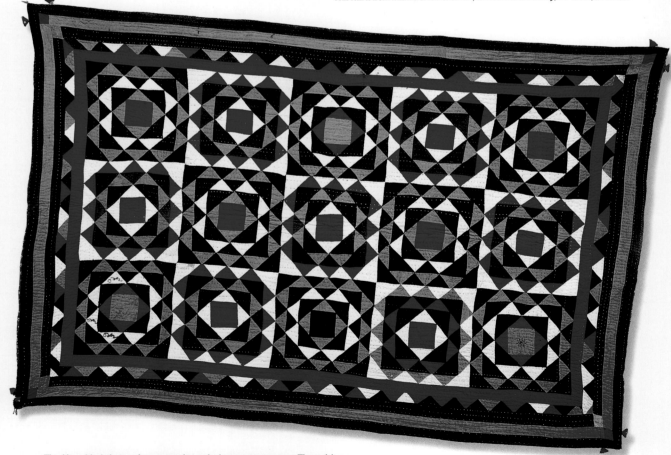

This fifteen block design of squares and triangles has great movement. The quilt has a printed yellow and red shawl on the back. The ralli is from middle or lower Sindh, late twentieth century, 77.25" x 51", all cotton.

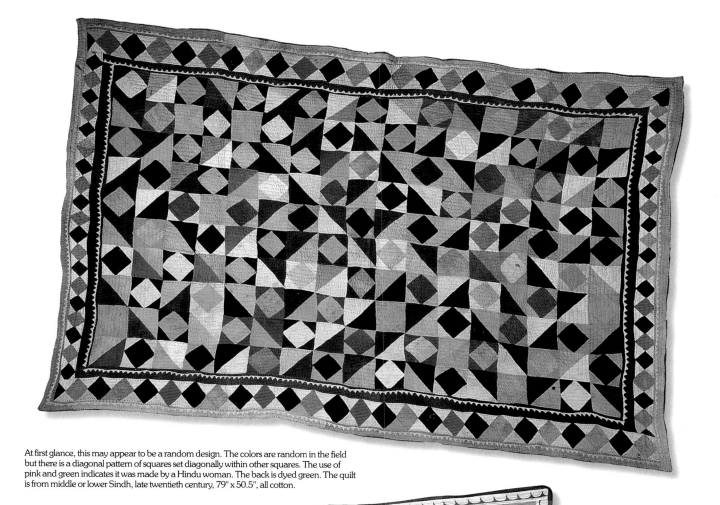

At first glance, this may appear to be a random design. The colors are random in the field but there is a diagonal pattern of squares set diagonally within other squares. The use of pink and green indicates it was made by a Hindu woman. The back is dyed green. The quilt is from middle or lower Sindh, late twentieth century, 79" x 50.5", all cotton.

This twenty-eight block ralli alternates a patchwork design with an appliquéd eight petal flower. The back is made of two pieces of yellow-green lungi. The quilt is from Rahimyar Khan, Punjab, late twentieth century, 74.5" x 48.5", all cotton.

61

Appliqué Rallis

Appliqué patterns can be made in almost any shape. The design is formed as one color of fabric is sewed on top of another color of fabric. There are two categories of appliqué. The first is called appliqué. The top fabric is cut into the desired shape. Often the fabric is first folded in quarters and cuts are made through all the layers of the cloth. The result is a "snowflake" style where the design is symmetrical on all four corners of the appliqué. The fabric to be appliquéd can also be cut into a natural shape such as a flower or animal. A tiny hem is formed on the edge of the appliqué as it is attached to the background fabric with a fine stitch. This appliqué technique is commonly seen in the row of connected triangles seen in the borders of many ralli quilts. The second kind of appliqué is called reverse appliqué. The bottom fabric in reverse appliqué forms the shape or design contrasted to the top fabric in appliqué. The top fabric, in effect, frames the design of the bottom fabric. The thread color of the top fabric is used to hide the stitches.[36] The stitch used in appliqué work is called the hemming stitch, antique hem stitch or slip stitch. It is often done so well that no threads are visible on the top. Sometimes the edge of the appliqué is decorated with a tiny zigzag that can be done with the zigzag running stitch or zigzag back stitch.

Appliqué quilts are often named for the number of blocks (guls or flowers) they have. For example, Four Flowers (Chau Gullo) is named for the design where each corner has the appliqué of a rose. The center has a large appliqué that represents the whole rose bush and is surrounded by representations of butterflies and honeybees. Eight Flowers (Ath Gullo) has a design of eight kinds of flowers including rose and jasmine. Nine Flowers (Nau Gullo) has appliquéd flowers based on a constellation of nine stars. These quilts are not common and it is said if this ralli is spread under a night sky it will rival the stars in beauty. A poem about this ralli describes how the moon and stars are shy in front of this brilliant ralli.[37] Sixteen Flowers (Sorhan Gullo) is made with four corners of roses and centers of jasmines with three jasmines joined together. Other designs commonly used in rallis are from the environment: stork, camel's hump, snake's hood, and jewelry.[38] Appliqué quilts, more often than on patchwork quilts, are beautified with embroidered designs (sometimes on the edge of the appliqué), mirrors, cowrie shells, sequins, tassels, and beads.

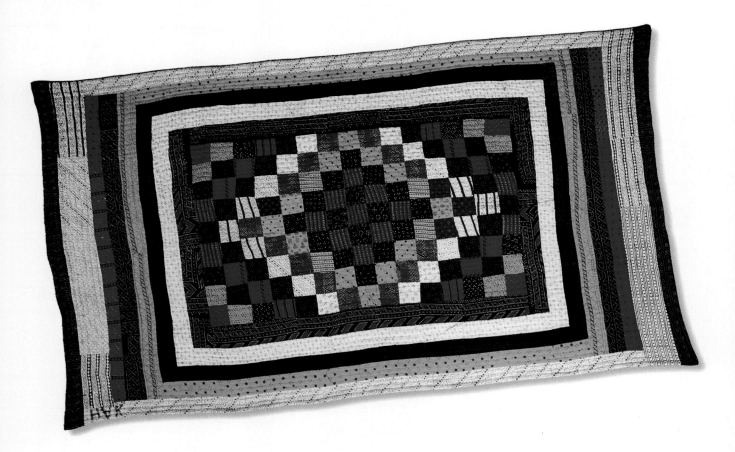

This ralli comes from a town that specializes in block print fabrics. The geometric design and borders are typical of a ralli but the use of printed fabric is unusual. The quilt is from Safiya-Bai from Gujarat, c. 1990, 97.5" x 55.5", all cotton.

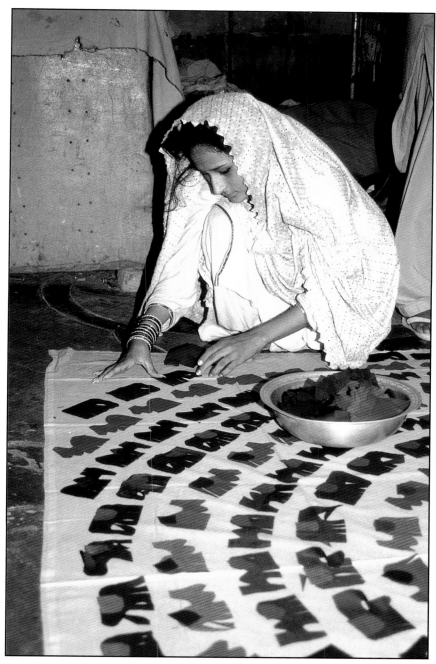

A woman in Mirpur Khas is cutting and laying out appliquéd elephants in preparation for sewing them on background fabric on a ralli made for sale.

Appliqué shapes are often taken from familiar objects in daily life. Peacocks, a common symbol on rallis and embroideries, are seen here on the roof of a home in Banni, Kutch.

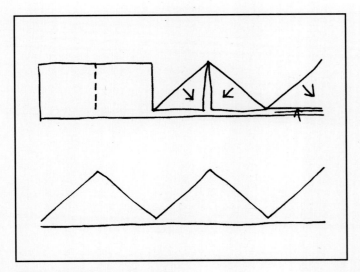

Appliqué technique for a row of triangles.

Reverse appliqué for a border pattern.

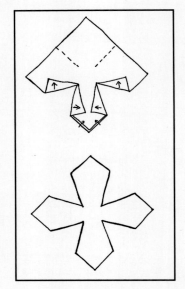

Appliqué technique for a mandherro shape.

Examples of appliqué shapes found in rallis.

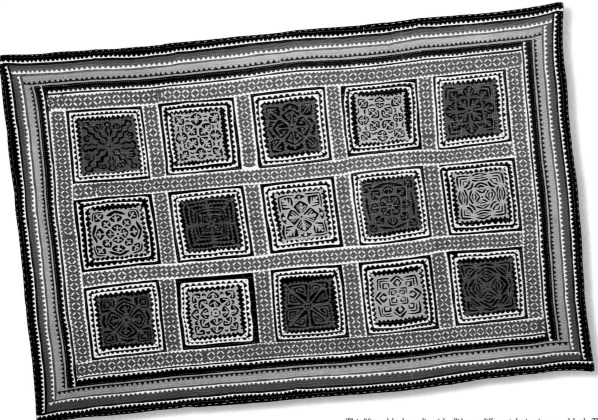

This fifteen block appliquéd ralli has a different design in every block. The yellow and red blocks are placed in a diagonal pattern. The back has a fine gargapot shawl from the farming community. The quilt is from Badin, lower Sindh, mid- to late twentieth century, 84" x 57", all cotton.

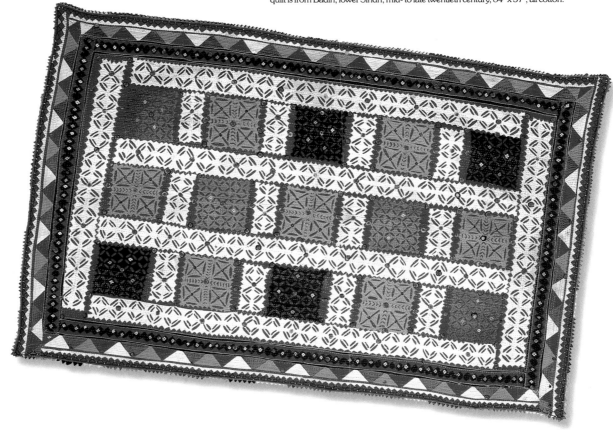

This fifteen block appliquéd ralli has many embellishments including small pompoms with clear beads in the field and a tiny folded fabric sawtooth edge. The seven gold colored blocks are all made in the same design, as are the eight black and green blocks. The quilt is from lower Sindh, mid- to late twentieth century, 74" x 47", all cotton.

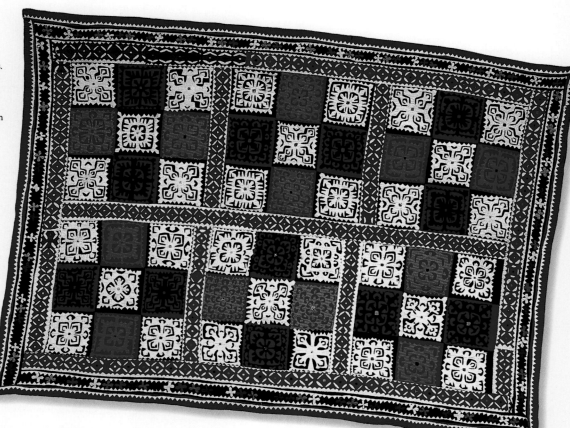

This ralli is covered with appliqué patterns. The six large blocks are composed of nine smaller appliquéd blocks. Within each large block are similar squares repeating the same design. The back is a fine black and burgundy block print. The ralli is from middle or lower Sindh, late twentieth century, 81" x 61", all cotton.

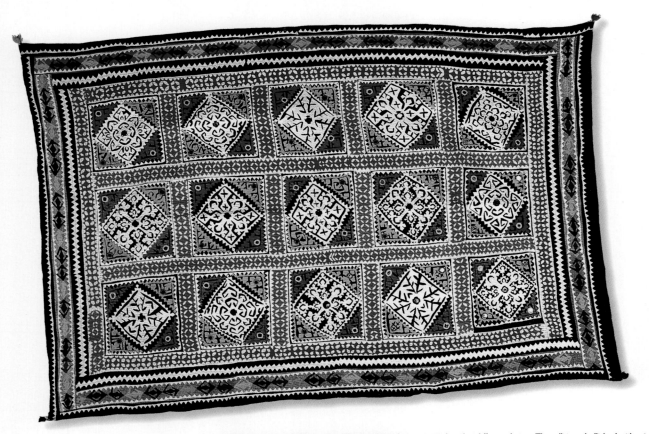

This fifteen block ralli has large white appliquéd squares, each with a different design. The ralli is embellished with mirrors, embroidery, and tassels and has a fine ajrak back. The ralli is from lower or middle Sindh, mid- to late twentieth century, 82.5" x 57.5", all cotton.

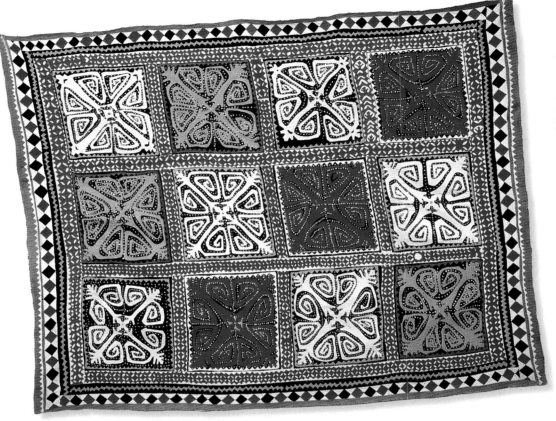

This twelve block appliquéd ralli has the same design in each of the white, red, and yellow blocks. The variety in the sewing of the appliqué as well as the accent of the sequins gives the quilt an appearance of movement. This ralli is from Rahimyar Khan, late twentieth century, 83" x 68", all cotton.

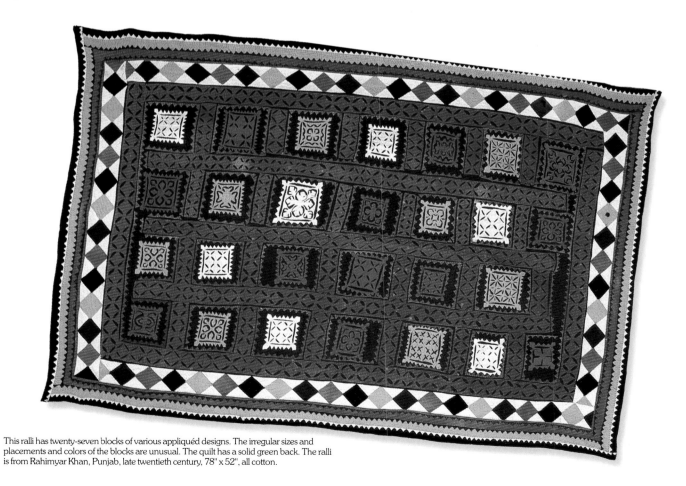

This ralli has twenty-seven blocks of various appliquéd designs. The irregular sizes and placements and colors of the blocks are unusual. The quilt has a solid green back. The ralli is from Rahimyar Khan, Punjab, late twentieth century, 78" x 52", all cotton.

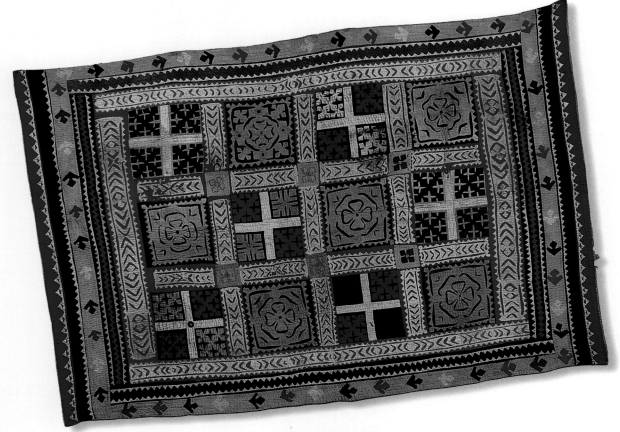

This twelve block ralli alternates a large pattern with a cross design. It is an older ralli described by the community as "an old design." It is from the Meghwar at Mirpur Khas, Sindh, mid-twentieth century, 78" x 52", all cotton.

This six block ralli has a circle appliqué with five borders including woven braid, small rickrack braid, and embroidery. A tie-dye piece is on the back. The ralli is from middle or lower Sindh, mid-to late twentieth century, 83" x 58", all cotton.

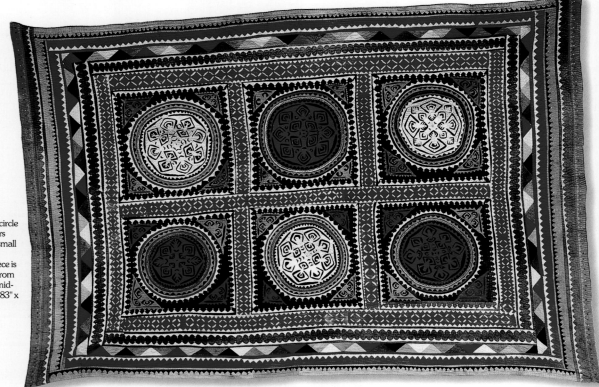

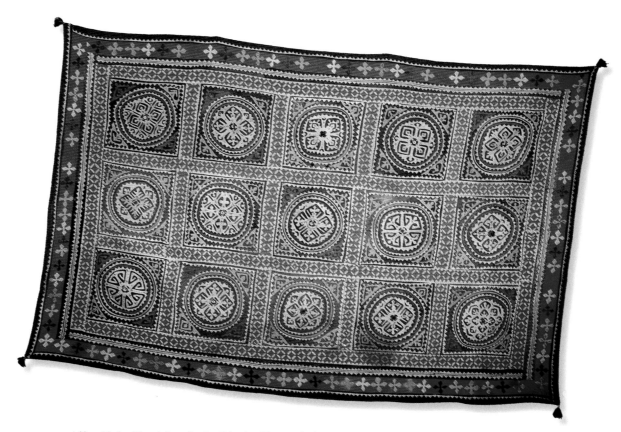

A fifteen block ralli has circle appliqués with borders. The muted colors are typical of the area of Thatta. The back is a piece of ajrak. This ralli is from Thatta, Sindh, mid-twentieth century, 88.5" x 68.5", all cotton.

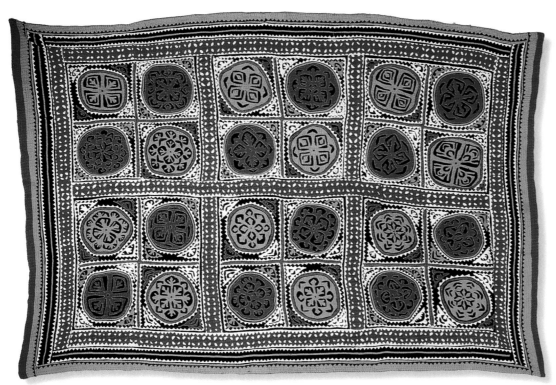

This six block ralli has four circle appliqués in each large block. The various designs have a natural, floral look. The ralli is from Badin, Sindh, late twentieth century, 83.5" x 61", all cotton.

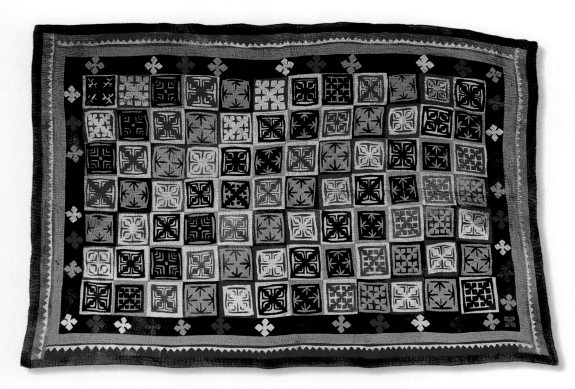

This appliqué ralli has eighty-four blocks. There is a strong diagonal feel in the placement and colors of the blocks. It is probably Hindu, judging by the use of pink and green. It is from middle or lower Sindh, late twentieth century, 78.5" x 54", all cotton.

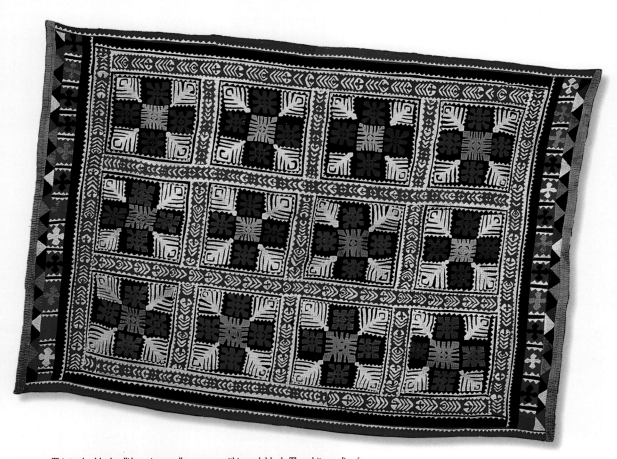

This twelve block ralli has nine smaller squares within each block. The white appliqué blocks in the corners create a traditional pattern. The quilt has a tie-dye back and is probably from middle Sindh, late twentieth century, 80.5" x 59", all cotton.

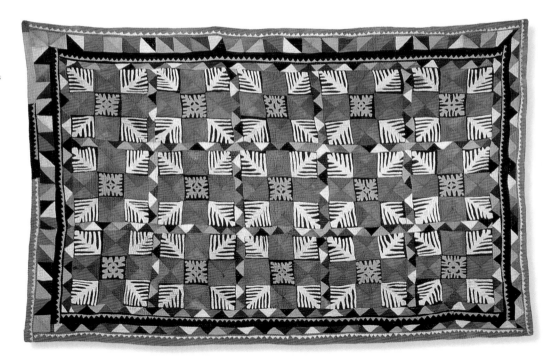

This fifteen block ralli has nine smaller squares within each block. The traditional white appliqué pattern in the corner position is sometimes called "hands." This quilt is from middle or lower Sindh, late twentieth century, 83" x 55", all cotton.

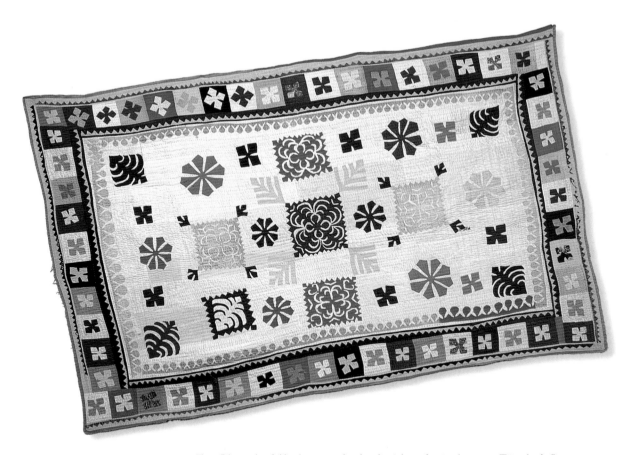

This ralli has a white field with various colored appliqué shapes forming the pattern. This style of ralli, with a large piece of fabric in the center field, is popular for rallis with a thicker filling, as this one has. This quilt is from lower or middle Sindh, late twentieth century, 83" x 55", mostly cotton.

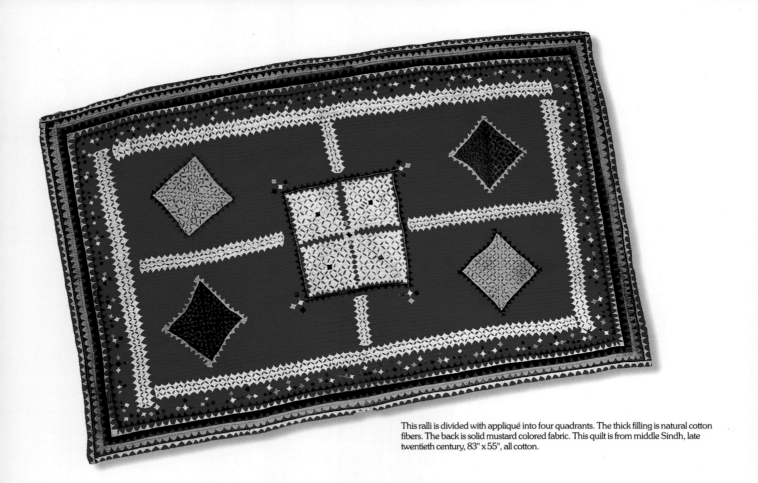

This ralli is divided with appliqué into four quadrants. The thick filling is natural cotton fibers. The back is solid mustard colored fabric. This quilt is from middle Sindh, late twentieth century, 83" x 55", all cotton.

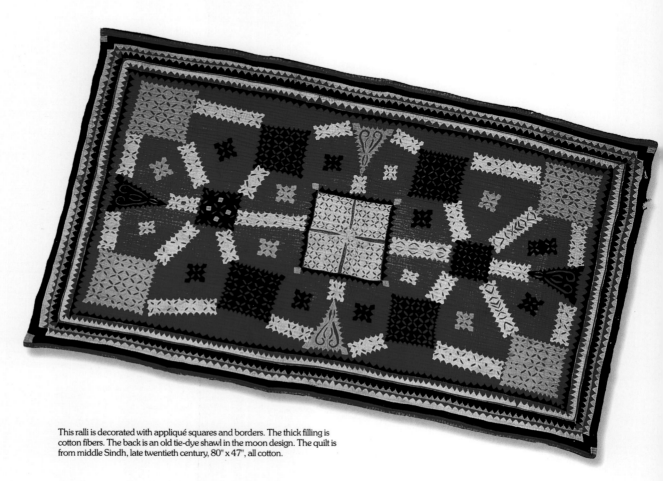

This ralli is decorated with appliqué squares and borders. The thick filling is cotton fibers. The back is an old tie-dye shawl in the moon design. The quilt is from middle Sindh, late twentieth century, 80" x 47", all cotton.

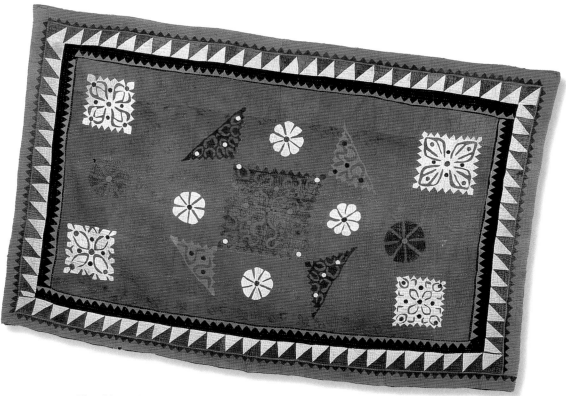

This ralli has appliquéd squares, triangles, and eight petal flowers on a field of red fabric. It is from middle Sindh, late twentieth century, 78" x 51", all cotton.

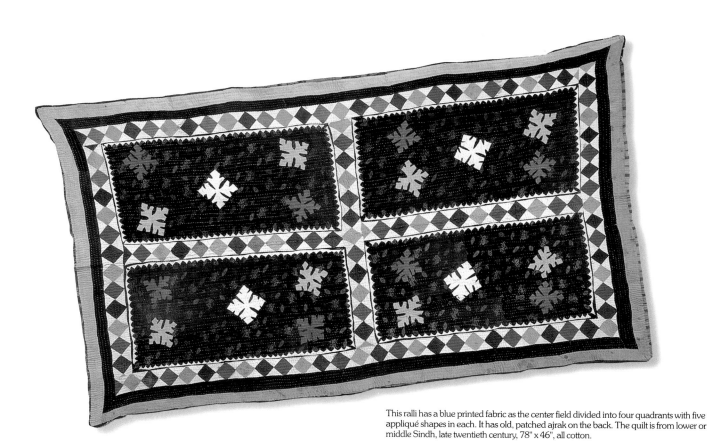

This ralli has a blue printed fabric as the center field divided into four quadrants with five appliqué shapes in each. It has old, patched ajrak on the back. The quilt is from lower or middle Sindh, late twentieth century, 78" x 46", all cotton.

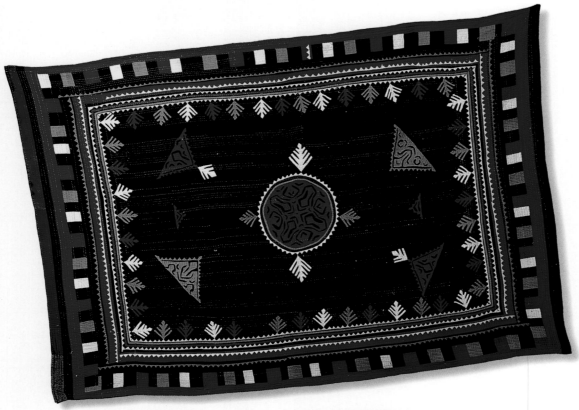

The field on this quilt is black with various circular, triangular, and plant-like appliqués. The back has a tie-dyed shawl. This ralli is from lower or middle Sindh, late twentieth century, 82" x 57.5", all cotton.

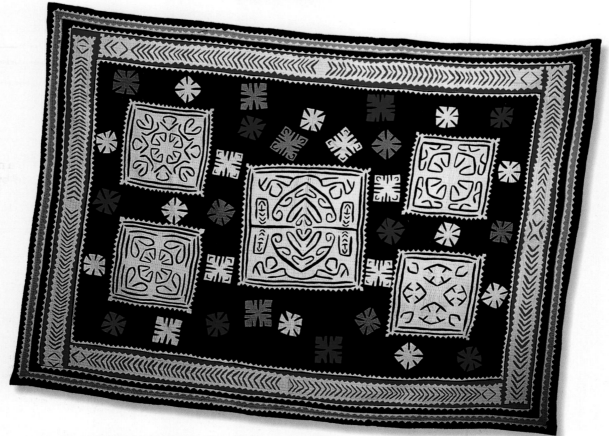

The black field on this quilt is decorated by five large appliqué squares and numerous smaller appliqués. The back has a large piece of commercially produced fabric with a small floral design. This ralli is from Phuleli, middle Sindh, 88" x 65.5", all cotton.

Embroidered Rallis

There are several tribal groups known for their embroidered rallis, particularly the Saamis and the Jogis. These rallis are stitched together with unique and unusual embroidery stitches as well as the straight stitch. Other groups decorate their rallis with embroidery to add to the beauty of the quilt. In these rallis, blocks are embroidered before adding them to a ralli.

The kabiri quilt is reportedly named after the Hindu Bhakti saint, Kabir. He worked to help the low castes of both the Hindus and Muslims. The simple nature of these quilts, worn cloth decorated with thread, illustrates his regard for poverty.[39] A traditional Jogi kabiri quilt is quilted starting from the outside in a series of increasingly smaller rectangles working to the center. The thread is colored thick cotton creating a definite design with the embroidery stitches. Often the background color is black. With both the Jogi and Saami embroidered rallis, the back of the quilt shows a series of small stitches with no loose threads. The Saami quilt often has a highly embroidered border with a piece of fabric in the middle embroidered with straight running stitches. Another type of Saami embroidered quilt has no border, and is made of large patches of fabric on both front and back. It is embroidered with very close straight running stitches.

In Jogi or Saami quilts, a variety of stitches are used. The stitches are both for decoration and also hold the layers of fabric together. Jogi embroidery is sometimes described as being coarser than Saami stitches, however, both can be very finely done and use many of the same stitches. Thick colored threads define the patterns. Commonly seen are chain stitches and cretan stitches in many variations. Connected almond shapes are made with a long-armed feather stitch in the center, outlined by a chain stitch. A famous Jogi design of stepped squares is made using two-sided line stitch and sometimes cross stitch as a border.

Embroidery is a village art and all the major tribes have their own designs. The embroidery stitches are many and varied. Commonly used stitches are the running stitch, chain stitch, herringbone, cross stitch, and buttonhole stitch. The Baluch and Sindhis are reported to have 118 embroidery stitches. (Most likely this number includes basic stitches and numerous variations. In the region, an embroidery name may refer to both a stitch and a pattern and the two are not distinguished.) The Baluch use more subdued colors than the Sindhis.[40] The designs may be stamped on the fabric with a carved wooden block and then filled in with embroidery stitches.[41] Much embroidery is seen in the decoration on women's clothing on the front panel and cuffs.

A description of the embroidery in Baluchistan in 1908 laments the affect of aniline-dyed silks on the quality of the embroidery. Among the embroideries mentioned included the artistic embroidery of the Brahui. They had a special embroidery called mosam, made by very close satin stitching in a geometric design. Kandahar embroidery was a double satin stitch done in ivory color. Padded or quilted embroidery was

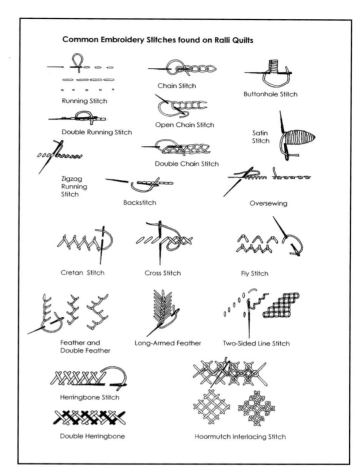

These are some of the common embroidery stitches seen on ralli quilts (after *Indian Glossary of Stitches,* Frater, 1995, 206 and Morrell, 1994, 137-140).

also seen. The Baluch of the Marri-Bugti hills had a medallion design, with areas of herringbone stitch outlined by rings of chain stitch.[42]

A unique stitch seen in the ralli region is the hoormutch (or hurmutch) interlacing stitch. Hoormutch uses two layers of herringbone stitch as a frame. Two layers of darning stitch are then interlaced around the herringbone stitches. Hoormutch is often seen as a decorative embellishment on rallis as well as other embroideries. Now the thread is cotton or synthetic but traditionally silk thread was used.[43] Another technique of the region is khaarek embroidery made from rows of satin stitching. The number of short raised rows is counted using the warp and weft of the cloth. The rows are set in geometric pattern creating a dense effect of dates growing on palm trees from which the name is derived. Khaarek embroidery is often seen at the bottom of quilted dowry bags.[44]

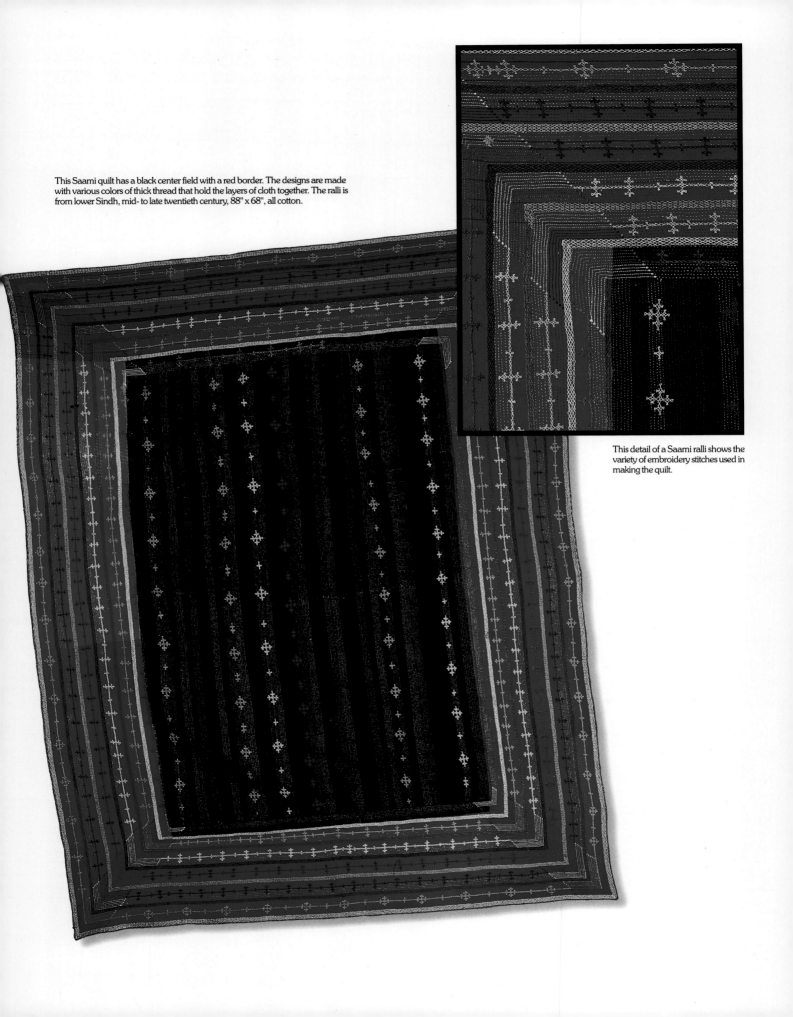

This Saami quilt has a black center field with a red border. The designs are made with various colors of thick thread that hold the layers of cloth together. The ralli is from lower Sindh, mid- to late twentieth century, 88" x 68", all cotton.

This detail of a Saami ralli shows the variety of embroidery stitches used in making the quilt.

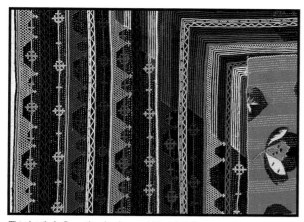

This detail of a Saami border shows additional stitches.

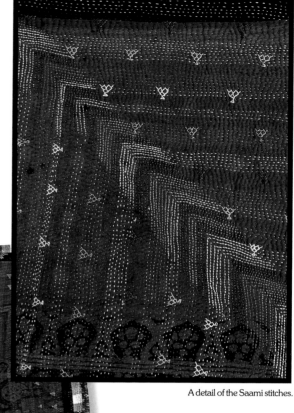

A detail of the Saami stitches.

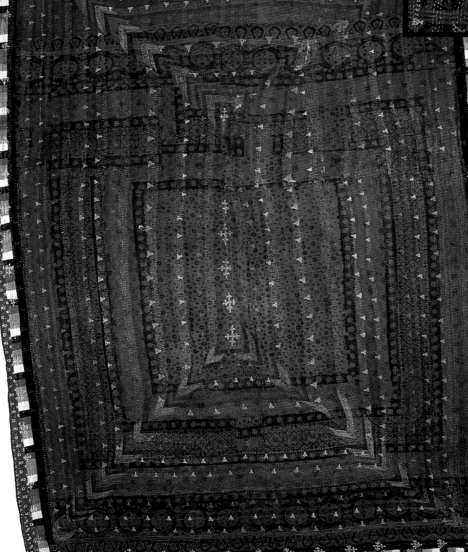

A Saami quilt with a burgundy field and a patchwork border. The characteristic right angle embroidered shapes at the corners going to the middle are clearly visible. The quilt is from lower Sindh, late twentieth century, 84" x 60", all cotton.

This detail of the Saami embroidery shows the fine stitching done with a thin cotton thread.

This small embroidered Saami piece shows a great variety of embroidery stitches. It was probably used as a table cover and is in Hindu favorite colors of pink and green. The piece is from lower Sindh, mid-twentieth century, 42.5" x 34", all cotton.

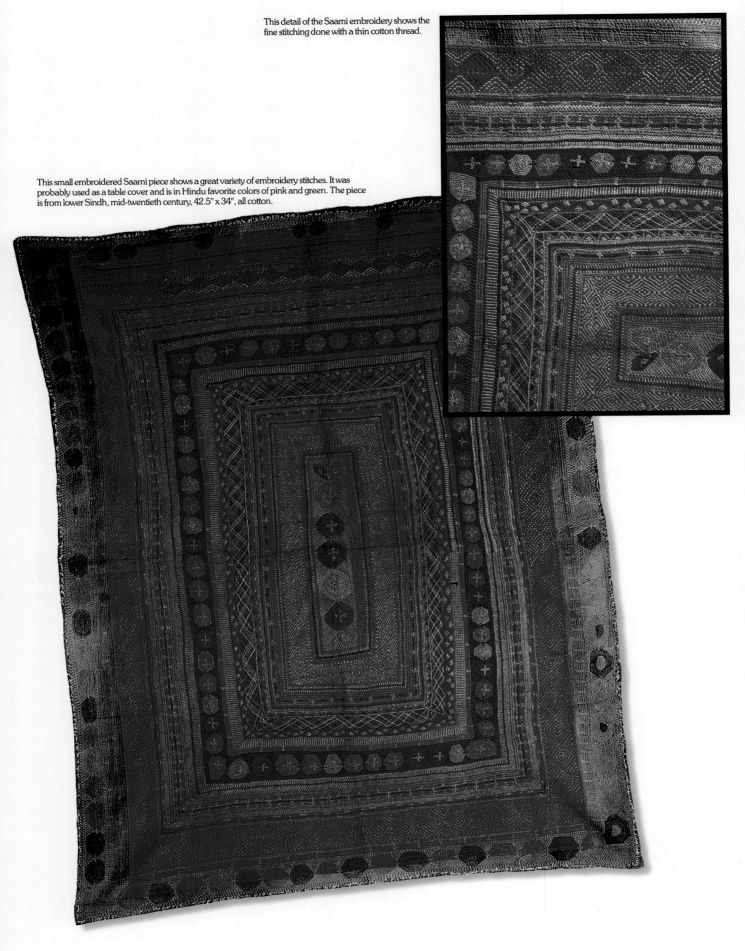

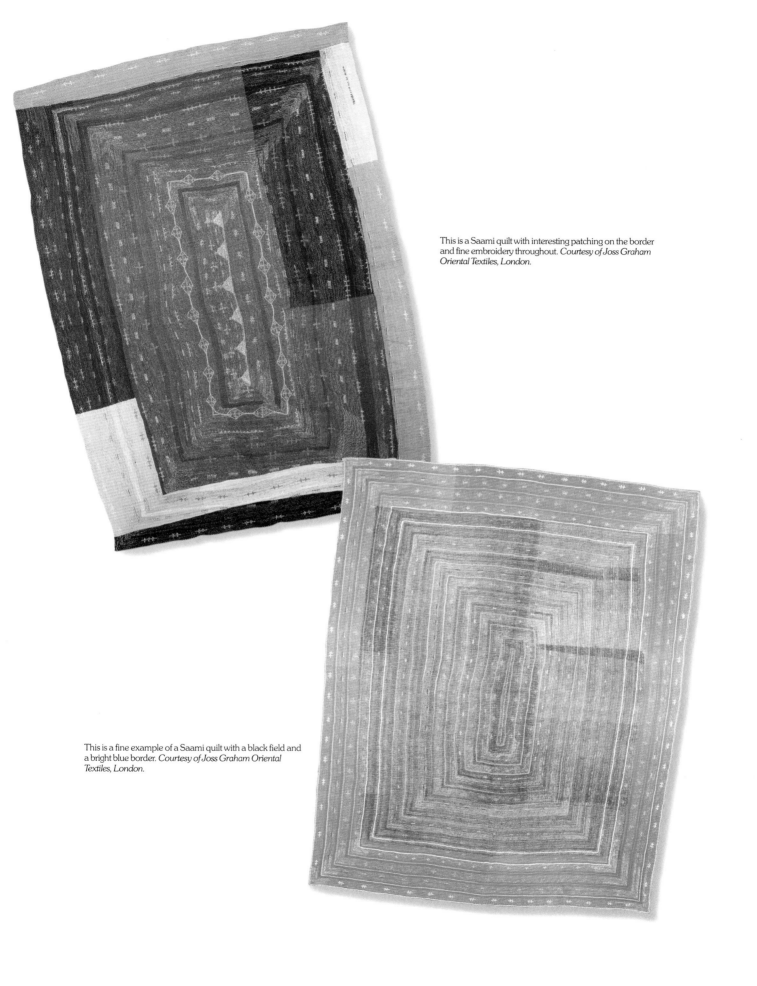

This is a Saami quilt with interesting patching on the border and fine embroidery throughout. *Courtesy of Joss Graham Oriental Textiles, London.*

This is a fine example of a Saami quilt with a black field and a bright blue border. *Courtesy of Joss Graham Oriental Textiles, London.*

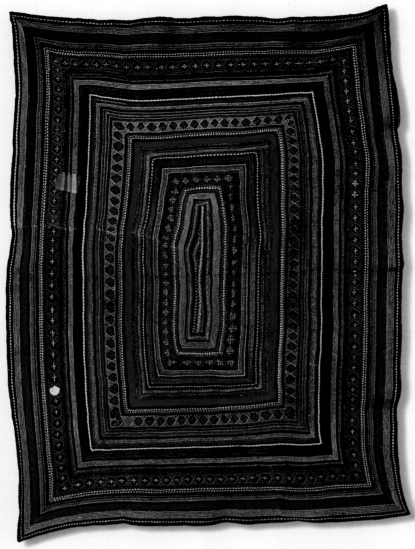

This Jogi ralli is done on a black fabric. It uses some of the same stitches as the Saami and also some others. It is from Badin, Sindh, mid-twentieth century, 76" x 54", all cotton.

This detail shows the variety of Jogi stitches including chain, cretan, and running stitches.

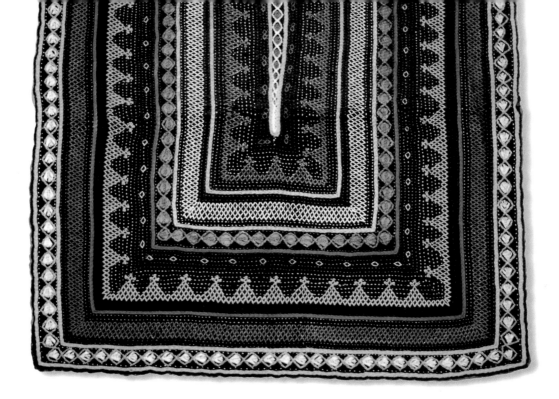

This Jogi table cover is embroidered on black fabric. This ralli is from lower Sindh, late twentieth century, 43" x 20", all cotton.

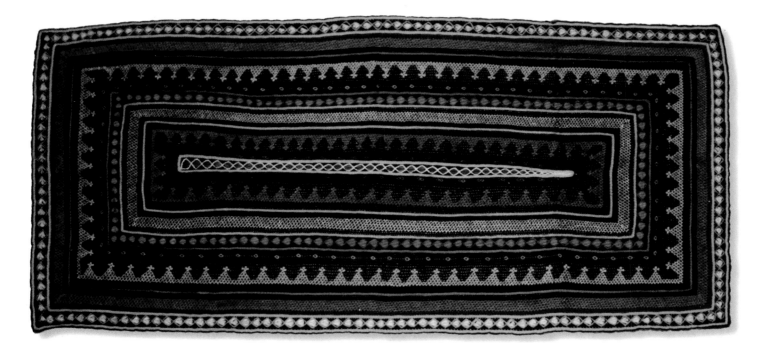

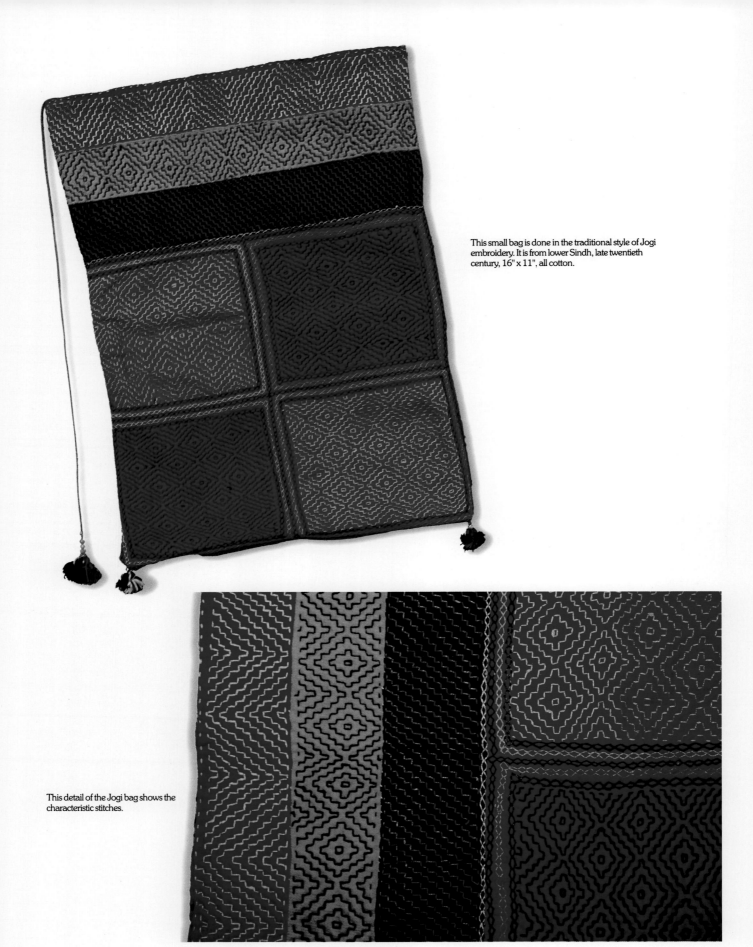

This small bag is done in the traditional style of Jogi embroidery. It is from lower Sindh, late twentieth century, 16" x 11", all cotton.

This detail of the Jogi bag shows the characteristic stitches.

Regional Ralli Patterns

Rallis can be described by both the region and the cultural group of the quilter. Some quilts are distinctive by the traditions of the region in which they were made. However, not all communities have a style of ralli that is theirs alone. Some quilts can be distinguished by the color or design preference of a certain group or caste. However, for many rallis, it is difficult to determine the exact place of origin. One factor is the migratory nature of the people who make many of the rallis. For centuries they have migrated across the Indus region, carrying their quilts on their animals, for others to see and perhaps use that pattern themselves on a future quilt. (Women quilters today will say they are inspired by what they see in choosing their quilt designs. As most of the women are not literate, the patterns for the quilts are not drawn or written but are totally visual.)

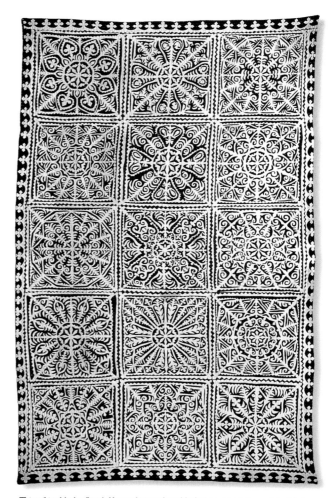

This striking black ralli with fifteen white appliqué blocks is amazing in the variety of designs used. The back is black and only white thread is used. The quilt is attributed to the Muharrano region, middle Sindh, mid- to late twentieth century, 93" x 57", all cotton.

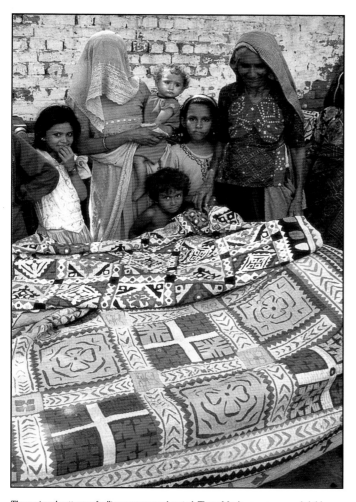

The regional patterns of rallis are many and varied. These Meghwar women and children are standing with some of their quilts from Mirpur Khas. The ralli in the foreground is described as an "old" pattern and the one in the back is a "new pattern."

Another reason for the similarity of designs in different communities is the Hindu tradition of marrying outside their village. The new brides will bring with them ideas from their home village. With this flow of ideas, it is possible to find incredible variety in one community. An example, from one small Hindu Meghwar housing area in Mirpur Khas came five quilts, each extremely different from the other. See pages 17, 54, 68, 122, 146.

There are some regional characteristics in the ralli patterns perhaps developing from community aesthetic customs or other local preferences. It is certain that the custom of nomadism and migration has carried ralli patterns throughout the region. Interestingly, some groups are known for a particular type of ralli. For example, Jogis are known for their embroidered quilts, but they also make patchwork and appliquéd rallis. It is not always possible to identify the origin of a ralli by its appearance. For example, black and white rallis are unusual in the usually colorful craft. However, black and white patterns are found in eastern and lower Sindh. The black and white rallis from the Muharano area, east of Hyderabad, are known for their beautiful design as well as fine stitching. The northwest hilly region, Kohistan, is also known for black and white quilts.[45]

The southern area of Sindh has a rich heritage of ralli patterns. In the delta area around Thatta and northward, the Jats use an old piece of cloth that has been tie-dyed or redyed for the front of the quilt and framed by red, white, and black patchwork borders. The same pattern is frequently seen in Gujarat. The colors used in the area of Badin are strong and traditional – red, black, white, and yellow-gold. The Chauhan women are known for especially close stitching. The colors of older quilts from the Thatta area are more muted and varied than those of Badin. The Saami and the Jogi from Thar Parkar and areas of Badin use kabiri embroidery as well as the running stitch to make their quilts. The Jogis use a color combination called garoon, including brown, off white, pale yellow, and pale orange red. The Thar Desert has quilts known for their bold design and the creative use of color. They do not use much stuffing, often use colored thread, and use more natural designs.

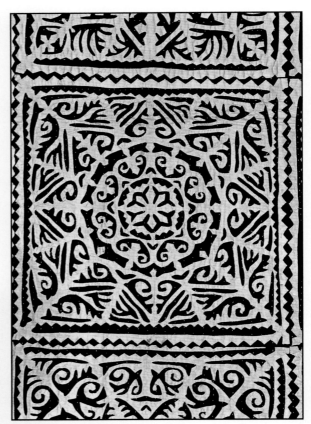

Close-up of ralli block.

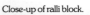

Close-up of ralli block.

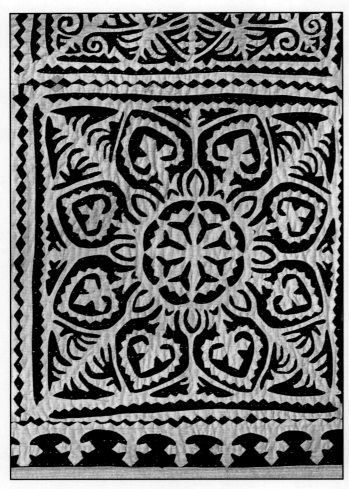

This and the following are various designs of appliqué blocks.

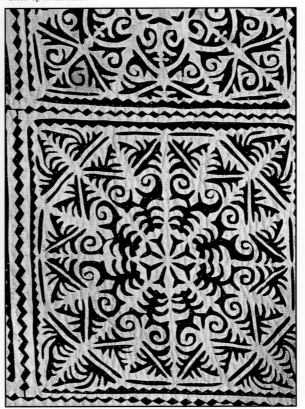

84

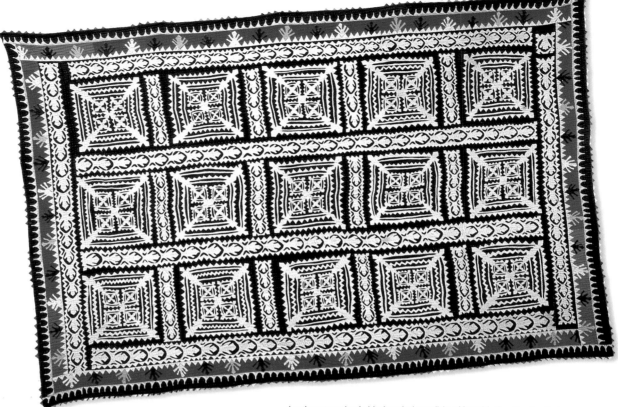

Another example of a black and white ralli has fifteen blocks with a border in between. The border is red, as is the back. This ralli is from Larkana, upper Sindh, late twentieth century, 85" x 57.5", all cotton.

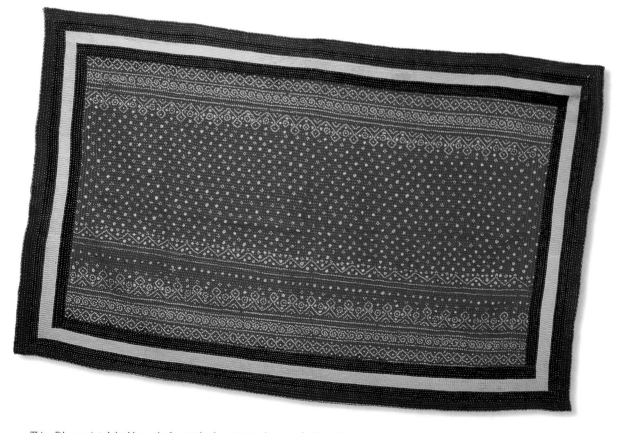

This ralli has a printed chaddar on the front as the decoration and a piece of ajrak on the back. It has plain borders. The quilt is from Gujarat, late twentieth century, 82" x 53.5", all cotton.

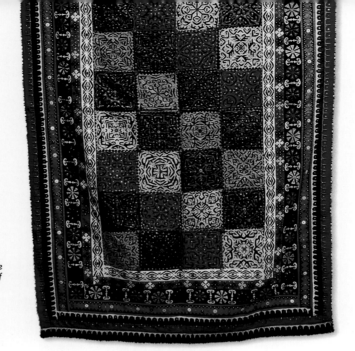

This ralli from the Umarkot area shows the remarkable colors of the area. *Courtesy of Dr. Harchand Rai.*

Going north in the central plains area around Hyderabad, and the towns north up to Nawabshah, the women like to make a variety of geometric checkerboard designs. Also famous from that area is a pattern with blocks of detailed floral appliqué designs. The intricate borders have repeated, connected patterns. The number of appliquéd blocks varies and can be six, eight, nine or more. The appliqués are placed on various colored backgrounds and colored fabrics are added to the cut out part of the appliqué.

In the Murharano area, (in the Nara Valley, around the towns of Umarkot, and Samara), the quilts are famous for their interesting color combinations, and their wide repertoire of intricate appliqué patterns and fine stitching. Some communities have favorite colors. For example, the Baluch group living between Umarkot and Mirpur Khas like yellow and purple, particularly yellow for weddings. The Bhil group typically uses burgundy, olive green, and gold in their rallis.

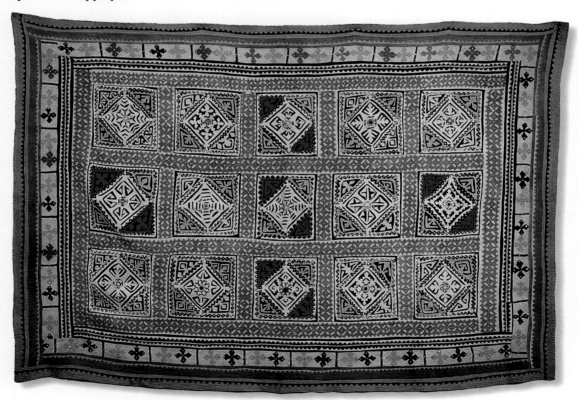

This ralli is made in a traditional pattern seen in many regions. The lighter, muted colors set this one apart as being from Thatta. The back is ajrak. This quilt is from Thatta, Sindh, mid- to late twentieth century, 83.5" x 57", all cotton.

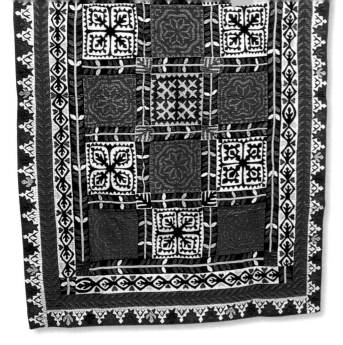

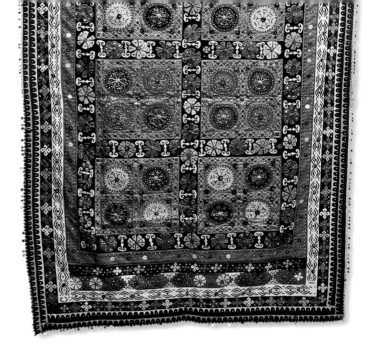

The juxapostion of the colors in this ralli from the Umarkot area gives a feeling of movement or vibration. *Courtesy of Dr. Harchand Rai.*

This ralli illustrates the fine appliqué work of the Umarkot area. *Courtesy of Dr. Harchand Rai.*

In western Sindh around Larkana and Dado is the style characterized by larger stitching and more "empty" space. The far northern area around Jacobabad is known for patchwork with very small squares. In the northern plains of Sindh near Sukkur (going northeast towards the Punjab), the Baluch and Mahar groups specialize in combinations of appliqué and patchwork. They make appliqué forms with very fine lines (as small as a few millimeters in width). This technique is also used in Cholistan up to Bahalwalpur. The appliqué is often combined with patchwork in smaller squares than is traditionally used elsewhere. The color palette is often black and white with red, yellow, and blue.[46] In the area of Rahimyar Khan, the eight petalled rosette is a popular pattern as it is in Rajasthan across the border. Colors used in this area are somewhat softer hues than in the south.

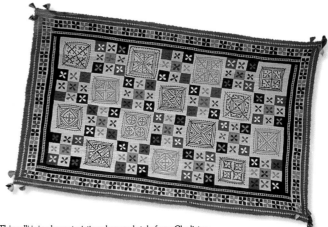

This ralli is in characteristic colors and style from Cholistan, Punjab. It is from the mid- to late twentieth century, 76" x 50", all cotton. *Courtesy Lok Virsa Museum, Islamabad.*

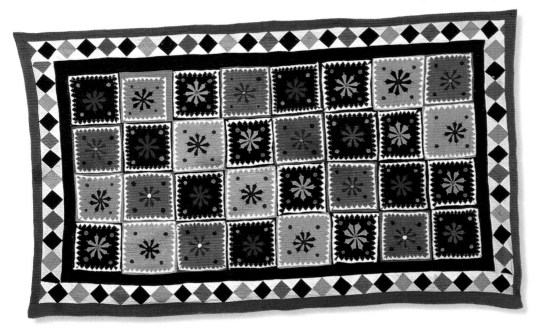

This thirty-two block ralli has colors and style that are seen in the southern Punjab and also in neighboring Rajasthan. The back is a gold printed fabric. This quilt is from Rahimyar Khan, late twentieth century, 75" x 45", all cotton.

The quilts made in Baluchistan are called gindi. They are made by the nomads and by those who have settled in villages. As in other areas, they are used for bed covers and for weddings. Unique to Baluchistan, the gindis have many small mirrors, particularly in the center of the quilt, many tassels, and cowrie shells. They like to use bright colors and, in the interior villages, still use vegetable dyes. They do not usually buy new material. It is traditional for a man's shalwar kameez to use twenty yards of fabric, therefore, an old, worn outfit could supply much fabric. Baluchistan is an area with extreme temperatures of cold and hot. For the colder seasons, gindis are stuffed with wool taken from camels, lambs or goats to make them warmer.

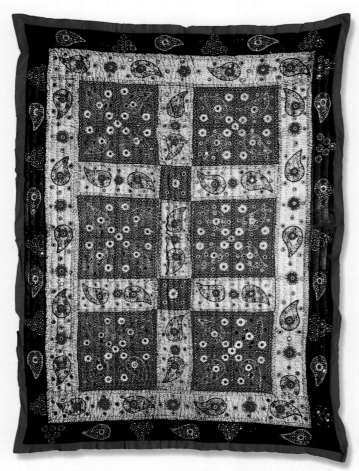

This newly made, highly embroidered quilt from Quetta, Baluchistan. The filling is fluffy cotton, about three quarters of an inch thick. The quilt is 90" x 66", all cotton.

Quilts from the western parts of India bordering Sindh and Punjab have similarities to the ones of Pakistan. Jaisalmer in the Indian state of Rajasthan is known for its ralli (or raali) quilts. The top fabric is white cotton and is appliquéd with patches of fabric in geometric shapes. Colors are important in Rajasthani textiles. Those described as fast (pukka) colors are considered sad and are worn by widows including brown, grey, blue, and green. However, fugitive colors (probably chemical colors called kutcha) include red, pink, yellow, gold, bright green, and sky blue and are considered happy colors. Young, unmarried girls and women whose husbands are alive prefer bright colors. Two colors with special historical significance are khaki green (amawa) used formerly by the rich for hunting and a shade of brown (malagiri) made from a mixture of several dyes that have a fragrant smell.[47] Colors frequently used in rallis are rust brown, olive green, maroon or black. Appliqué work is done on the borders or the field including animal, human, and floral designs. The best known appliqué is done by the Marwari community. The corners of the ralli are usually decorated with sequins or tassels made from silk or cotton.[48] Many needlework and embroidery techniques came to Rajasthan through immigrants from Sindh after Partition in 1947.[49] A ralli style used in Rajasthan that may have come with the Sindhis includes geometric patterns in white, black, red, and orange.

Quilts from Kutch, in the state of Gujarat, are called dhadaki, godadi, and other names. (Durkee is an old British spelling of the name.) The quilts are traditionally made of old clothing, but can be made from new cloth. Used ajrak and tie-dyed pieces are used for both the backs and fronts of various quilts. It has been reported that some quilts are gender specific. A quilt with ajrak is a man's quilt and one that uses tie-dye is for women. Both patchwork and appliquéd quilts are sometimes made with embroidery where the borders join the center field. Black or dark green fabric is often used on the backs of the quilts. The Pathan group uses an unusual light green printed cloth on one side and a yellow printed cloth on the other with a unique geometric design. Haliputras living in both Kutch and Pakistan make a detailed stepped design. A woman may make a quilt alone or with others, depending on the traditions of her family and community. When a woman works alone, she usually uses a series of concentric rectangles. If she is working with other women, the pattern may be parallel lines. Usually, the color of the quilting thread alternates between red and black.[50] In the Banni region of Kutch, quilts are made by the Maldhari, Meghwar, and Mutava groups. They all make a variety of quilts, including large abstract appliqué designs made in blacks and also placed randomly on a field, quilts with a large patterned cloth on the front (usually tie-dyed), and highly embroidered quilts.[51] The Rabaris have a vibrant quilt tradition used for, among other things, camel coverings and ceremonial seats.[52] The peninsula of Saurashtra also has a quilting tradition. Patterns are a combination of squares, rectangles and diamonds, and appliqués. Borders often have flower, leaf, and cross designs that are also used in the center of the quilt. Finished quilts are often stored in a quilted and decorated bag made to hold quilts. The stack of filled quilt bags is a sign of the prosperity of the household.[53]

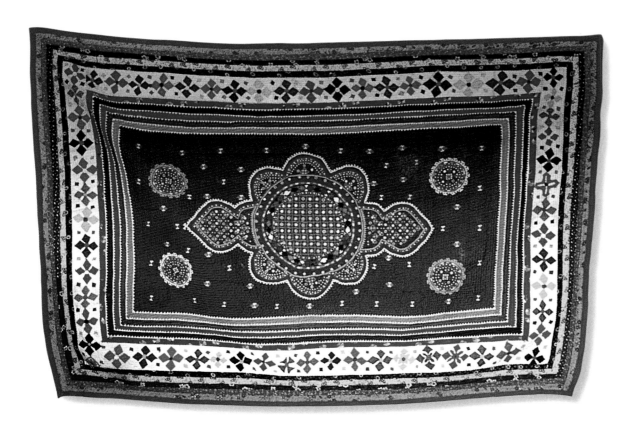

This is a Mutava Muslim quilt from Banni, Kutch. These quilts were taken from the family quilt pile to show the author examples of their quilts (1998). All are exceptionally finely stitched with beautiful colors and craftsmanship. Many fine borders are seen on the quilts.

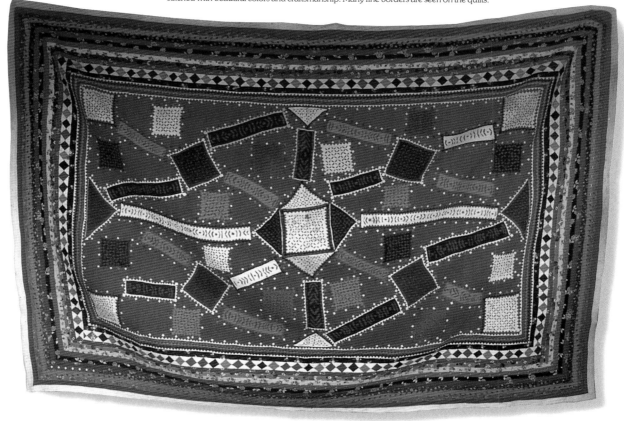

This Mutava ralli uses appliqued squares, triangles, and elongated rectangles to form a brilliant pattern in the field of the quilt.

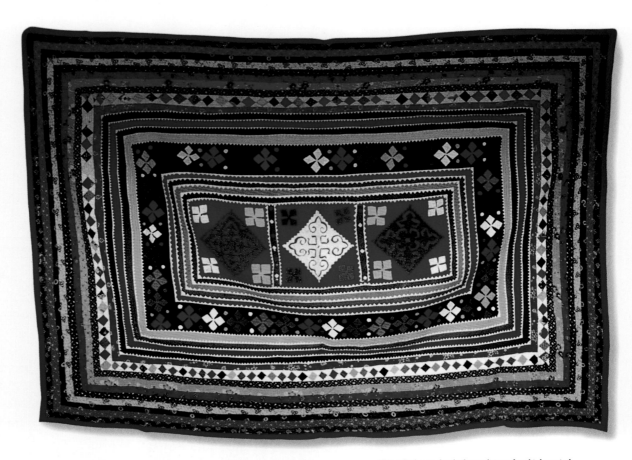

This ralli shows clearly the tradition of multiple varied borders on Mutava quilts. This one has almost twenty borders with the center field of only three blocks.

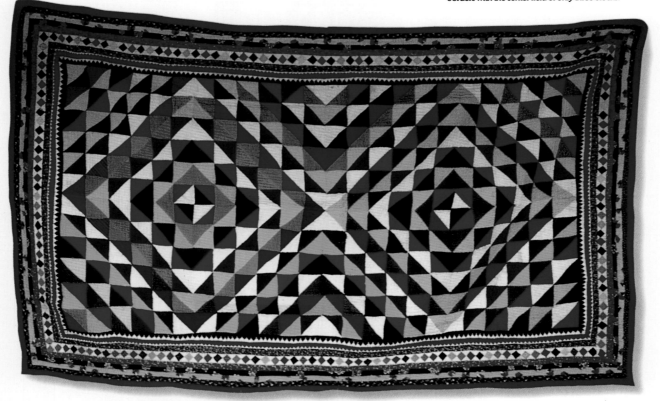

This Mutava ralli has the strong geometric patterning of squares and triangles so characteristic of rallis.

Other Quilts of the Region

Comparisons are sometimes made between rallis and other quilts made in south Asia. One of these is the kantha, made in Bengal, a region now in both India and Bangladesh. The quilts are usually made from discarded cotton saris with three layers of cloth. The quilts are embroidered and the threads are taken from the borders of the saris. The quilts are usually white with white threads used in the body of the quilt and the colored threads for the other designs and borders. The construction starts by stitching in the middle of the kantha and then proceeding to the edges. The kantha usually has a tight, wavy look because the stitching is done in small blocks stitched in different directions. The stitching can be evenly spaced or a long stitch on one side and short on the other. The designs used are based on local life and folk art or religious motifs.[54]

A second kind of quilt is the sujani made in Bihar. It uses old saris, like the kantha quilts, but differs in its construction. The sujani has four layers of fabric held together by a running stitch. The quilt is stitched with straight running stitches from one end to the other. Knots at the start and finish are seen on the back. The embroidery, using a darning stitch and a chain stitch, are added later.[55]

A third kind of quilting comes from the colorful Banjara group who live in Deccan Plateau of central India and other parts of India. Their traditional work was transporting important commodities throughout the subcontinent. This work was abandoned after the British railway system was developed in the nineteenth century. Now they are mainly build roads or other labor, and are often nomadic. The Banjara make lively geometric quilts stitched with a running stitch interspersed with other stitches giving the quilt the look of a patterned fabric. They also make square covers for gifts or food, purses, and bags. The dowry bags are made from quilted squares decorated with cowrie shells and tassels. The colors for these textiles are usually brown or blue and the patterns result from the quilting and embroidery stitches. Some Banjara stitching bears a resemblance to Jogi embroidery (who are reportedly a subgroup of the Banjara).[56]

Some groups have distinct styles of quilts. Robyn Davidson, an Australian woman, traveling among the nomadic Rabari tribe of Gujarat recounts her experience making a quilt called gudio. She went to the market with the Rabari women to purchase new cloth. They made the gudio together. "Eight women sat with me in a circle, the gudio stretched between us like a picnic blanket, needles and thread to the ready. It measured five feet by three feet and consisted of two outside layers of white cotton, and three inside layers of thin woolen rug, all clamped together with a few rough stitches which would later be pulled out. I understood why they helped each other begin their gudios. Imagine how depressing it would be to sit alone in front of fifteen square feet of cloth knowing that you had to make several thousand stitches before it even began to look like a mat.

"Parma studied the white space for a while, then, watched and approved by the older women, began to pencil in a design. She halved the rectangle. Inside each half she drew paisley swirls, large as palm leaves, locked together ingeniously within the two frames. She made the patterns in long continuous lines, so that one would not need to stop stitching until one ran out of thread or reached the outermost border. When it was done to everyone's satisfaction, we began. In tiny running stitches with thick red cotton we followed the lines of Parma's fancy. I noticed that this was only a guide, a theme if you like, and that when someone felt like it she added subtle variations—nothing so individualistic as to break the harmony of the pattern but enough to make it live.

"Each woman had, as it were, a sewing signature and to this day, when I look closely into that gudio, I think I can remember who stitched what."[57] (from DESERT PLACES by Robyn Davidson, copyright © 1996 by Robyn Davidson. Used by permission of Viking Penguin, a division of Penguin Putnam Inc.)

There are some similarities between these types of quilts and the rallis. Some of the differences include the appearance of both the kantha and the sujani and their methods of construction and the flowing stitching lines of the gudio. The appearance of the Banjara quilt indicates some similarities with the embroidered quilts of the Jogi and Saami. All these varieties of quilts indicate a long history of quilting making in the region.

This is a quilt made by a farmer's wife in Bijapur in northern Karnataka, India (south of Gujarat). It is made from scraps of worn saris and shirts with features similar to the three general categories of ralli quilts. It has geometric blocks of the patchwork rallis, appliquéd shapes, and embroidery characteristic of the Saami style (after Huyler, 140).

Patterns on the Back

Often the fabric used as the lower purr will relate to the pattern on the upper purr in style or color. The lower purr will at least give an indication of the maker of the quilt and whether it was intended to be a utilitarian or a special ralli. The fabric most often found on the back of a ralli is a worn woman's shawl. There are a number of different kinds of shawls. A chaddar is a large square or rectangular piece of cloth that is used by women as a cover for their head or shoulders. A dupatta, a head cloth worn by women with shalwar kameez, may also be used for a ralli. An odhani is another kind of shawl and a chundari is made of tie-dyed fabric. Occasionally, an abochhnai, a large rectangular embroidered shawl presented to a bride and worn at the wedding and other special times, is used in a ralli. Also used is a lungi, a rectangular piece of cloth used as a sarong wrap or turban by men in the Sindh and the Punjab. Fine old pieces of ajrak, a traditional block printed fabric, are also found as the lower purr. Usually the old head covers are not quite large enough to completely cover the bottom of the quilt, and are supplemented by other scraps of fabrics on the ends. Following are descriptions of ajrak, tie-dye, block print, and lungi.

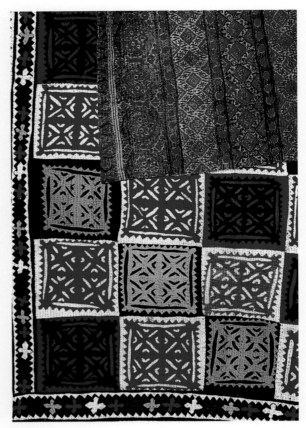

Ralli with ajrak back.

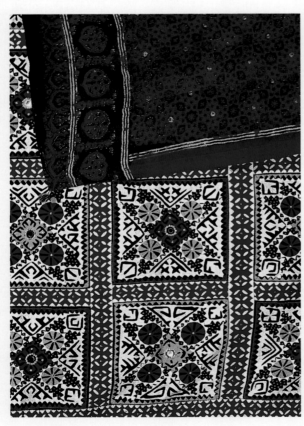

Ralli with ajrak back.

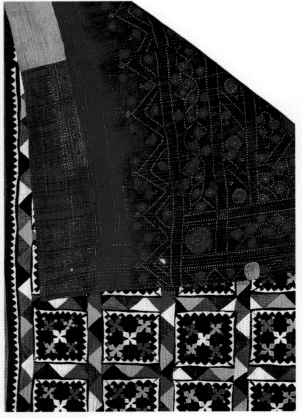

Ralli with tie-dye back.

92

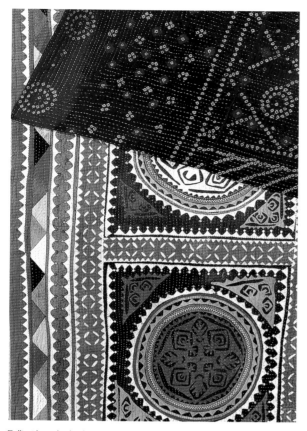

Ralli with tie-dye back.

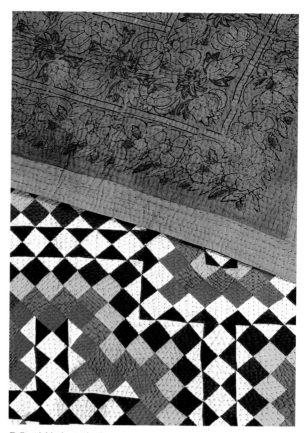

Ralli with block print back

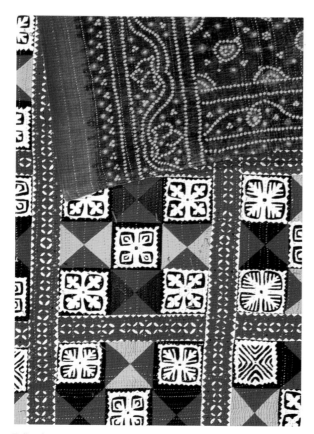

Ralli with tie-dye back.

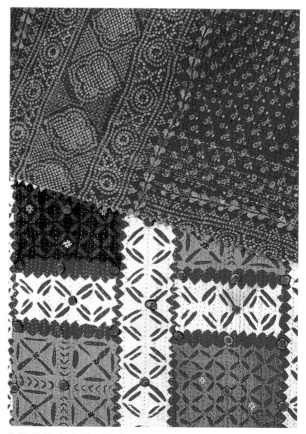

Ralli with block print shawl back.

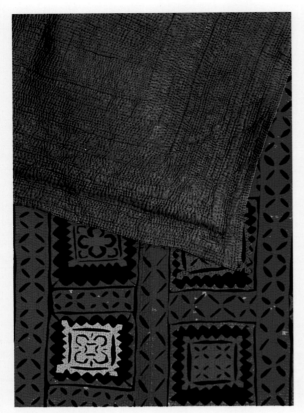

Ralli with a green back.

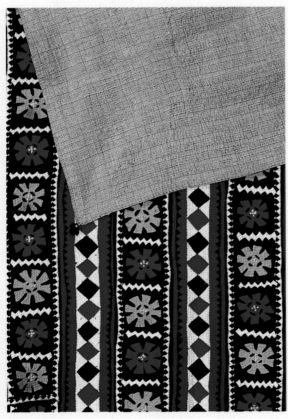

Ralli with lungi back.

Ajrak is a highly traditional rectangular fabric that is much a part of the culture of Sindh, Kutch, and western Rajasthan. Only a few craftsmen remain who produce ajrak following the traditional, complex, and lengthy production methods. The typical ajrak is indigo blue and red and black with white highlights. The ends of the fabric have wide borders with large block printed patterns and the body of the cloth is printed with symmetrical designs resulted from repeating prints from square blocks. The result is a harmonious pattern of circles, squares, eight-pointed stars, and almond shapes with stylized flowers and vines between. The designs have names from their lifestyles: date, peacock, sweetmeat, mortar, almond, knots of love, ring, and floor covering. Designs representing clouds and vines are made with rectangular blocks. There are variations on the process of making ajrak (particularly the chemical ingredients) according to the area and the craftsmen. Machine-made white cotton is washed, bleached, and softened with a mixture of ingredients. A "resist" paste is then printed on the fabric with carved wooden blocks to retain white in the pattern as the dye process continues. Two more processes of resist and mordant follow for the blue (or black) and red areas. The resists are "fixed" with cow dung or dried rice bran and then dried. The fabric is then dyed in indigo and madder in varying complex processes of dying and washing. When dying is complete, there is another wash, and beating to soften the fabric. Many craftsmen prefer to wash the ajrak in the river where the sun, hardness of the water, and the motion of the water all affect the colors produced. A fine quality ajrak has a clean, unsmudged pattern, is printed on both sides, and has clear colors. Ajrak is often found on the back of rallis. Often when a worn ajrak (usually two and a half meters long) is used on the back of a ralli, it is not large enough to cover the entire back and is supplemented by another piece of fabric on the end or edge.[58]

Tie-dye is an ancient textile patterning technique used in the subcontinent. It is called bandhani from the Sanskrit word bandhna, meaning to knot or to tie. (The English in the eighteenth century borrowed the name and style for the men's patterned handkerchief, the bandana.) Bandhani is popular in Sindh, southern Punjab, Gujarat, and Rajasthan as shawls for daily wear and also as a wedding scarf, sometimes decorated with embroidery in Thar Parkar and Hyderabad areas. (The tie-dye patterns are called chunari or chundadi and shawls made from the fabric are called chunri or chunni.) The earliest written reference to bandhani goes back to the seventh century AD in India in the court records of King Harsha of Kannauj. The records describe the textiles glittering like myriads of rainbows including the cloth that was tied by the city matrons. From the same time period are paintings of women wearing bandhani fabric on the walls of Ajanta caves.[59] Famous bandhani workshops are found in Saurashtra, Gujurat, where the water produces a bright red color. Hindu and Muslim Khatris, by profession textile dyers and printers, are also known for their time-consuming production of bandhani. In Rajasthan, bandhani is known as chundari and is a part of the culture. One Rajasthani painting of a woman in a bandhani shawl in a rain storm. She is rushing toward her lover. The accompanying poem says how the beautiful red color of her chundari will make her more attractive to her beloved.[60]

Special detail is often seen on the edges of the quilts. Most quilts are simply turned in on the edges. This means that both the upper and lower purrs are turned to the inside so no raw edges are showing. The edges are stitched with a running stitch. Some variations include oversewing or a blanket stitch to finish the edge. Other decorations are also added to the edges. A saw tooth edge is made by folding small squares of fabric to form triangles. They are then evenly placed along the edge and sewed so that no raw edges are seen. Other edge treatments include crocheted edges with and without small beads. There are also examples of yarn with beads strung on it in a triangular shape ending in a tassel. Tassels are often placed in the corners of the quilts. They may or may not have beads or sequins. A very fine quilt may have silk tassels all around the edges.

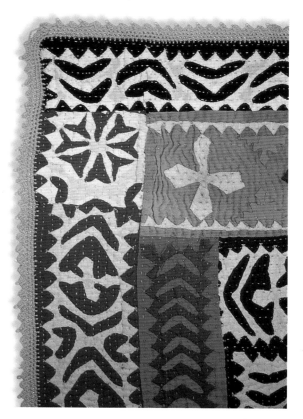

The edges of a newly made ralli have tassels with gold foil for extra sparkle. *Courtesy of Jeanne Davies.*

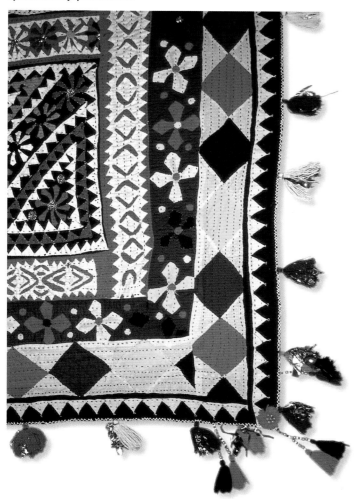

This ralli is crocheted all around the edge in yellow thread. *Courtesy of Jeanne Davies.*

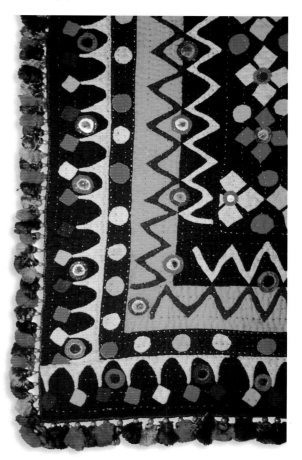

Silk tassels with a small bead edge this quilt.

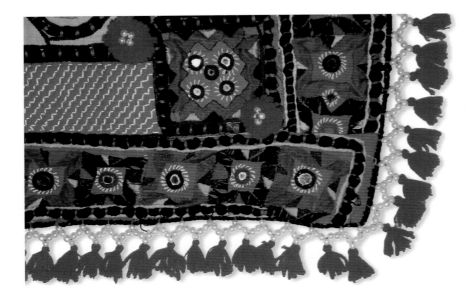

Small beads and synthetic yarn edge this newly made ralli.

Small cotton tassels are on the corners and middle of the side of this patchwork quilt.

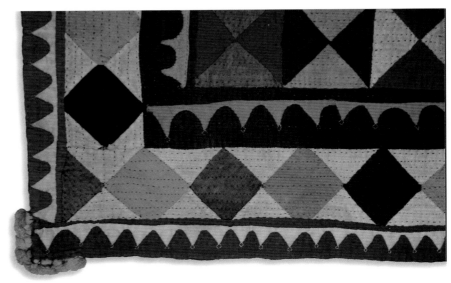

This ralli has long tassels with sequins and an edge of folded cloth to form a "kungri" saw tooth edge.

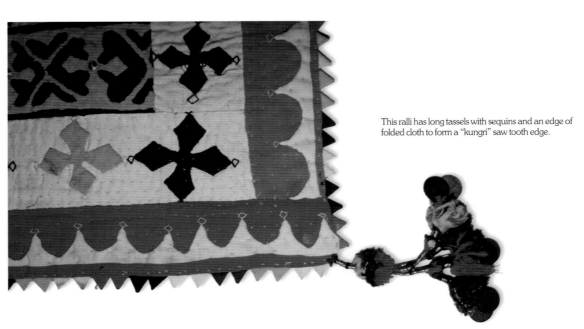

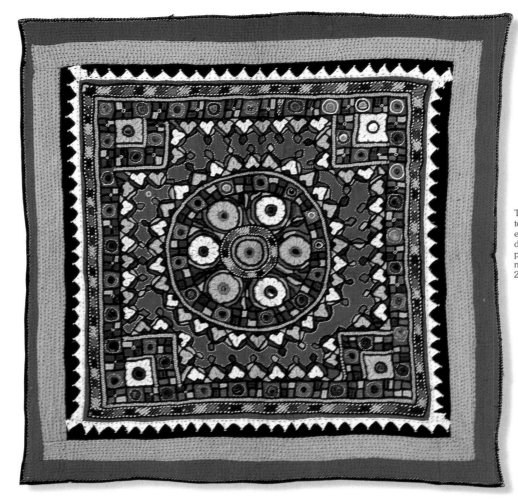

This quilted square, once sewed together as a bag, is highly embroidered with mirrors as decoration. The piece is probably from the Thar area, mid- to late twentieth century, 25" x 25", all cotton.

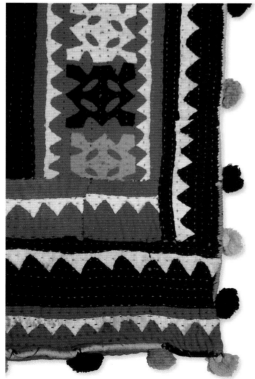

Small pompoms decorate the edge of this quilted bag.

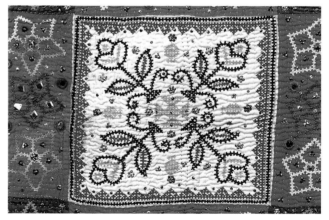

This example of embroidery is used to decorate a quilt block on a Meghwar ralli from Mirpur Khas.

Embroidery is also used as a decoration. Often it is a small symbol. Some symbols will identify a quilt as belonging to a particular family. Sometimes a whole block is embroidered and sewn in the field of the quilt. Often the hoormutch stitch is used as an embellishment on the rallis. Another use of embroidery is to embroider a zigzag stitch over a woven braid or rickrack trim to attach it to the ralli. Embroidery is usually used on rallis that have been made for a special purpose, such as a dowry ralli.

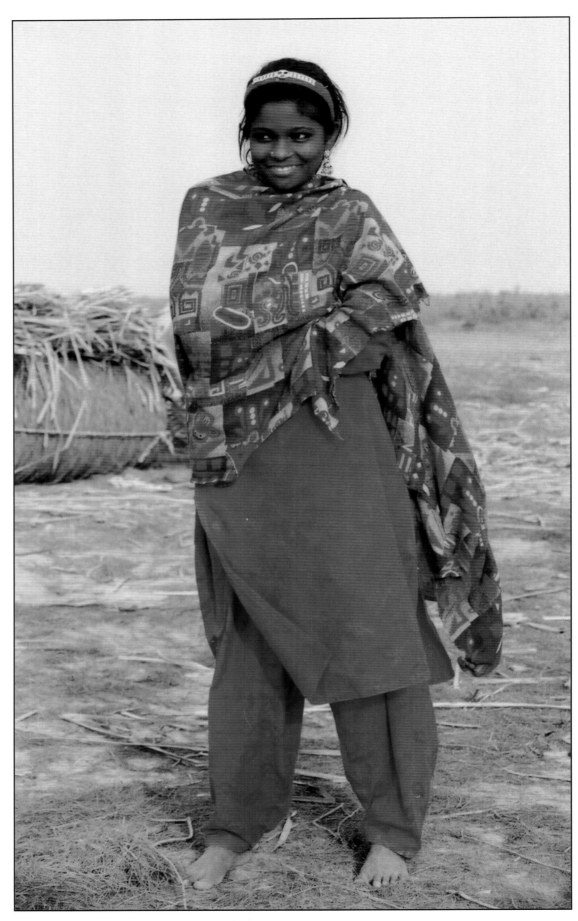

A young woman on the shore of the Indus River, northwest of Multan.

Chapter 3:

Historic Motifs in Rallis

As I set out to understand the motifs used on the rallis, little did I expect to be led on an exciting trail of discovery going back over six thousand years. The quest to understand the source of symbols and patterns used on rallis was started for me by an intriguing sentence in a book pointing out the similarity of Cholistani appliqué with ancient pottery from Baluchistan and sites to the north.[1] Questions immediately arose in my mind. Are there other similar patterns in modern textiles that were also used in ancient decorations? What kind of civilizations produced this pottery? What are the linkages between then and now? To gain greater understanding, I researched past civilizations, the region and its artifacts, ancient textiles, and other historical connections. This adventure took me through many cultures, trade routes, and archaeological sites. One discovery was, in this corner of the world, several traditions, including textile patterns, have survived over many thousand years.

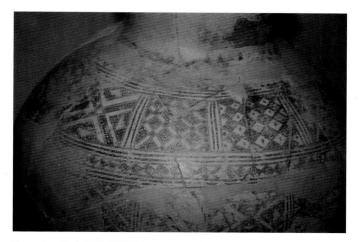

This pot from Pirak (1800-800 BC) shows a variety of detailed geometric patterns characteristic of the style found in Baluchistan. *Photo taken courtesy of the Islamabad Museum.*

Ancient Civilizations in the Indus Region

The ancient history of the region where rallis are made provides some interesting insights into the motifs used today. Archaeological discoveries during the twentieth century have brought to light remains of cities and civilizations that started as far back as 8000 BC. Probably the best known is the Indus Valley Civilization that flourished in the region between 2500-1500 BC, but there were cities before and after this time. As more artifacts of this ancient world are found, the background of designs and traditions of the Indus region may become clearer. In particular, the oldest city, Mehrgarh, predating the Indus Valley Civilization cities and the later city of Pirak (both in what is now Baluchistan), share fascinating similarities in the symbols on their artifacts with the modern rallis.

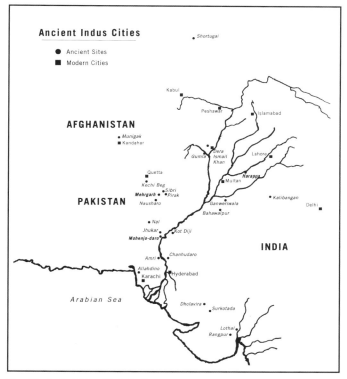

Map of the Ancient Cities of the Indus Region.

See page 171 for timeline.

Baluchistan, now a dry area, once had continuously running rivers and streams. When the remains of ancient sites were first found there, the sites were thought to have been part (perhaps colonies) of ancient cities on the Iranian Plateau or Turkmenistan in south central Asia (about 4000 BC) due to the similarities in artifacts found in Iran, Afghanistan and Quetta. Further excavations in the Kachi Plain and at Mehrgarh, however, revealed more ancient settlements possibly going back to the eighth millenium BC, predating most of the known cities of the ancient world including Egypt. Instead of merely being a "colony" of another civilization, the cities of Baluchistan are now seen as important in the cultural development of the entire Indus area, the Iranian Plateau and south central Asia. The climate of Mehrgarh and variety of nearby ecological zones allowed early people to domesticate animals such as sheep, goats, and cattle and plants such as wheat, barley, and cotton.[2]

An important feature of the culture and civilization at Mehrgarh is the development of pottery. It is through the pottery that we can see and appreciate the designs and motifs that were important to the people of the time. Other artifacts perished long ago with the moist climate and a shift in the Bolan River 4000 years ago. Early examples of pottery (6000 BC) were rough pots of earthenware strengthened with straw. Pottery techniques improved and Baluchistan became the first area to use the potter's wheel. Other skills included the use of kilns and decorations such as geometrics and animal motifs. By the fifth millenium, there was similarity in the painted decoration of the pottery from a large number of locations in central Asia, due to the trade and contact of various cultures. Potters continued to experiment and produce new styles of pottery. For example, the Kechi Beg style from the middle of the fourth millenium had large black and white designs on a red background. By the end of that millenium, the potters had refined the firing process and produced excellent grey ware that was exported to the west including Afghanistan and the Iranian Seistan. From 4500-3800 BC, the painted designs became more set. The development started with squares or parallelograms and then became triangles, crosses, lozenges, and rosettes. The Nal style was decorated in several colors including yellow and blue after firing. This style used animal and plant motifs from the area. Most of the pottery was mass produced but some was obviously of higher quality, perhaps for trade. Small ceramic seals, used in trade, were also made. Most were geometric designs except for the zebu bull (humped south Asian cattle), typical of the area.[3]

The historical period of Mehrgarh showed a time of great development, innovation, and change in the Indus area. Even though the city of Mehrgarh did not survive into the time of the Indus Valley Civilization (2500 BC), nearby cities did and carried on traditions into the later period.[4] The ancient cities of the Indus Valley Civilization extended over an enormous area with over seven hundred known settlements. Most of the settlements were small, less than fifteen acres, but both Harappa and Mohenjo-daro were over 330 acres. The settlements went west to the present border with Iran, north to the Oxus River in Central Asia and east to the Gangetic Plain in India and south to include present day Gujarat in India. The settlements shared important characteristics: a systematic grid pattern, advanced drainage systems, extensive trading, similar artifacts, and an apparent absence of wealth and art.[5] Another feature that does not appear to be important in the Indus Valley Civilization is war. There are walls around the settlements for protection, and evidence of spears and knives but none of the war artifacts found in Egypt or Mesopotamia. The society did have symbols of status and stratified social classes as people lived according to their occupation. House size and complexity and the presence of seals used to stamp goods to indicate ownership are evidence of more well-to-do citizens. There were not, however, burials with many goods.[6] It is interesting to note that human remains from Mohenjo-daro show several racial types. The Mohanas of Manchar Lake are said to be descendents of the lake dwellers of this time.[7]

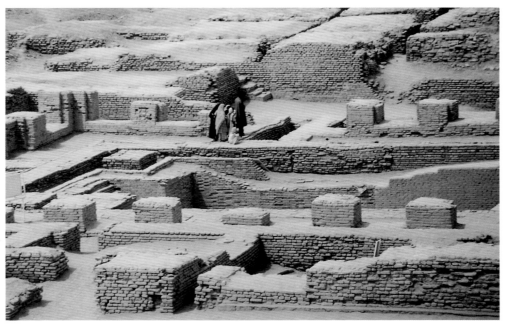

A view of the remains of Mohenjo-daro, a major city of the Indus Valley Civilization, on the west bank of the Indus River. *Courtesy of Herb Stoddard.*

It is not known if the Indus Valley Civilization was an empire with capital cities but there was certainly a sharing of culture throughout the area. In fact, between 2500-2000 BC, there was a remarkable uniformity in the cultures of the cities now in Baluchistan, Sindh, and Gujarat. Few things were made outside the civilization, in contrast to two thousand years before when trade and contacts with other cultures was important. After 2000 BC, however, new styles in pottery developed in various cities including Chanhudaro and Harappa where the style became that of Cemetery H.[8] The Indus Valley area was a great exporter of goods. Indus seals have been found in Nubia, Anatolia, Syria, and Afghanistan. In Oman, Indus artifacts have been found including pottery. Indus ivory, beads, and other objects have been found in Iran and Turkmenistan.[9]

Unfortunately, there is no deciphered written text from the time to study. Traditional ways, used now in the Indian subcontinent to illustrate human activities such as carved panels of wood, painted scrolls of cloth, or sculptures of reed or unfired clay, would not have survived as an ancient artifact. What has survived from Indus Valley cities are terracotta puppets and masks that may have been used, as they are today in villages throughout the subcontinent, to tell stories and legends that have been passed down from memory for generations.[10]

Near the end of the Indus Valley Civilization as urban life disappeared in Sindh, the settlement of Pirak (1800-800 BC), a second millenium site in the upper Kachi plain, arose. There was economic prosperity and diversification. All the Indus crafts were produced and new methods of production were added. Life was based on agriculture including rice, sorghum, barley, and wheat, with new growing cycles and more efficient cultivation. Use of horses and camels increased the speed of transportation compared to ox carts of Indus times. Pirak, by 1500 BC, probably looked much like the first Indian villages seen by Europeans many years later.[11]

Looking down a street of Mohenjo-daro. *Courtesy of Herb Stoddard.*

This pot from Pirak (1800-800 BC) shows a variety of detailed geometric patterns characteristic of the style found in Baluchistan. *Photo taken courtesy of the Islamabad Museum.*

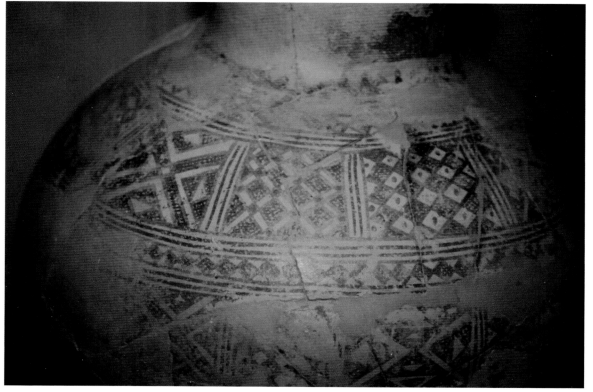

The Indus River Region

Many examples of highly developed geometric designs have been found on the pottery remains from Pirak. In contrast to Harappa where pottery was mass-produced and wheel-thrown, Pirak pots were hand-made for local customers. Nothing similar to the precise painted geometric designs has been found outside of Baluchistan. In fact, some of the pottery designs were a surprising return to old regional traditions of the nearby city of Mehrgarh. For example, a unique polychrome pattern of squares fitting into each other (see vase on page 105) was first seen in the fourth millennium at Mehrgarh and is also found at Pirak many thousands of years later. Pirak appears to have been very culturally conservative during its thousand years. The pottery showed repeated designs without any great changes.[12] Most of the painted pottery west of Baluchistan started declining in the last half of the third millenium. Pirak, too, experienced the gradual disappearance of the painted pottery as undecorated, utilitarian, wheel-made pottery gained dominance.[13]

Ancient Sindh, once at the center of the Indus Valley Civilization, encompassed a larger area than the present province of Sindh, extending to "Kashmir, Kandhar, and Kanoj in the north and to Saurashtra in the south."[14] A unique aspect of the geography of both ancient and modern Sindh is the mighty Indus River running through the center of the region. From ancient times, the Indus River was almost revered as a deity. The Vedas (meaning knowledge) are four collections of hymns of the early Aryans dating from 1000 BC or earlier. The earliest collection is the Rig Veda that details proper life conduct. The ten volumes of the Rig Veda and other books were strictly memorized by the Brahmins until it was recorded in written form about 1000 AD.[15] A passage in the Rig Veda paid tribute to the Indus (calling it Sindhu): "… From the mountains onward towards the Sea, the Sindhu hasteneth in her strength, rushing in the path that Varuna had smoothed out; eager for the prize, she surpasses in that race all that run. Above the earth, even in the heavens, is heard the sound of her rolling waters; the gleam of bright lights lengthens out her unending course. From the mountainside the Sindhu comes rolling like a bull, as from the clouds the waters rush amid the roll of thunder. The other rivers run to pour their waters into thee." The Vedas also record, "The Sindh is rich in horses, rich in chariots, rich in cloths, rich in gold ornaments well made, rich in wood for ever fresh, abounding in Silama plants, and the auspicious river wears honey-growing flowers."[16]

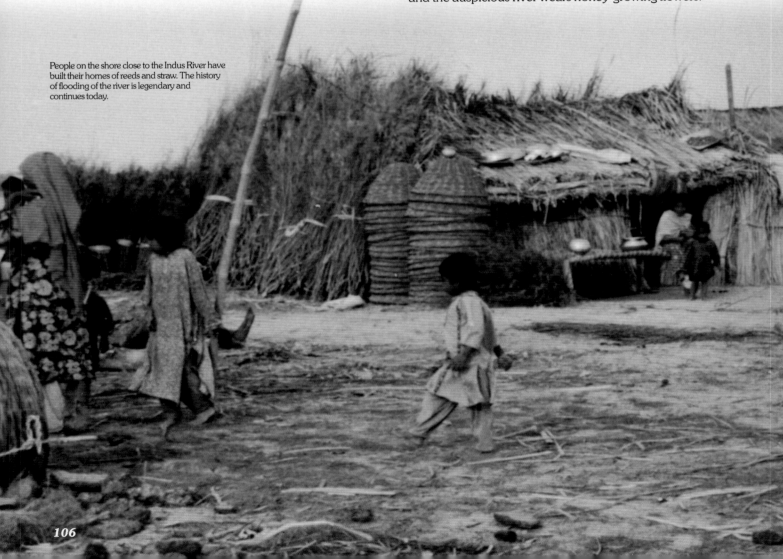

People on the shore close to the Indus River have built their homes of reeds and straw. The history of flooding of the river is legendary and continues today.

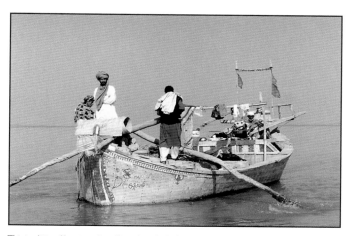

This traditional boat used is still used on the Indus River. The red and green painted decoration on the front is traditional. An old faded geometric ralli was in the bottom of this boat for use by the boatmen.

This settlement is on a high bank above the Indus River in the Punjab. This village is made of mud brick houses, hopefully safe from flooding.

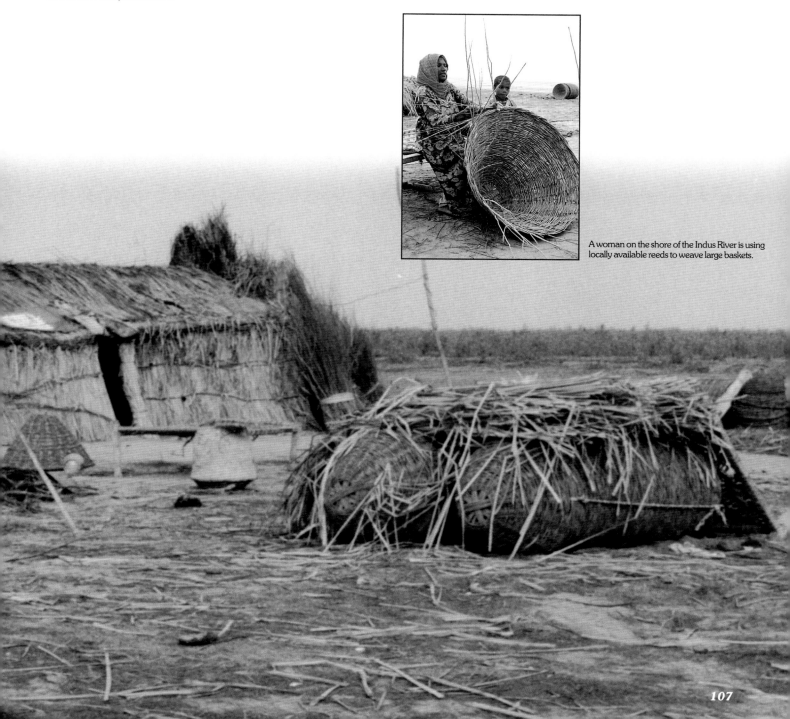

A woman on the shore of the Indus River is using locally available reeds to weave large baskets.

107

For all its life giving force, the Indus has also made the region of Sindh very unstable and subject to regular changes. The Indus throughout history has changed its course, gradually moving from the east to the west. The breath of the Indus Plain is sixty miles (taken from the 300 miles north of Hyderabad.) The similarity of the importance of Indus and Nile Rivers on their respective civilizations was noted by early British visitors. However, the effect of the Indus was much more dramatic. The alluvial plain of the Nile is about 2,000 square miles and that of the Indus is ten times that size. The Indus has three times the silt content of the Nile. With the silt, the level of the land has risen thirty feet judging by the level of Mohenjo-daro. That city managed to flourish for almost a thousand years. Many other cities mentioned by the Arab geographers in the tenth century AD were not so fortunate and have disappeared or were destroyed by too little or too much water from the Indus.[17] Usually gradual erosion moved inhabitants from its banks but sometimes the shift came suddenly into new channels causing people to abandon homes and towns. Towns whose major purpose were as trading ports were ruined when the river shifted away and some areas that were productive farming areas became desert.[18] An example of this is the ancient capital, Thatta, known for the production of fine textiles. Once on the Indus with an outlet to the sea, it now sits far inland. People who built their towns and homes on the edge of the river were sometimes swept away as the river changed its pattern.[19]

Much interesting history has been erased with the lack of records in the area. For example, in one area it appears that women had an important place in society. A place called the Women's Haven, a harbor west of the Indus delta, was mentioned in the first century AD. A Chinese chronicler of the seventh century AD, Yuan Chwang, tells of an area of flourishing population where there was no overall government and each valley had its individual government. The capital area was called "Woman Paramount" close to "West Woman Country" or "Woman Kingdom." It is speculated, from old records, that the present site of Karachi was once called "Woman's Harbour" because a woman once ruled there.[20]

Cultural Influences in the Indus Region

The Indus region has been influenced by various peoples who moved to or through the area over the centuries. People from the west, including the present countries of Iran, Afghanistan, and Central Asia, moving towards India had great influence on arts and crafts of the area. Groups of Aryan peoples from Central Asia entered the Indian subcontinent around 1500 BC. These nomadic hunters were part of the Indo-Aryan language group from which the European languages, Latin and Sanskrit, evolved. The Indus Valley Civilization was in decline yet had much to offer the Aryans in terms of settled communities, agriculture, and crafts. The Aryans brought their social system of four separate groups: teachers and priests, leaders and warriors, merchants and farmers, craftsmen and laborers. They also brought their religion detailed in the Vedas. Both the Aryan social system and religion with legends and mythology were taken into the developing Hindu religion.[21]

The thousand years starting in 500 BC was an important and formative period for the arts of the region. An indigenous Indian Empire developed (Mauryan), with a unified government, learning and literature, and an emphasis on art. As suggested in the Vedas, guilds were formed and villages became known for a particular craft such as weaving, pottery or weaponry. Both the court and village craftsmen were highly esteemed. Trade routes covered most of the northern areas. Ocean trading was open on both west and east coasts with Rome and China. The Persians desiring the treasures of Sindh (including horses, cows, spices, jewels, cotton, and fine muslin) annexed the area in 512 BC.[22] The Greeks, beginning with Alexander the Great's conquest in 326 BC, settled in what is now northern Pakistan and passed through Sindh. The Greeks probably introduced the techniques of stone carving to the area. In the same period, Buddhism developed, including teachings against the new, rich society and caste system. Buddhism spread from India across northern Pakistan and filled the mountains with cities, monuments, and shrines.[23]

The foreigners added artistic motifs to the region including various organic patterns of flowers and plants. Floral garlands and scrolls came from the Greeks. The pipal leaf, is a symbol of the bodh tree sacred to the Buddhists. The kairi, now known as the paisley, came from this period and was associated with threes: it has three compartments, and a central area with three symbols is decorated with leaves and flowers showing a connection with life energies. Other motifs of the time are the spiral, peacock, and peacock feathers. They are said to be sun symbols with protective powers.[24] The lotus became an important symbol. The lotus is usually shown with eight elongated or rounded petals and is shown as a creeper, as a flower or flowering in a vase. The lotus was used by numerous religions: Hindus, Buddhists, Jains, and Muslims. One sacred Hindu text describes each cosmic life starting from a lotus growing out of the navel of Vishnu. The Buddhists adopted the lotus as a symbol of purity as it is not affected by the mud or water upon which it grows. However, with the different forms of the lotus and sun symbols, it is often difficult to distinguish one from the other.[25]

Islam also had a great influence on the culture of the region. Islam first entered the region through Arab traders, followed by armies invading Sindh in 712 AD. They were unable to move into the northern areas of Hindu India but continued to fight and exert their influence for over four centuries. Muslim Turks captured Delhi in 1196. With the Islamic Empire now extending from Delhi to Spain, there was much cultural exchange. Until the fifteenth century, rulers and migrants came from the Middle East and Central Asia to set up trading and crafts centers in the larger cities of Sindh. The Islamic custom against representing living beings in art led to the development of calligraphy as an art form, as well as the development of artistic repetitive geometric and floral patterns.[26] Even though the exact dates of the origin of ajrak are not known, the beautiful blue and red geometric block printed fabrics carry a name probably taken from the Arabic word for blue and were made during this period.

The Mughals (Muslims of Turkish and Mongolian origin) invaded and created an empire that lasted from 1526 to 1858. This was a time of great assimilation of art forms when Western, Central Asian, Persian, and Chinese elements merged with the indigenous Indian styles. During their relatively peaceful empire, the Mughals patronized many forms of art and built some of the most beautiful buildings in the world. Textiles were among the prized crafts.[27]

The wealth of the Mughal Empire caused great interest on the part of European traders. In 1612, the British East Indian Company established a port for trading in what is now Gujarat. New ports continued to be established on both coasts. Rural craftsmen and farmers supplied many of the goods including quilts, carpets, and embroideries. Other textile exports included: calico, chintz, muslin, gingham, and fine silk, velvet satin, and brocades. More than fifty kinds of textiles were traded. Also metal work including gold, silver and brass, jewelry, arms and armor, and woodwork were sent west. As the Mughal rule on India weakened, the British trading companies gained power by making agreements with various small kingdoms within the subcontinent. By 1790, the British East India Company, now under the British government, controlled most of India.[28]

The British ruled the area for the next 157 years through direct administration or by agreements with the princely states. The British added a railway system and good roads to the subcontinent as well as an education and administrative system and a great interest in India's ancient past; however, the people held much resentment towards their imperialist attitudes and actions.[29]

India was given independence from Britain in 1947 and Pakistan was separated from India to create a national state for the Muslims of the country. In the partition of Pakistan from India, the new border went through the center of the large dry desert area that now comprises western India and eastern Pakistan. The states of Punjab and Sindh in Pakistan were divided nationally from Rajasthan and Gujarat in India. Traditionally the cultures among the rural and nomadic peoples in these areas were very similar with Muslims and Hindus remaining on both sides of the borders.

Development of Cotton

Cotton fabric, the basic material for rallis, was probably first cultivated in the Indian subcontinent. Early evidence of crop cultivation was found at Mehrgarh, about 5500 BC, where cotton seed and date stones were found. Both of these crops need a moist climate and are harvested in late summer. This was the environment in the northern area of the Kachi Plain where Mehrgarh is located and later the cities of Nausharo, Sibri, and Pirak.[30] The ancient city of Mohenjo-daro, located in Sindh, dates back to about 2500 BC. During Marshall's excavations of Mohenjo-daro in the 1920s a piece of dyed cotton cloth was found wrapped around two silver vases. The fabric, from about 1750 BC, was preserved by the silver salts.[31] The fibers in the fabric were from a plant related to Gossypium arboreum, an indigenous cotton plant requiring a long period of cultivation, the same species found at Mehrgarh.[32] Other evidences of cotton found at Moenjodaro by Mackay include metals: fabric remains on razor, a cord around a copper blade, and a cord wound around a copper rod.[33] Evidences of cotton have also been found at Lothal in India.[34] At Harappa, fabric impressions on the inside of faience vessels and on pottery pieces were found. (Faience is fired powdered quartz that has a shiny turquoise finish when covered with silica and copper.) The fabric impressions show uniform thicknesses of threads and a tight weave.[35] The only other finding of ancient cotton is from Dhuweila in eastern Jordan where the cotton is dated from 4450-3300 BC.[36]

Cotton grows in a field in lower Sindh.

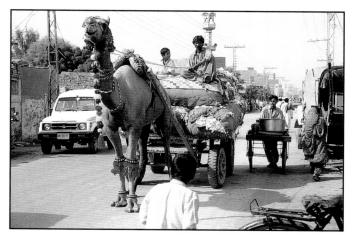

A camel drawn cart delivers picked cotton to a town in lower Sindh for weighing and processing.

This weigh station collects cotton grown in lower Sindh.

The people of the Indian subcontinent were probably the first in the world to spin cotton and use it in making fabric. Wool and bast (woody plant) fibers had already been developed elsewhere but the fibers of the cotton plants were so short, slippery, and delicate that a special way of spinning was required. The spinners of the subcontinent developed a small, light, fully supported spindle that did not put too much weight on the delicate thread.[37] Another unique factor is that the Indian spinners spun in the direction of a Z by whirling the fibers with the action of the thumbs and fingers of the right hand while the spinning in the rest of the world was done with an S twist.[38] It is said by using their technique, the Indians could spin over 200 miles of thread from a pound of cotton. Even modern machinery cannot duplicate this achievement.[39] The spinning whorls found in Mohenjo-daro were made from simple earthenware and also from expensive materials such as shell and faience indicating that cotton was spun into thread by both rich and poor.[40] In addition, bronze sewing needles were uncovered at Mohenjo-daro.[41]

Cotton fabric from Sindh became famous throughout the prehistoric world because it was cool, absorbent, and easy to dye. It was known by the Babylonians as "sindu," by the Greeks as "sindon," and by the Romans as "cendatus" or cloth from Sindh.[42] Sennacherib's (705-681 BC) garden in Nineveh had trees that "bore wool" and after shearing the "wool" was used to make garments. There are two references by Herodotus describing tree wool and how they provided the Indians with clothing.[43] The famous Roman togas were made of Indian cotton. So much gold was sent to India from Rome that it drained the Roman coffers, a factor in the fall of the Empire.[44] The first known record of trade between the Indian subcontinent and the world to the west, *Periplus of the Erythraean Sea*, written in the mid-first century AD, mentions the region of present Gujarat as one of the major textile producing areas. "All sorts of cloth" including silks, flax cloth, and mallow cloth (made fiber from a species of Hibiscus) were exported. In addition, the record mentions Indian cotton cloth, Indian broad cloth, and Indian coarse cloth as trade imports to areas of northeastern Africa.[45] Not until the discovery of cotton that was more easily grown, Gossypium herbaceum, in the sixth or seventh century AD, did cotton cultivation spread widely beyond the Indian subcontinent.[46]

This is a collection point for cotton in Gujarat on the road to Ahmedabad.

The fabric found in Mohenjo-daro appears to have been dyed with madder.[47] It is unclear what other patterning may have been used on fabric. One clue is the famous Priest-King statute found by Sir John Marshall at Mohenjo-daro. The seven inch high bust is clothed in a shawl with a rolled edge decorated with trefoils with occasional small circles filled with red coloring. Trefoils are found in other ancient civilizations. They are also found carved in relief on a small faience bead from Mohenjo-daro and painted on a steatite bead from Harappa. The masters of ajrak printing think the pattern is actually the cloud (kakar) pattern still used in ajrak. However, there is not enough evidence to say the patterning was printed or embroidered.[48] The important point is the Priest-King illustrates that patterning was used to decorate fabric in the time of Mohenjo-daro.

The techniques of dying cotton fabric with colors that remained fast through the use of mordants (metallic salts) remained with the Indian dyers since ancient times. Panini, a great historian of the fourth century BC, describes the cloth of the region by the colors; indigo blue, two kinds of red, and black.[49] These colors, along with a vast variety of dying techniques including dying yarns for weaving, bleaching, use of resists, using multiple blocks for printing, mixing of complicated dyes, and other processes, made the application of color to fabric India's finest textile achievement.[50] The Indians were the world experts in dying cloth until the introduction of chemical, artificial dyes in the nineteenth century. Sindhi cotton continued to be among the most prized of textiles for over a thousand years.

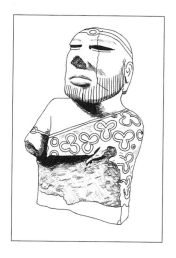

A famous discovery has been the statute of the Priest-King of Mohenjo-daro now in the National Museum in Karachi. His robe is patterned with a trefoil design. (After Kenoyer, 215.)

A bead found in Harappa is decorated with the same trefoil design as found in the Priest-King's robe. Fabric designs were used with other materials, in this case, steatite (after Vats, Plate CXXXIII, Fig. 9).

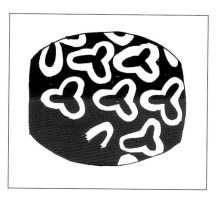

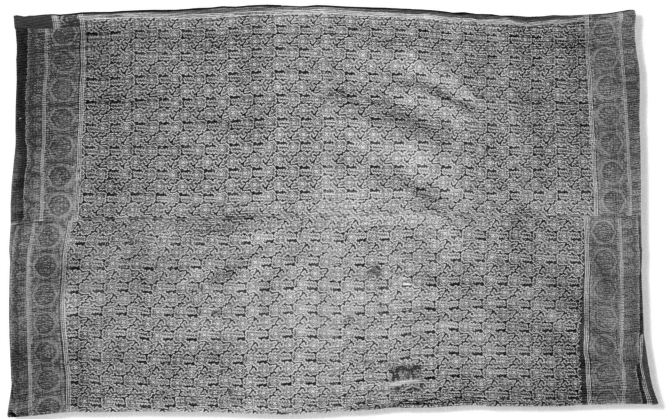

A fine old piece of ajrak in the cloud pattern found on the back of a ralli from Hala, middle Sindh.

Cotton, the fabric of rallis, has been a major crop in the subcontinent since the beginning of history. A cotton crop takes up to four months to mature and, depending on the rainfall, several crops can be grown a year. Traditional cotton cultivation in Sindh is still used. Cotton is planted in the summer after the flooding of the Indus and is picked in November. Other methods are used to grow winter crops and to grow cotton on the plains.[51] The indigenous cotton is over six feet high and is resistant to pests but has only a quarter of the yield of other varieties. Most of the cotton now grown is a new variety that has middle staple length cotton, high yields, but requires intensive care.

The tradition of dying fabric is still strong in the region. Here, yellow printed fabric is hung over a line to dry in Dhamadka, Gujarat (a town mostly destroyed in the earthquake of January 2001). To regain a good water supply, many residents moved to a new area they named Ajrakhpur.

Women's historical involvement with textiles in the Indus region is illustrated in the following poem by Shah Abdul Latif, the famous poet of Sindh. Longing for her Baluchi lover who has gone to a place called Kech Mekran, Sassui cries:

O mother, from the spinning seat remove the spinning wheel away.
That man of hills for whom I spun went home to Kech, nor did he stay.
Card not the ball of cotton now if, mother, thou for me dost care.
Kick down the wheel, and cast the cotton ends upon the water's face.
Love struck me down. Get cotton spun and pay for it the spinning fee.
The wheel and cotton, spinning seat, O girls, banish anywhere.
The man I loved, who is my life, has gone and brought me sorrow's pain.
In spinning place they say to me "Spin." Though the strands I pull and strain,
No thread emergeth. But the wheel to stain with tears has been my lot,
With tears of blood.[52]

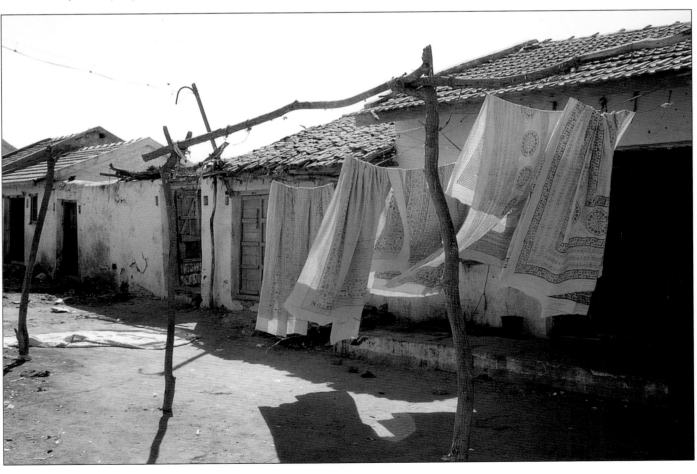

History of Quilting, Patchwork, and Appliqué in Asia

Throughout early history, women produced fabric. When the women were home, cooking and tending children, they also could clean textile fibers, spin fibers, and weave cloth. Elizabeth Barber stated "The textile industry, in fact, is older than pottery and perhaps even than agriculture and stockbreeding, and it probably consumed far more hours of labor per year, in the temperate climates, than pottery and food production put together. Up until the Industrial Revolution, and into this century in many peasant societies, women spent every available moment spinning, weaving, and sewing, and even had men helping them…"[53]

Perhaps the first quilting took place in the "invisible" environment of a village home where a resourceful woman was making use of a scarce resource—fabric. The story of the first person to sew several layers of fabric or other materials together for use as bedding or warm clothing was never recorded for posterity. Likewise, the first time small pieces of fabric were sewed together to make patterns with fabric was not recorded either. Some think the origins of quilting (layering fabric and a filling and sewing it together with continual seams) and sewing together pieces of fabric to form patterns, took place in Asia. Initially, the purpose of patchwork and quilting was probably utilitarian, using fabric and other natural materials as protection against cold, pressure, and impact. Throughout history, wool, silk, cotton and other plant fibers, leather, fur, and husk fabrics have been pieced depending on what was available. They were used as clothing, bedcovers, hangings, or other useful items. Due to the delicate nature of fabric, few ancient pieces have survived.[54] Only unusual circumstances such as the steady dryness of Urumchi in northwest China or in Egypt permitted textiles produced thousands of years BC to remain intact.[55]

There is evidence of techniques used in rallis in ancient Egypt and Asia. Historically, the oldest evidence of quilting is a carved ivory statue found in the Temple of Osiris in Egypt. The statue (c. 3400 BC) is of a pharaoh in a mantle with deeply cut diamond patterns indicating the coat was stitched through several fabric layers. There is evidence of ancient patchwork on a wall painting at Thebes, Egypt (1198-1167 BC). The painting shows a boat with sails made of various colors of fabric in a checkerboard design with a border in a chevron pattern. A patchwork ceremonial canopy of small dyed gazelle leather squares made for an Egyptian queen (c. 980 BC) still survives in a Cairo Museum. The canopy is decorated with cut shapes of flowers and other symbols.[56] In Asia, ancient appliqué on a saddle blanket was found in the graves of tribal chiefs in Central Asia made between the sixth to fourth centuries BC. The felt appliqué figures of fighting animals were preserved in permafrost in Pazyryk in the Altai Mountains of Russia. In the Cave of the Thousand Buddhas along the Silk Road in the Serinda region of India (from the sixth to ninth centuries AD) altar hangings of patchwork comprised of patterned rectangular pieces of cloth, banners, and a small silk bag made of squares and triangles were found.[57]

Tradition says the idea of quilting was brought to Europe in the twelfth century by the men returning from the Crusades in the Middle East. They saw the defending soldiers, the Saracens, with shirts made from layers of fabrics stitched together giving protection and comfort under the chain mail armor. Decorative quilted clothing, such as the velvet quilted jacket worn by the Black Prince, came to be used. Heraldic banners and flags were made of patchwork and appliqué. At this time bedcovers were probably made of whole cloth quilting. None has survived but there is a French reference to a quilt with a checkerboard pattern made of two kinds of silk from a twelfth or thirteenth century poem. Three quilted linen Sicilian bed covers from the late fourteenth century still survive. Written records from the time mention quilting in bed covers. Quilted bedding became popular among both aristocrats and peasants.[58]

In the history of quilting in Asia, it is important to mention the development of trade in quilts between the Indian subcontinent and Europe. As the Portuguese, English, Dutch, Danes, and French competed for Indian trade, the Europeans kept records of the textiles from the Indian subcontinent starting in the sixteenth century. Early reports indicated that quilts were being made in India. Chintz and calico were also made there and were popular in Europe. Chintz, at the time, meant variegated or spotted cloth and calico referred to plain cotton. (Over time the definitions changed. Chintz became glazed cotton printed with large polychrome figures of flowers and branches and calico became cotton dress fabric printed with small repeating designs.) In 1515, Pires, a Portuguese traveler, reported every year ships arrived from Gujarat with valuable cargo including thirty kinds of cloth. He reported that Bengal exported beautiful bed canopies "with cut-cloth work in all colours."[59] In 1518, the Portuguese reported that the city of Cambay, India, made beautiful quilts. Traditionally, a large cotton panel called a palampore was used as a bedcover or wall hanging. The design was hand painted, often depicting a flowering tree of life design. Quilted cloths were also used as floor coverings. The quilts were made with a cotton batting and the top, batting, and bottom layer were sewn with a running stitch. The sewing followed the design of the fabric or created a new pattern. A report from an agent of the East India Company in 1609 from Surat in Gujarat said the quilts made from white calico and also painted chintz were readily available and very reasonable. He predicted a good profit for them in England. A shipment of quilts to England, in 1619, had one hundred palampores and a number of other fine quilts. Some quilts were all one color fabric front and back, others were reversible with different fabrics on each side, and others, described as the most popular in India, had borders of different colors going around the quilt. The English liked fabrics with a light colored background, and a design in the middle of the quilt discouraging the "sad red" colors. During the seventeenth century, thousands of Indian quilts were shipped to Europe and decorated bedrooms with matching window covers. The Indian quilts and palampores inspired the English quilts of the eighteenth century and thus the early American quilts as well.[60] A British soldier's quilt from the Indian Army clearly shows the influence of rallis with hundreds of tiny patch-

work squares in familiar ralli colors and a pattern of multiple borders and varying patterns of patchwork blocks.[61]

There are also reports that quilts were exported since the seventeenth century, going to Greece, Iran, Yemen, Indonesia, and Sri Lanka. There is evidence that rallis were known in Iran, since Sheikh Saadi mentions ralli in Gulistan. "Ten faqirs can come under one ralli but two kings cannot rule one kingdom."[62] Rallis like those still used on the boats on the Indus River certainly could have accompanied the traders. Traders from Sindh ventured into the known world by sea or traveled overland into Central Asia.[63]

Patchwork has continued to have symbolic and mystical meanings in Buddhism and Islam. Holy men in both religions have worn patchwork cloaks, robes, and mantles as an outward sign of their commitment to poverty. In Buddhist temples, donated cloth is made into patchwork garlands and hung in temples to drive away evil spirits and monks use cloth scraps to make their clothes. In Islam, faqirs and dervishes have traditionally worn patchwork clothing. The dervishes say Mohammed wore patched clothing, as did the four caliphs who followed him. Caliph Omar would sleep in his patchwork robe beside the poor on the steps of the mosque. The highly educated dervishes served as teachers and wise men and tried through prayer, song, and poverty to become unified with their creator. Their patchwork clothing identified them as wise men as they traveled through Persia and Central Asia.[64] The name faqir comes from an Arabic term meaning a person who is immaterial to the world. In Pakistan, faqir is used in two contexts. One is a man who begs and the other is one who has spirituality. Both wear patchwork clothing. Sufis are known for wearing patched jackets, head covers, and caps to demonstrate their humility and renunciation of the world.[65] The symbol for a beggar is a cap made in patchwork with triangles. The same pattern is seen in the unique patchwork of quilted horse armor found in the southern Sahara. The solid colors of red, black, deep yellow, blue, and purple are seen in the armor.[66]

The dervishes of Islam were known for their patched clothing, indicating a lack of concern about worldly objects. This dervish from Uzbekistan wore a robe that was both patched and quilted (after Gillow and Sentance, 161).

This tent wall from a shamiana tent is decorated with shapes (borders, blocks, and chevrons) that are seen on rallis. The tents and walls have many uses, for weddings, meetings, fairs, and, in this case, to mark the edge of a parking area in Islamabad.

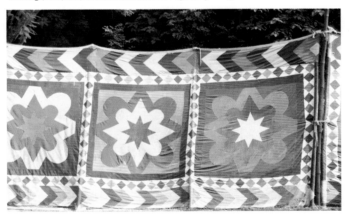

Patchwork and appliqué are still seen throughout Asia as animal decorations and tents. Colorful ox and horse coverings, camel blankets, and elephant decorations are a part of many festivals.[67] Turkish tents are famous for their lavish decorations. Multi-colored and patterned tents in Egypt are called "chiameya."[68] In Pakistan, a common tent used for weddings, parties, gatherings, and even as a cover for building construction is a cotton tent called a "shamiana" with large bold appliqué designs. It has been popular since Mughal times. The Oswal Banias of Rajasthan and Vagad of Kutch are known for the large wedding canopies made in panels of six, nine, twelve or more squares that are decorated with a white appliqué pattern. Each appliqué is cut with the help of a paper pattern.[69]

Motifs from Ancient Indus Artifacts

Many of the designs used on rallis today first appeared anciently in the Indus region, and in West and Central Asia. There are many designs that are commonly used throughout Asia. One illustration of the connection of textile designs in various areas of Asia is the use of the word "flower" to describe a design. The lozenge design used in the durrie weavings of northwestern India is called phul or flower. In Iran, the same design is called gol (flower) or gul in Persian meaning rose. The common design element in Turkmen carpets is called gol or gul, flower.[70] Likewise blocks of design in rallis are called gul or flower, whether or not they depict flowers.

Textiles have not survived from prehistoric times but patterns have been recorded in pottery and stone. There are dozens of patterns and motifs found on the rallis that are also found on painted pottery of the Indus civilization and especially from the older settlement at Mehrgarh in Baluchistan starting before 6000 BC. It is interesting to note the colors used in the pottery. Harappan pottery was painted in black with red, white, and yellow as ground colors and sometimes green applied after baking.[71] Nal pottery used the colors of black, white, red, and yellow, with green and blue. These are the colors used in rallis and embroidery work throughout Sindh and adjoining regions today. The ancient pottery from other sites in Sindh was usually painted on red and buff backgrounds with black, brown, and sepia.[72]

The majority of the designs used on rallis that are also found on the ancient pottery and seals of Mehrgarh, later Indus Valley cities, and Pirak are geometrically based on a grid design. A grid design is a repeating pattern set on a framework of horizontal and vertical lines. These motifs include many variations of lines, squares, triangles, and circles. A few other shapes found may be based on natural objects such as flowers, plants, and animals. These shapes are found in rallis as appliqué. Ancient pottery designs may be found in almost all rallis to some extent, be it a border or a block, with the exception of some of the embroidered rallis.

In many cases, there are numerous examples of pottery or seals to illustrate a certain pattern or motif. The examples used in this book are chosen for the clarity of the pattern and the age of the artifact, with the older patterns having preference to show the possible age of a particular motif. The methodology used for this research was to examine the published drawings and photographs of pottery and other artifacts from ten ancient cities of Sindh, Baluchistan, and surrounding regions. These were compared to approximately three hundred ralli quilts from several private collections, museum collections, and from published books. Due to the large variety of ralli designs and some possibly not yet recorded, similarities may continue to be found.

Lines

Lines, the simplest of design elements, are used for bordering. A single line or multiple, parallel lines are used. Shown are brown on buff examples from Mehrgarh. The ralli uses three solid lines (bands) of color as the borders. Plain lined borders such as this one are usually used on ralli quilts with a simple design in the field.

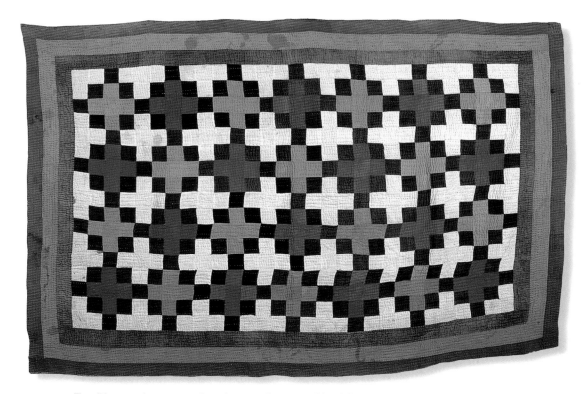

A pot with lines as border decoration is from Mehrgarh, Period VI (after C. Jarrige et al., 123).

The ralli has a simple cross pattern that is also seen in the carvings of the tribal tombs in the desert. It has twenty-eight colored crosses with eighteen white crosses in between. The quilt is from lower Sindh, late twentieth century, 80" x 53.5", all cotton.

Lines at right angles are an expanded use of lines as a design. A common ralli pattern from Sindh has the same design as pottery pieces with parallel lines at right angles creating small squares at the intersection of the lines. The pottery example was found in Pirak.

The pottery showing lines at right angles is from Pirak, Period IA (after Enault, fig. 36).

This pottery is also from Pirak, Period IA (after Enault, fig. 36).

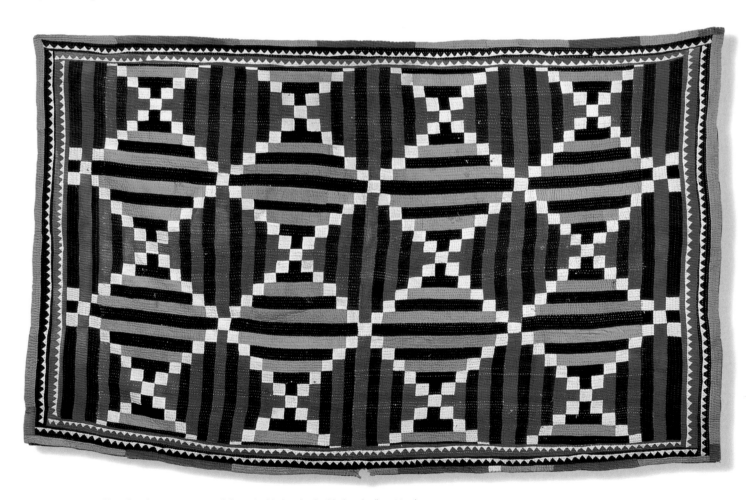

The ralli with common pattern of alternating black and red or black and yellow striped blocks is from lower or middle Sindh, late twentieth century, 78" x 53", all cotton.

116

The zigzag line is a very common pattern in ancient pottery as well as ralli quilts. It is called snake design in embroidery. The zigzag is used as a border or divider between motifs in both the pottery and the quilts. The pottery was found in Mehrgarh.

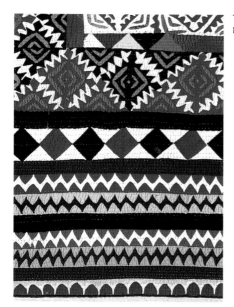

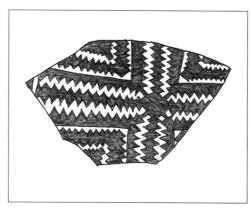

This detail from a ralli border shows four rows of the zigzag pattern separated by three solid strips of fabric.

Zigzag lines were common in Faiz Mohammad gray ware pottery from Mehrgarh, Period VI (after C. Jarrige et al., 160).

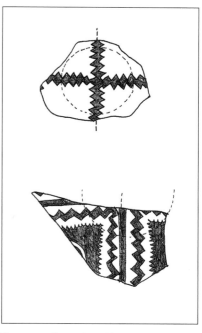

This pottery with zigzag lines is Faiz Mohammad gray ware from Mehrgarh, Period VI (after C. Jarrige et al., 160).

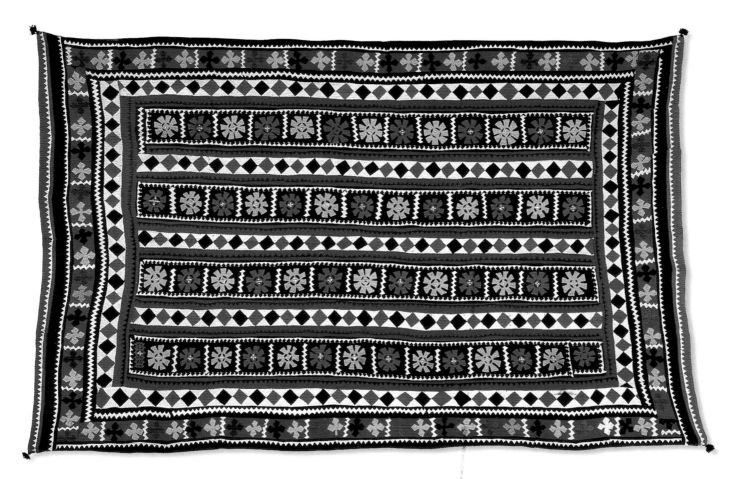

The ralli uses a variety of motifs, including using a short zigzag line as a separator between the eight petal flower-like design in the four vertical rows in the field of the quilt. Small zigzag lines are also used in the outside border between the mandherro patterns. The quilt is from lower or middle Sindh, late twentieth century, 85" x 56.25", all cotton.

Squares

The checkerboard pattern with alternating dark and light (or in the case of the quilts, colored) squares is a common pattern in ancient pottery as well as in ralli designs. One pot is from Mehrgarh, and the other is from Amri. Painted pottery starting with Mehrgarh and also Harappa is often decorated with a checkerboard pattern. The undecorated squares may be filled in with dots or other features.[73]

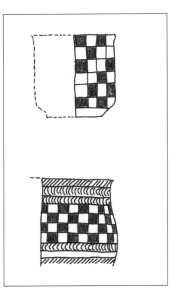

The pot on top is Faiz Mohammad gray ware from Mehrgarh, Period VII (after C. Jarrige, 130). The other pot is from Amri (after *Pakistan Archaeology*, No. 5, 1968, Plate XXI).

This small square ralli was originally a storage bag. It was folded in half and two sides were sewn together. The colored blocks are arranged asymmetrically. It is from lower or middle Sindh, late twentieth century, 25" x 28", all cotton.

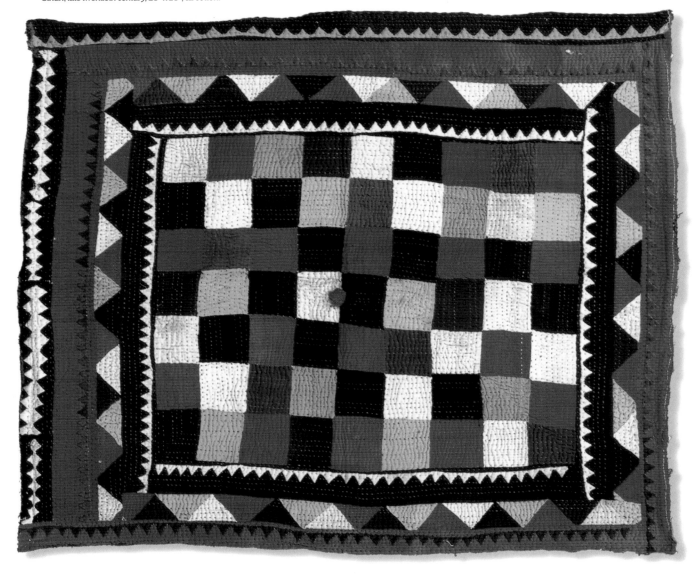

Setting squares on end in the checkerboard pattern is a common pattern for pottery and quilts. It is also found in the ancient pottery from Pirak. This is a classic ralli pattern.

The pot is from Pirak, Period II (after Enault, fig. 49).

This quilt has twenty-two concentric rectangles of colored squares (counting the middle) forming a striking pattern. The ralli, from Matli, Badin, Sindh, late twentieth century, 73" x 53", all cotton. This was the first ralli I saw.

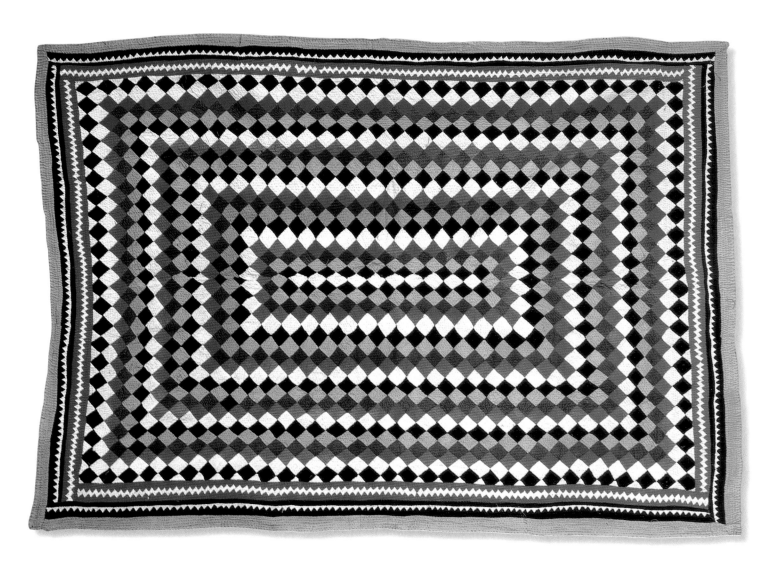

A row of squares placed on end is commonly used as a border in both pottery and rallis. The pot is from Pirak. Like the pottery, the pattern on the ralli is a row of squares on end with a border in between. A variation of the border has an additional square placed in the middle of the original square. The pot is from Pirak and the ralli shows the design in the border.

The pottery is from Pirak, Period IA (after Enault, fig. 38).

This quilt has six rows of squares on end using mostly red squares and other random colored blocks. The rows are separated by five rows of the traditional red border of concentric circles. The ralli is from lower or middle Sindh, late twentieth century, 81" x 53.5", all cotton.

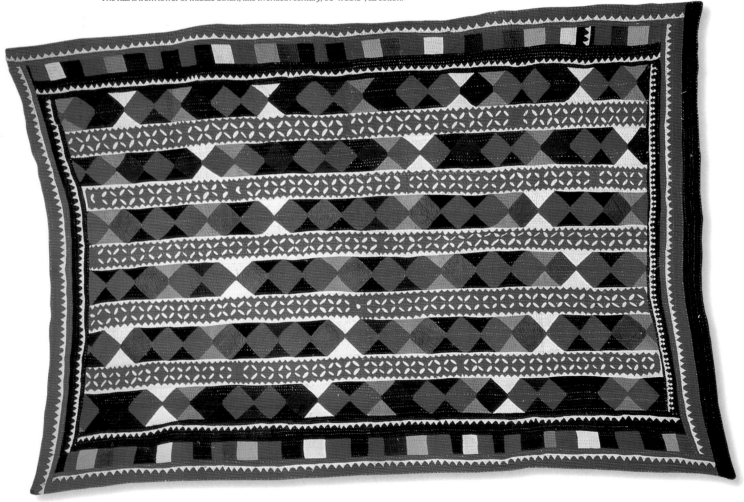

This pottery piece showing a variation of the border of squares is from Pirak, Period IA (after Enault, fig. 38).

This ralli has squares on end with an additional square in the middle in the border. The center field has a pattern reminiscent of some block print patterns (one of which is on the back of the quilt). The quilt is from lower or middle Sindh, late twentieth century, 79" x 54", all cotton.

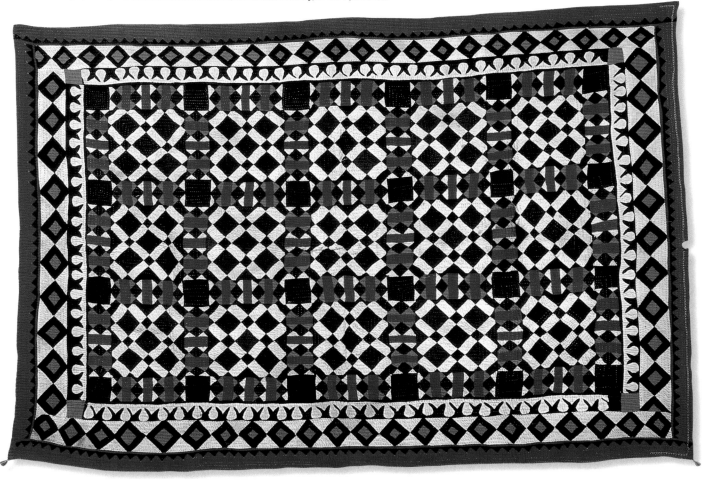

Lines forming squares is an important design element in both the pottery and on the quilts. The examples of the pottery and the quilts are strikingly similar. Parallel lines at right angles form squares. Additional patterning is placed in the resulting squares. The pottery is from Pirak. The ralli has two parallel lines forming squares. The four triangles within the squares are alternating light and dark.[74]

In this motif, two, three or four parallel lines are used to form squares. The pottery example from Pirak incorporates two parallel lines with a design in the center of the square. The quilt has a similar pattern and uses three parallel lines with an appliqué pattern in the middle of the resulting square.

There are examples of both pottery from Pirak and a ralli with four parallel lines forming a square. The center space of the lines is colored a darker color. In both pieces, a checkerboard pattern of squares filled in the spaces created by the parallel lines. This example is particularly interesting due to the exactness of the matching details.

The design of two lines forming squares is from Pirak, Period IA (after Enault, fig. 36, no. 16).

This ralli was considered an ordinary design by the quilter. She called it farsh or floor tiles. It has sixty blocks formed from four triangles of alternating colors. The quilt is from Mirpur Khas, Sindh, late twentieth century, 83.75" x 57", all cotton.

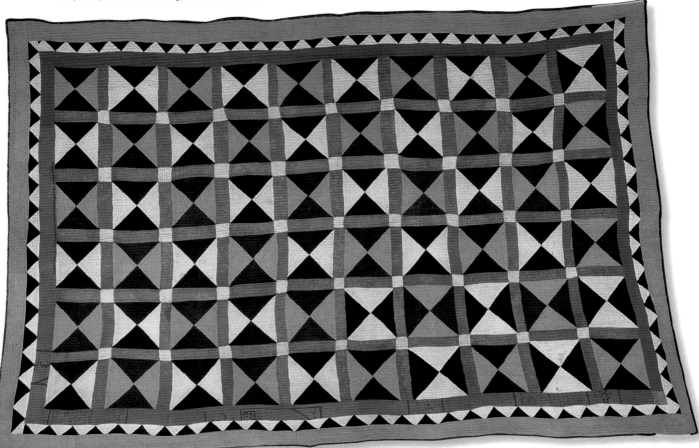

The pottery with the square within a square design is from Pirak, Period IA (after Enault, fig. 38).

The ralli with eight blocks of the square within a square pattern is smaller than normal and probably made for a child. There are great varieties of fabrics in the quilt, indicating that small scraps of fabric were used. The quilt is from lower or middle Sindh, 68" x 45", all cotton.

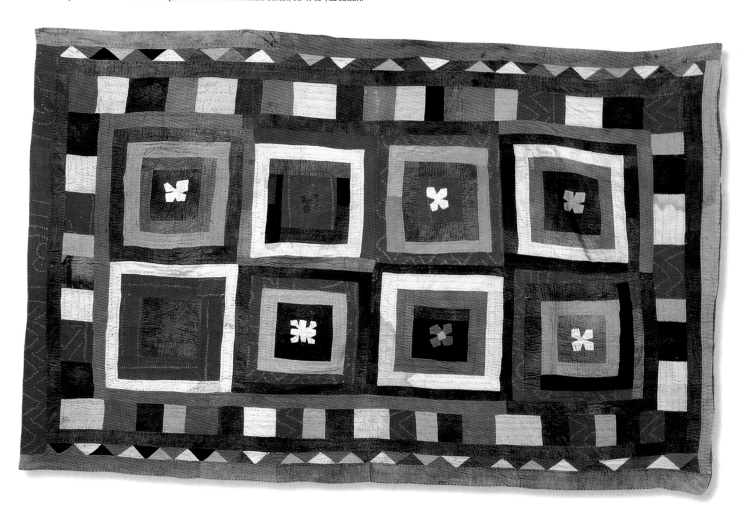

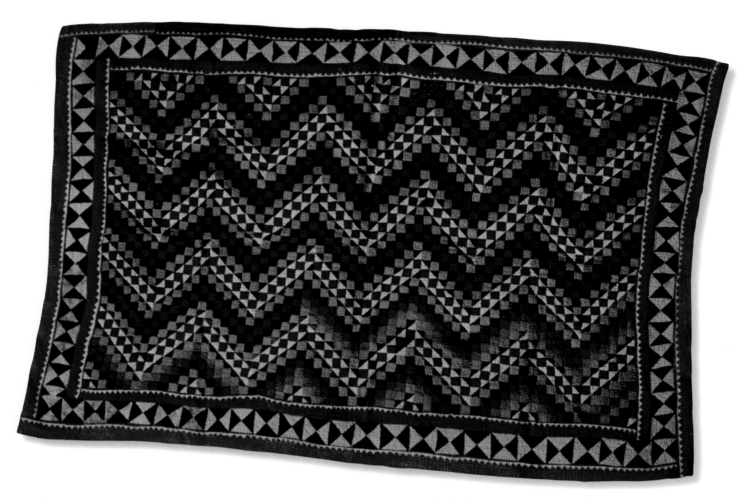

This quilt has four predominant red and white zigzag lines in the center field. The pattern is also seen in the small colored squares that follow the same pattern. The ralli is from Jati, lower Sindh, late twentieth century, 76" x 52", all cotton.

A square divided forming four triangles is a common and very traditional design in the rallis, particularly of the Badin area. In the pottery, these triangles are shaded and in the quilts, they are appliquéd. The pottery is from Mehrgarh. The design of the square divided into four triangles is evident in the ralli done in traditional colors and style.

The vase, with squares divided to form four triangles, is from Mehrgarh, Period IV (after C. Jarrige et al., 232).

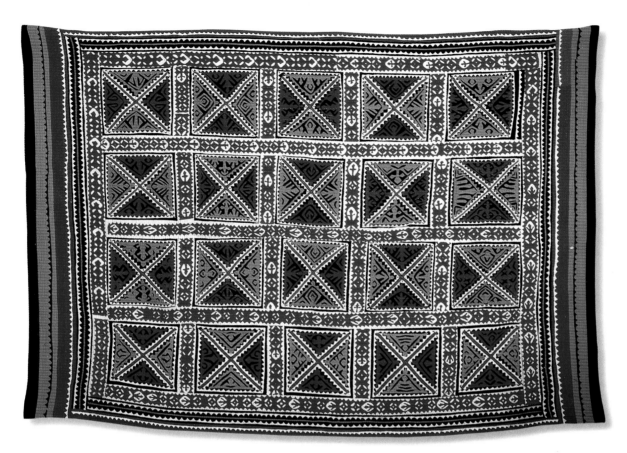

This is an example of a ralli where the square block is divided to form four triangles.
Courtesy of a private collection.

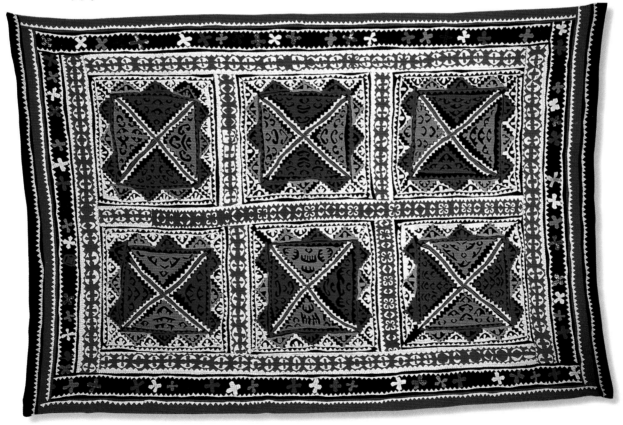

This ralli has six large blocks of squares divided into triangles. In addition, a border of smaller patterned triangles was added to each block before it was framed by a red and white appliquéd border. The back is a tie-dyed shawl matching the black, red, and white colors of the front. The quilt is from Badin, lower Sindh, late twentieth century, 85.25" x 62.25", all cotton.

Squares creating a cross within a cross is a symbol from the Indus Valley Civilization. In the symbol from Harappa, the cross is said to symbolize the cosmic soul. The dots in the corners represent the macrocosm or the world. Together the symbol signifies the powers of heaven and earth.[76] The seal with a small handle on the back is from Harappa. The pottery fragment from Amri also shows a cross design with multiple outlines. This ralli has a center cross, with eight colored outlines. Interestingly, in each corner of the block, where the dots are in the Harappan symbol, a yellow square is carefully placed.

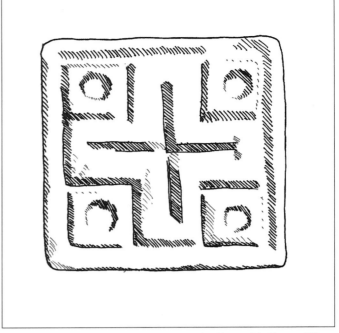

The pottery showing a cross with many outlines is from Amri (after Starr, 56).

The steatite seal with a handle on the back (1.6 x 1.6 cm) is from Harappa (after Kenoyer, 195).

This ralli has six large crosses composed of a center square, outlined by other squares. In each corner of the block, where the dots are in the Harappan symbol, a yellow square is carefully placed. The quilt is probably from the Thar Desert, late twentieth century, 86" x 56.5", all cotton.

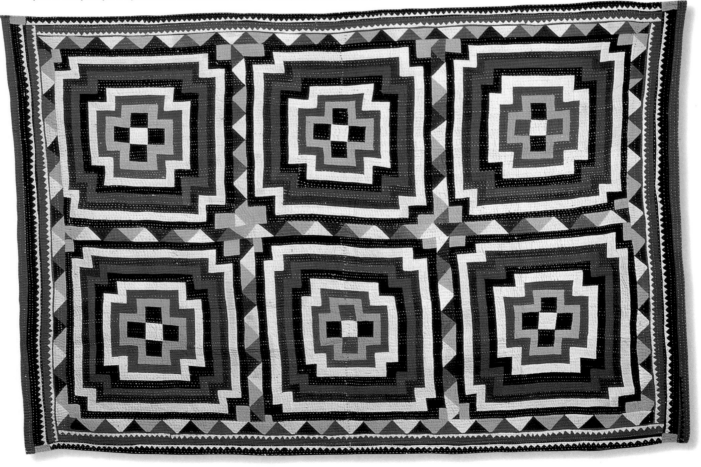

Triangles

A row of triangles in a line is a very common border or outline and is also a separator between motifs. A goblet from Mehrgarh, shows triangles used as an outline for the lozenge block as well as a border around the top edge of the vase. A row of triangles is a common motif in the pottery from the first half of the third millennium BC in Baluchistan as well as in Amri.[77]

The ralli border shows up to five rows of triangles on the edges. Rows of triangles are also used in pairs with the straight sides together and a space in between. The pottery piece shown is from Mehrgarh, and the motif is also seen later at Pirak.

A variation, found usually on finer ralli quilts, is a tiny square atop the apex of each triangle. The similar pottery is from Pirak.

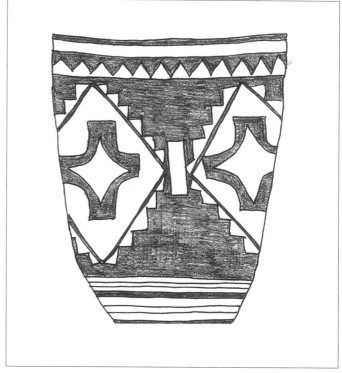

The polychrome goblet is from Mehrgarh, Period VI (after C. Jarrige et al., 121).

This quilt has five rows of triangles in top and bottom edges. A row of triangles is also used to border each of the thirty-five appliquéd blocks. The ralli is from lower or middle Sindh, late twentieth century, 79" x 52", all cotton.

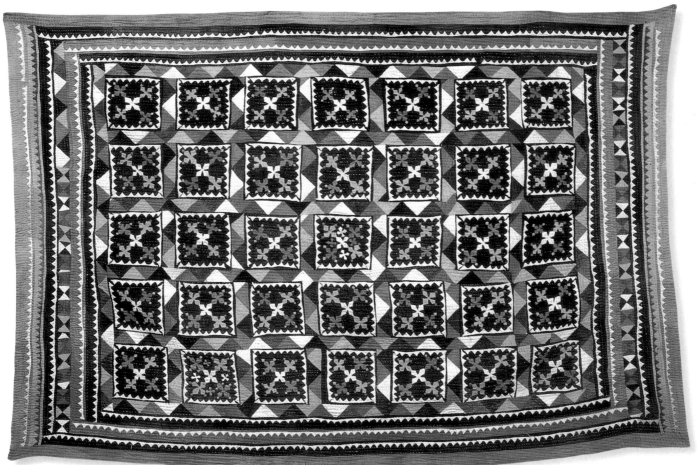

131

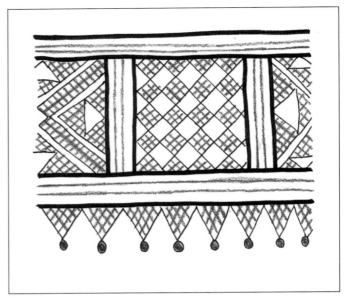

This pottery is from Pirak, Period II (after Enault, fig. 55).

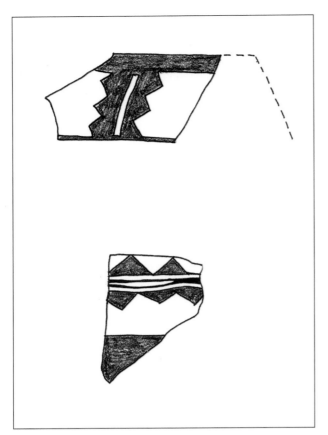

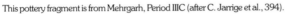

This pottery fragment is from Mehrgarh, Period IIIC (after C. Jarrige et al., 394).

This detail of the edge of the Matli quilt shows the attention paid to the details. The row of triangles bordering the center field has a small square appliquéd to the apex of each triangle. (Sometimes small embroidery is placed on the apexes.) Pairs of mandherro designs are separated from the next pairs by two strips of triangles. In between is a strip of black carefully embroidered on the edge with yellow thread.

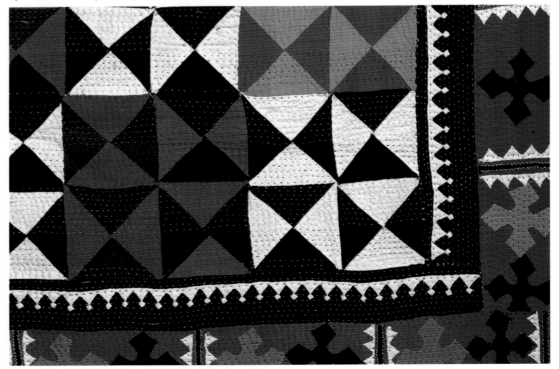

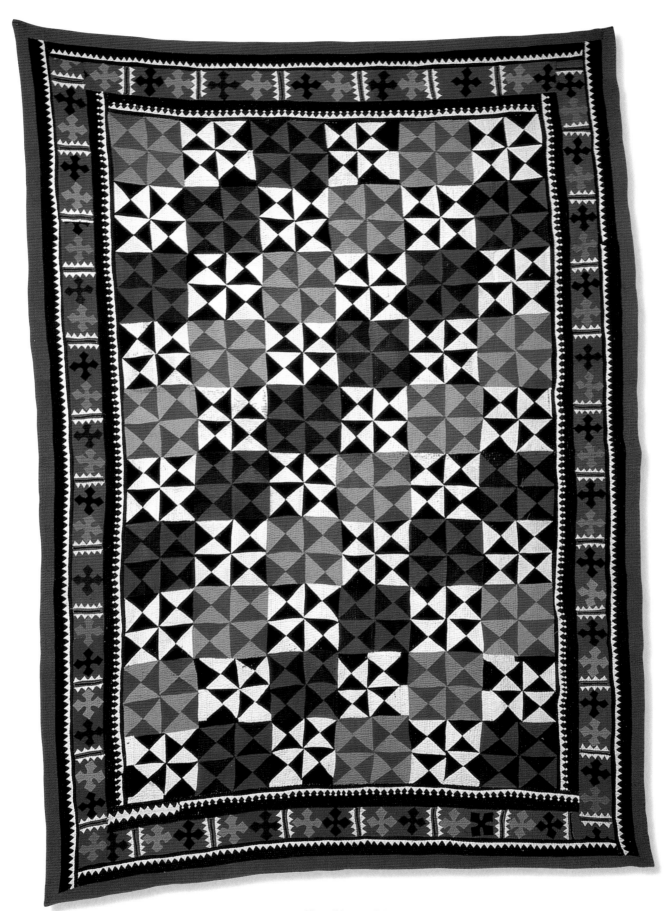

This well-known ralli design has sixty blocks composed of triangles in contrasting colors. The quilt is from Matli, Badin, in lower Sindh, late twentieth century, 78" x 54", all cotton.

Small triangles forming larger triangles are a common design in Pirak pottery. By alternating upright and pendant triangles, a larger triangle shape is formed. By alternating the larger triangles, a zigzag pattern is formed. The ralli pictured has the stacked triangles used as both the block design (within the divided square) and as a border. This pot and ralli are very similar in both motif and composition.

This tall pot used triangles as decoration. It is from Pirak, Period IA (after Enault, fig. 37).

This unusual ralli has fifteen blocks made of four alternately colored triangles, decorated with rows of triangles forming a larger triangle. The three borders of green, red, and black are decorated with triangles. The back of the quilt is solid red. The quilt is from lower or middle Sindh, late twentieth century, 80.5" x 50", all cotton.

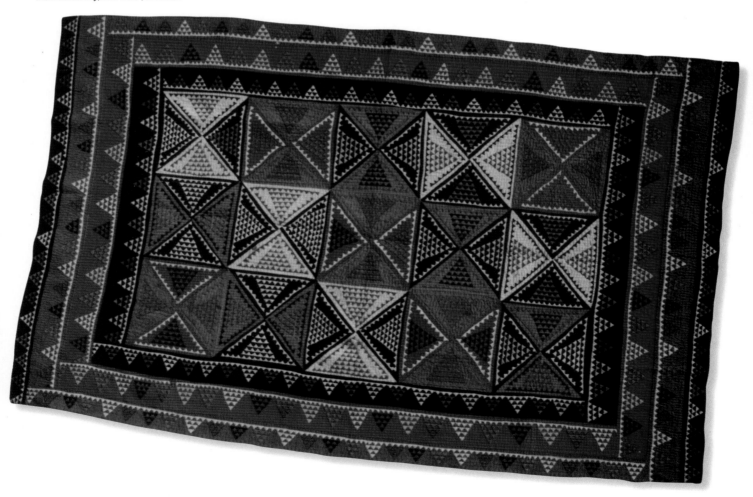

There are several **configurations of triangles** used in both the pottery and in the quilts. One of these is rows of triangles stacked on top of each other along an invisible diagonal grid. The terracotta seal on the left is from Mehrgarh. The pottery example is from Pirak. Both designs show how a corner can be turned with this configuration of triangles. The seal has a different shape in the center (diamond) and the quilt uses the two triangles with apexes together.

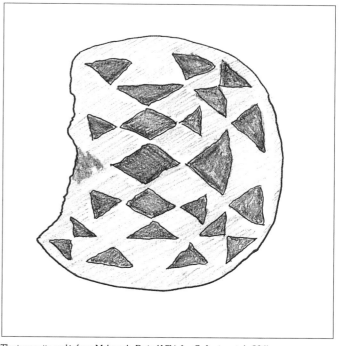

This pot is from Pirak, Period IA (after Enault, fig. 37).

The terracotta seal is from Mehrgarh, Period VII (after C. Jarrige et al., 204).

This ralli has stacks of triangles forming the pattern with a center rectangle composed of triangles with apexes together. The quilt is from lower or middle Sindh, late twentieth century, 69" x 54.5", all cotton.

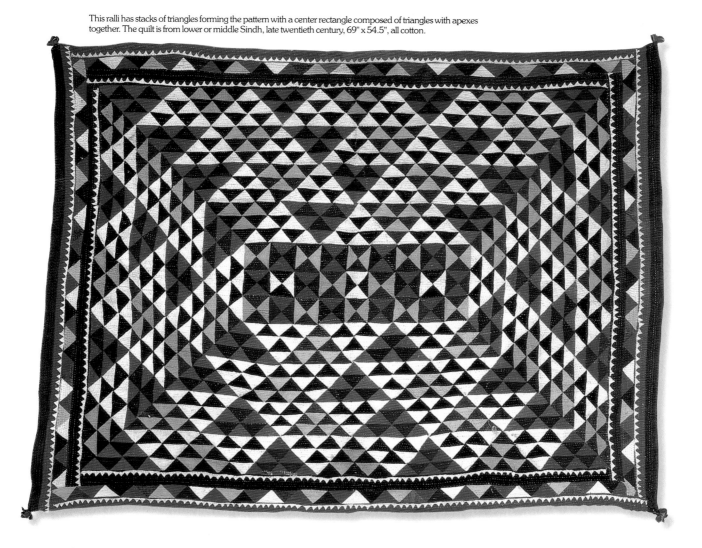

135

Triangles as borders and pattern are often used. This pattern is composed of triangles placed on top of each other with the long edge and a short edge free. The same composition is also used in the main field. The triangle pattern is seen in pottery from Pirak. The ralli pictured used the triangle pattern in both the border and in the field. Often in Harappan pottery, every other triangle is colored in with solid color or cross-hatching. A simplification of the triangle in the grid pattern is used as a border on Harappan pottery.[78]

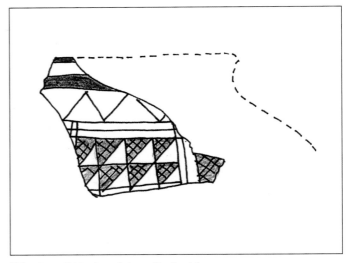

This pottery, with triangles as design and borders, is from Pirak, Period IA (after Enault, fig. 36).

This ralli uses triangles in both the center field and the border. It is from lower or middle Sindh, late twentieth century, 86" x 55.5", all cotton.

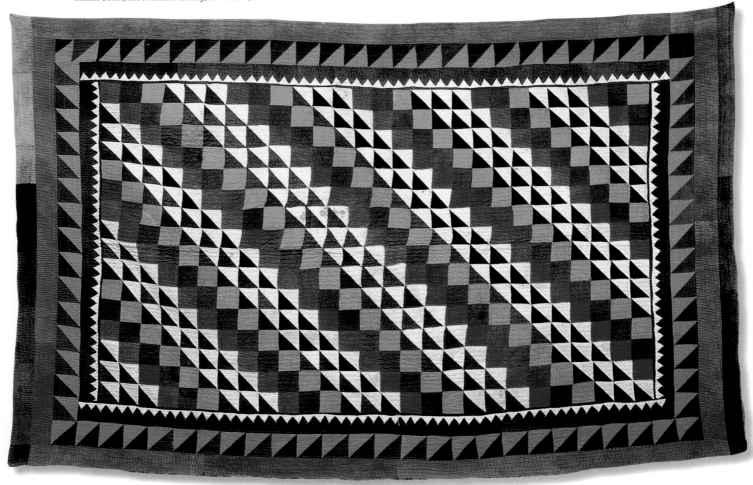

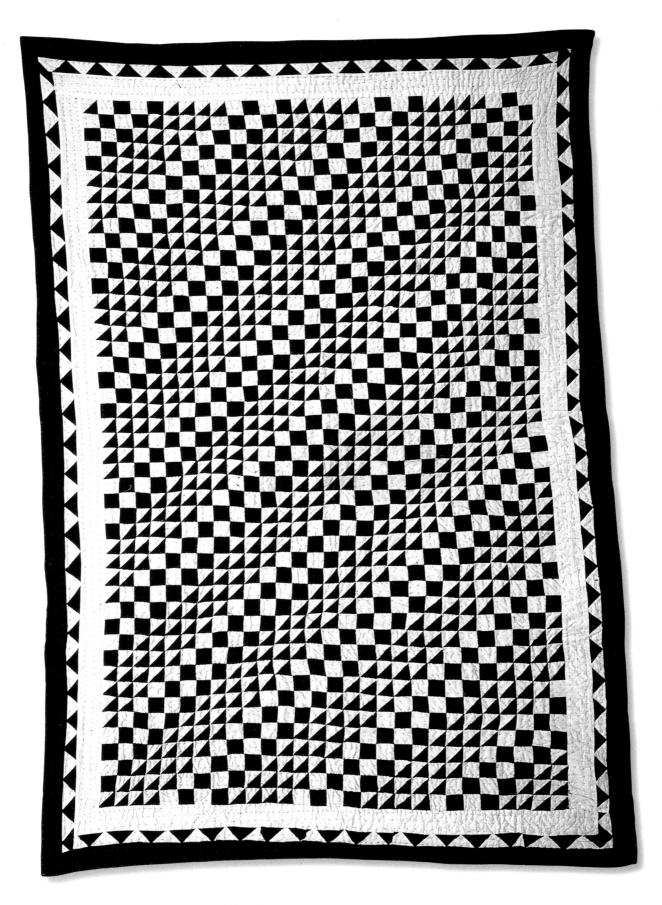

Using the same pattern as the previous ralli, this quilt is made in black and white with a red back.
The ralli is from Jacobabad, upper Sindh, late twentieth century, 82.5" x 54", all cotton.

Eight triangles in a square pattern are square blocks formed by placing eight triangles with the tip from the long edge in the middle. Alternating triangles are colored in a contrasting color, forming a pinwheel pattern. The bowl from Pirak, shows the triangles and squares with dots patterns, both on rallis. The ralli is made in the pinwheel design with a design of squares highlighted through the use of white instead of black as the contrasting color.

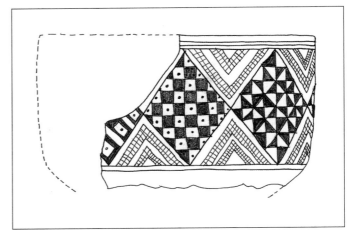

The eight triangle pinwheel and squares pattern bowl is from Pirak, Period II (after Enault, fig. 49).

This ralli from Thatta, made for sale in synthetic fabric, shows the squares and dots pattern.

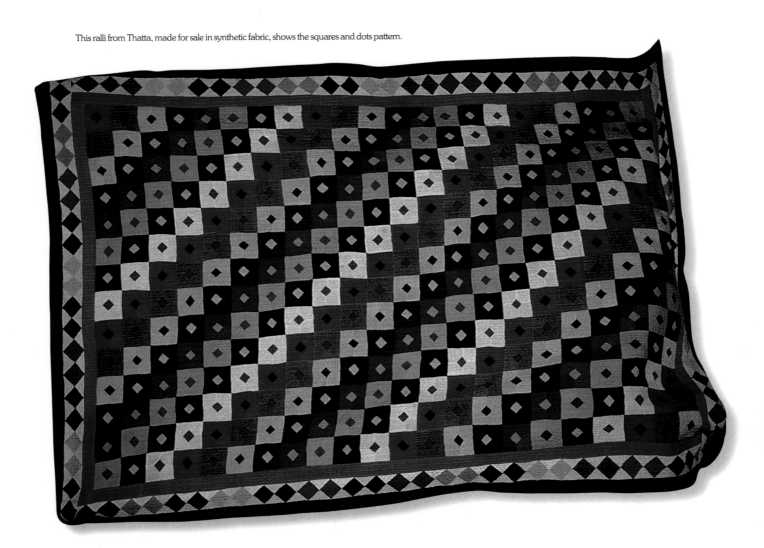

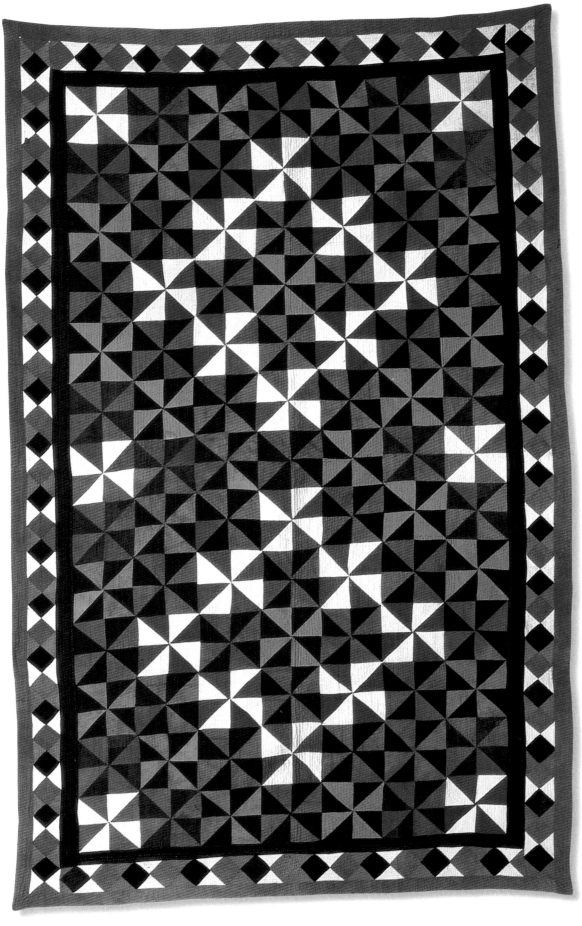

The eight triangle pinwheel pattern is popular for rallis, especially in lower Sindh. This one is unusual in that the red and white blocks have been placed to make a pattern of two squares and accents. This quilt is from lower or middle Sindh, late twentieth century, 87" x 52", all cotton.

Two triangles with apexes touching are often used in the design of pottery and quilts. There are many pottery examples, especially with these triangles used in borders. The painted pot is from Mehrgarh. This design is found later in Harappa and at Lothal.[79] The ralli uses the pattern of two triangles in varying colors throughout the field of the quilt.

The pot with two triangles with apexes touching is from Mehrgarh, Period IV/V (after C. Jarrige et al., 443).

This ralli with 1,344 triangles is made with muted colors. It is a lightweight ralli with a dark green back. The quilt is from lower or middle Sindh, mid- to late twentieth century, 78" x 50.5", all cotton.

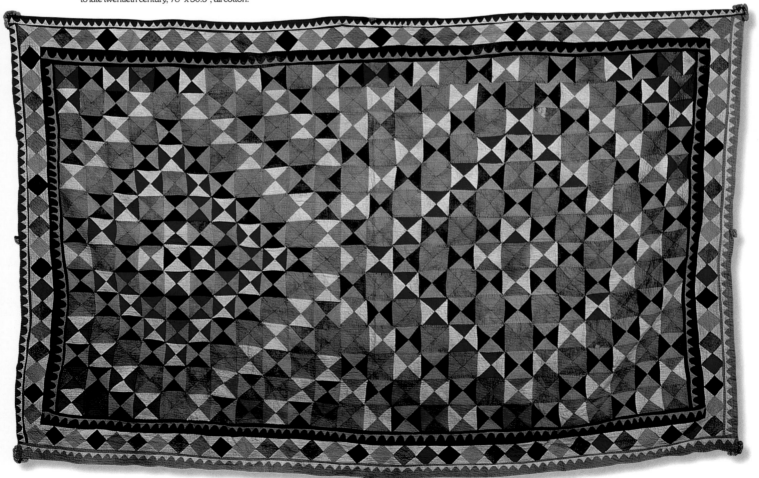

140

A variation on the two triangles motif adds two more triangles to the top and bottom. The pottery is from Pirak. The ralli has used triangles in both the field and the borders.

This pottery is from Pirak, Period IA (after Enault, fig. 39).

This ralli design has sixteen triangles in two contrasting colors forming one block. Ninety-six blocks make up the center field. The quilt is from lower or middle Sindh, late twentieth century, 76" x 54", all cotton.

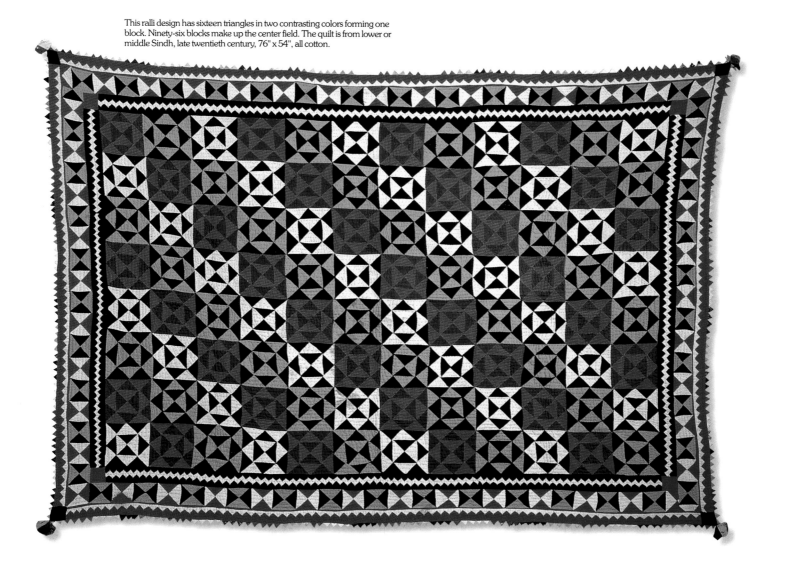

141

An **eight-pointed star** is formed from eight triangles placed around a square. Though not a common design in the Indus region pottery, it is now seen in ralli quilts in several variations. From the late fourth and third millennium BC, in several sites in Turkmenistan, there are examples of eight-pointed stars. This motif is still seen in the tribal rugs of Iran, Turkey, and Central Asia. In the Indus region and West Asia, the symbols of stars and solar objects were depicted as rayed circles or six- or eight-pointed stars.[80] In Suf and Khaarek embroidery, this motif is known as chaki or guli, both meaning flower or "design."[81] The pot is from Mehrgarh. The ralli shows clearly the star pattern.

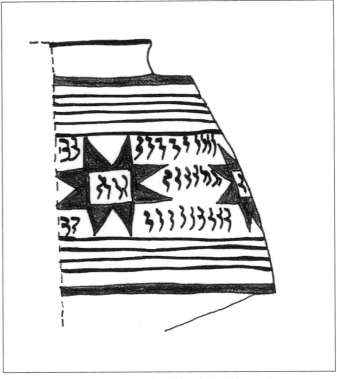

This ralli has twenty-four blocks of the eight-pointed star pattern. On the back is a commercially printed salmon and white floral pattern. The quilter is Haleema from Phuleli village in middle Sindh, c. 1995, 84" x 60", all cotton.

This pottery with the eight-pointed star is from Mehrgarh, Faiz Mohammad gray ware from Period VI (after C. Jarrige et al., 124).

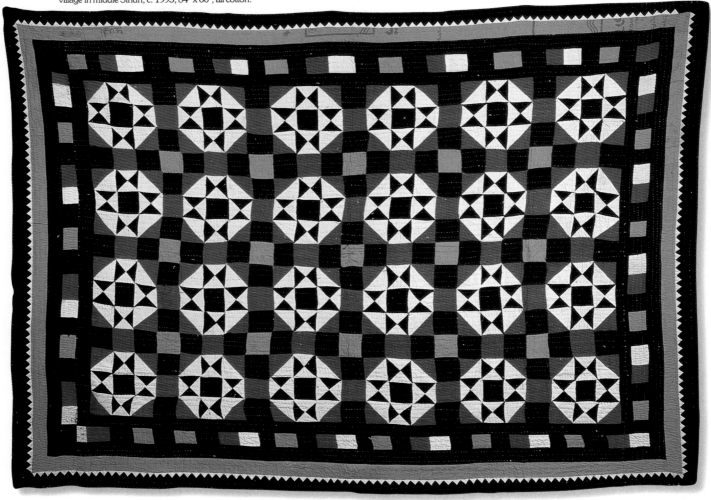

Chevrons are seen as rows of V-shaped motifs common on pottery as well as on rallis. They are used both as a pattern and as a border. The pottery pictured is from Pirak. The ralli detail shows chevrons used in both a border design and in the block design. The block uses nine small squares with four chevrons pointing to the middle.

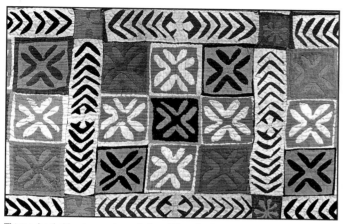

This is a detail of the chevron shapes in the ralli from the Punjab.

This pottery is from Pirak, Period II (after Enault, fig. 47).

This ralli has fifteen nine-patch blocks. There are chevrons in the nine-patch block as well as in the borders surrounding the block. The ralli has softer colors than normally seen in the south with beige backing. This quilt is from Rahimyar Khan, Punjab, late twentieth century, 69.5" x 48.5", all cotton.

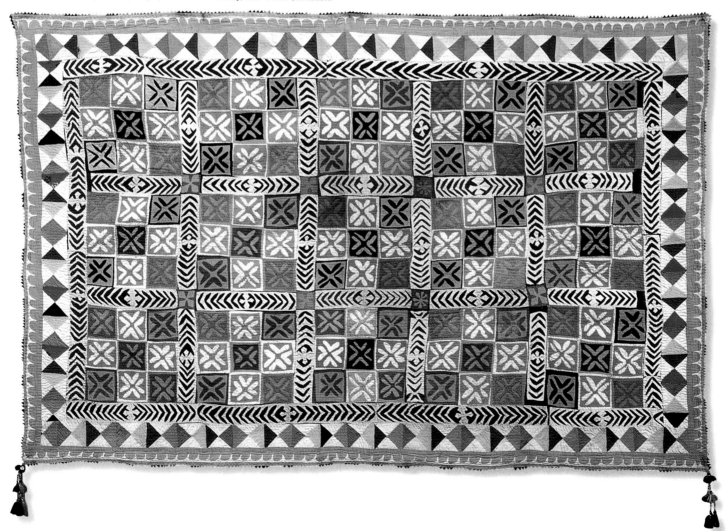

Circles

Groups of circles, though not common, do appear in Indus Valley artifacts. An ivory button seal from Mehrgarh shows a grouping of eight small circles. The seal from Harappa has nine small circles, as does the quilt block. The ralli has six large blocks containing nine circles each. Small terracotta seals also have designs similar to the appliquéd circles of the ralli. Two seals are from Mehrgarh, and two are from Pirak.

This seal with nine small circles is from Harappa (after Vats, Vol. II, Plate XCV). An earlier ivory button seal from Mehrgarh, periods V/VI was similar with eight small circles (C. Jarrige et al., 495).

Small terracotta seals from Mehrgarh, Period VIIA (after C. Jarrige et al., 404), have a circular design.

These two small terracotta seals from Pirak, Period IB (after Enault, fig. 97), have similarities to the appliquéd ralli circle designs.

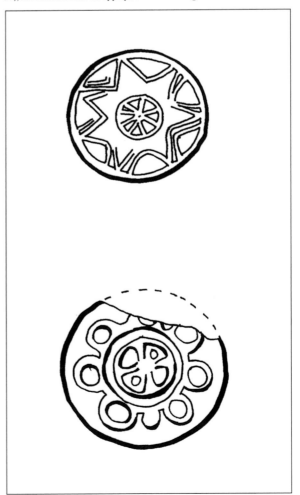

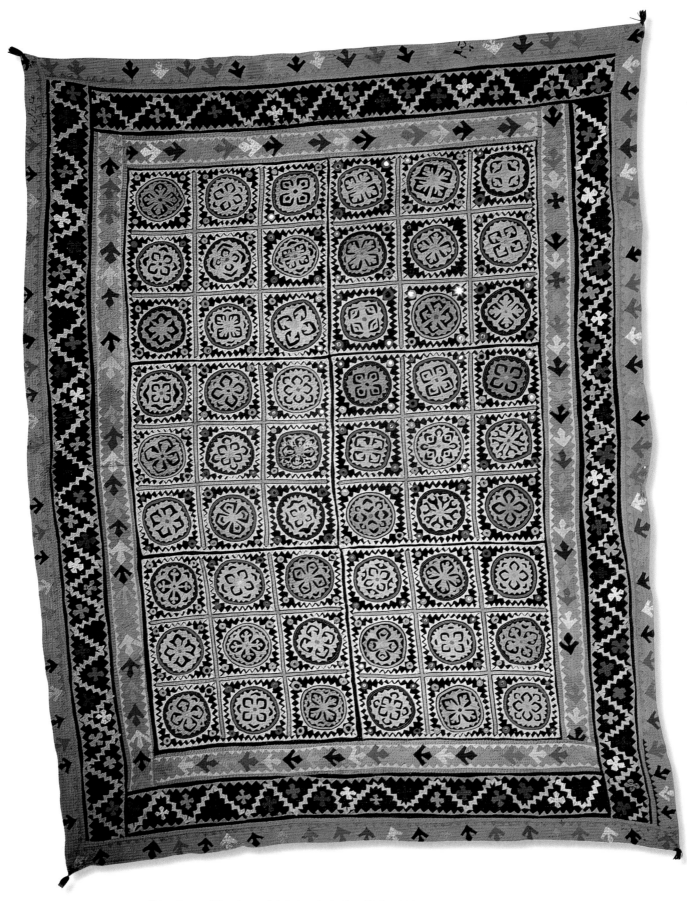

This well-worn ralli has nine small circles in each of six large blocks with fifty-four total circles. (Other rallis have a similar pattern with a fewer number of circles, for example, six or more.) Ajrak is on the back. The ralli is from Thatta, lower Sindh, mid-twentieth century, 86" x 64", all cotton.

The interlocking circle pattern, based on a grid of squares, is a common motif in Indus Valley pottery. The intersecting circle pattern can also be found on many relics of painted pottery from the Indus region including Mohenjo-daro, Amri and Chanhudaro, Lothal, and a site in Afghanistan. The pattern on pottery disappeared with the city life of the Indus area about 1500 BC. However, from the second millennium BC at Jhukar, west of the Indus in Pakistan, incised pottery was found with a four-petal design, a variation of the intersecting circle pattern.[82] The design shown, found on a shallow bowl from Kot Diji, is very similar to a motif found in the borders of ralli quilts.

The detail of a ralli described by the quilter as an "old pattern" shows the interlocking circle pattern including the small dots in the middle of the circles. It also shows the row of triangles used with the circle pattern as seen in the pottery. A detail of a common red and white appliqué border appears to be a simplification of the interlocking circle pattern. Note the sequins where the dots originally were.

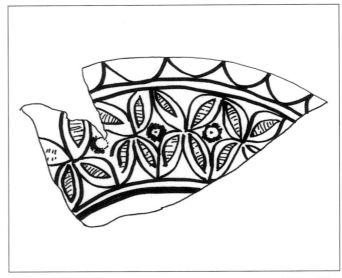

This design is on a shallow bowl from Kot Diji (after *Pakistan Archaeology*, No. 5, 1968, Plate, XV).

This well-worn and patched ralli is described by the originating community as an "old pattern." It has six large blocks with circles called breadbaskets. The border on the blocks is similar to the Kot Diji pottery. The ralli is from the Meghwar in Mirpur Khas, middle Sindh, mid-twentieth century, 81.5" x 57", all cotton.

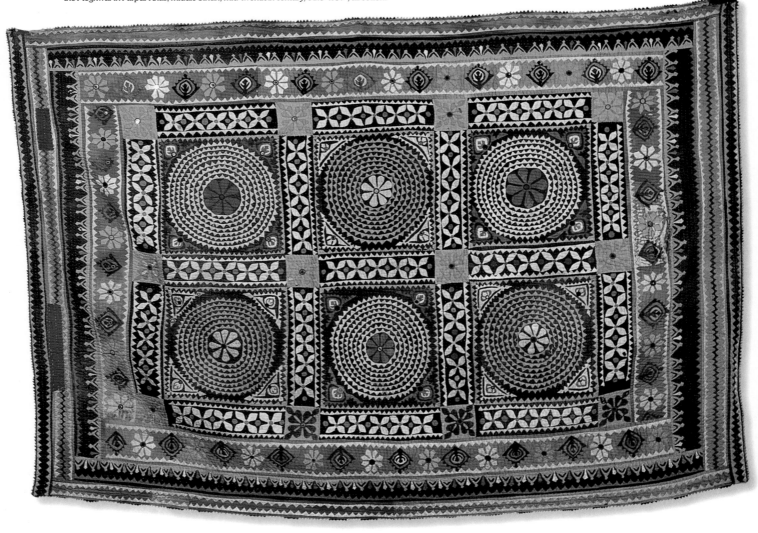

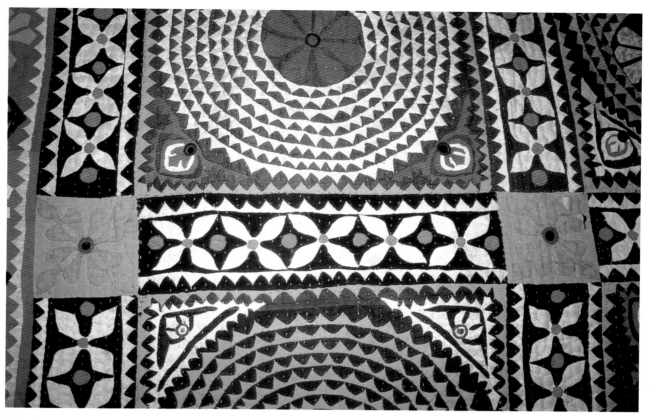

The border on this ralli is similar to the old pottery design including the small dots in the middle of the circles.

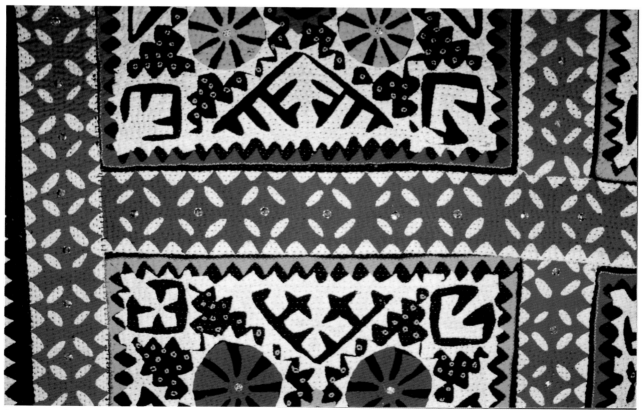

A very common border, called simply "putti" or border, is similar to the interlocking circle design. It is customarily made in red fabric over a white background, sometimes with sequins or other embellishments added.

Small stars or flowers placed on a plain background without blocks or borders are found on both the pottery and quilts. This pottery is a burial jar from Harappa, Cemetery H. This ralli shows five large appliqué circles and numerous other smaller shapes, all sewn on an open field.

This is a burial jar from Harappa, Cemetery H (after Vats, Vol. II, Plate LXIV).

This ralli has a pattern of a full sheet of fabric on the center field with five large appliqué circles and numerous smaller shapes as the design. The quilt is attributed to the Jogi community of lower Sindh, mid- to late twentieth century, 78" x 53", all cotton. The garoon color scheme is typically Jogi.

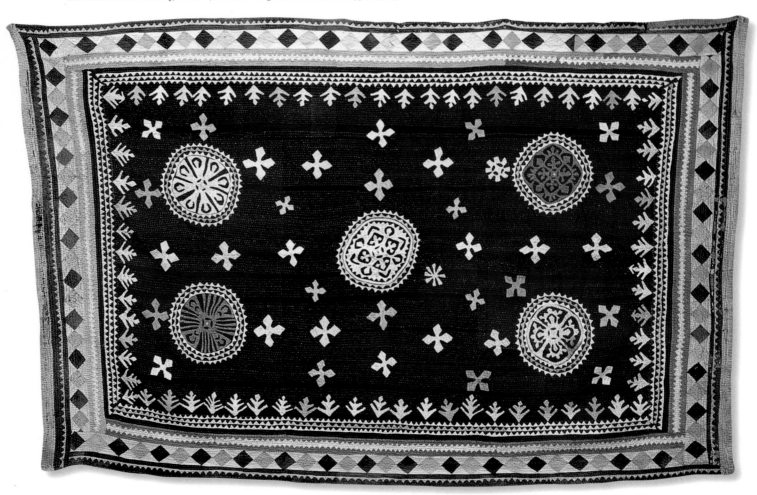

148

Stepped Squares

The stepped square pattern is interesting due to the widespread nature of the pattern and its many variations. The pattern is characterized by square or triangle, diamond or half-diamond shapes filled or outlined with various straight lines and zigzag or stepped edges. (The diamond shape is called a lozenge and may have serrated sides.) The stepped square was first noted on Nal pottery and was a very common motif on Quetta Ware. The Quetta designs are more angular than the Nal and include the stepped cross (probably originating in Central Asia) as an important motif. Versions of the wheel thrown buff Quetta Ware and the stepped square can be seen in ceramics from neighboring Mehrgarh, Mundigak, Said Qala, and Damb Sadaat. Similar motifs painted in several colors are seen in Central Asia.[83] The stepped square was used in the Geoksyur culture of southern Turkmenistan in the second half of the fourth millennium BC, Iran in the late fourth to third millennium BC, Seistan in Iran, and western Afghanistan. Lozenge designs in different combinations are used widely in the bridal durries of India plus in the flat woven rugs (kilim in Turkey or gelim in Iran) as well as in pile carpets from several areas.[84]

This pattern most frequently appears in rallis as a triangle shape with line outlines or zigzag edges. The stepped triangle is very common in appliqued rallies, particularly in borders. Sometimes they are placed together to form a square shape. The triangles are also common as an addition to the corner of a block to complete a design. Some of the ancient pottery examples have a lozenge enclosed in the lattice pattern. That is frequently the pattern seen on the rallis. Cholistan has a unique tradition of lozenges with thin multilinear outlines. These are similar to some of the early designs from Baluchistan. These designs may enclose a cross design also.[85]

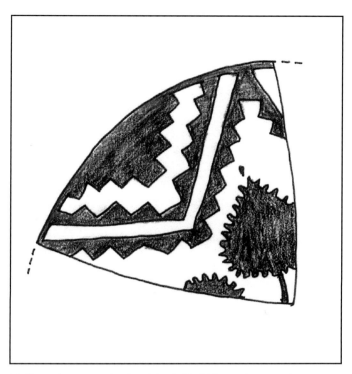

A half stepped square is on the edge of a bowl of Faiz Mohammad gray ware from Mehrgarh, Period VIIA (after C. Jarrige et al., 442).

This painted pottery with a stepped square motif is from Mundigak, Afghanistan, third millennium BC (after Fairservis, Fig. 38, No. 53).

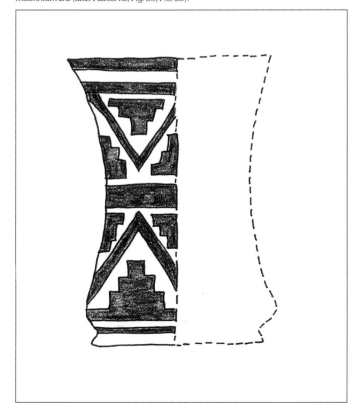

Fragments of painted buff ware from Mehrgarh, Period VI, include a stepped square shape (after C. Jarrige et al., 154).

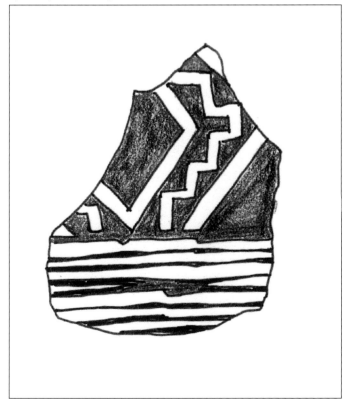

This pot from Rehman Dheri has a stepped square motif (after Durrani, 130).

This border is a row of single stepped triangles with additional motifs.

In this border, two triangles are placed together to form a lozenge shape. The resulting triangle shape at the edge is also a stepped triangle.

What do these ancient painted bowls tell us?

A number of painted shallow bowls were discovered in Mehrgarh and other sites. The Mehrgarh bowls are in the Faiz Mohammad gray ware style from Period VI or Period VIIA (c. 3200-2500 BC). (Period VII marks the end of Mehrgarh's existence.) This time period corresponds with the Early Dynastic Period in Egypt.

Interestingly, all the bowls have a geometric basis to their pattern. By identifying the pattern of the "block," perhaps distorted by trying to fit a square onto a round bowl, a motif can be identified. These block motifs are similar to the blocks found in modern ralli quilts. Could the pottery painters be using patterns also used on the textiles of the time? These six bowls illustrate a format for the composition that is found on the rallis today. The basic elements are: the pattern is enclosed within a square shape that resembles a quilt block; each square is bordered; patterns are repeated for the design; and there is an outside border. Most have lines or zigzags.

The first bowl has a particularly intriguing design. The four blocks with circles are similar to ralli designs as well as the motif in the center of the circle. The blocks are bordered with several rows of triangles. There are an irregular number of rows on all sides, a feature also seen on the quilts. The design is very similar to the bowl from Damb Sadaat (3200-2600 BC), a site in the Quetta Valley. It has four blocks with the stepped cross or square design. The blocks are separated by two lines creating a square at the intersection, a pattern already shown to be used in rallis. Again, there are zigzag lines used as a border. (see page 154)

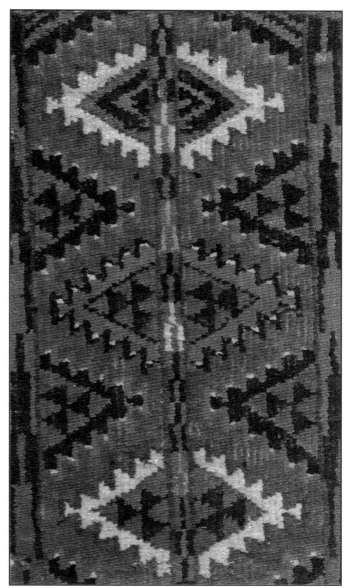

This detail of a border on a Central Asian carpet from the early twentieth century shows two variations of stepped squares halved into triangles. The pattern used predominately in the border shows the stepped square with stacks of small black triangles. The other stepped square has straight lines in the center of the triangle.

Stepped triangles are commonly used to fill in the corner space when a square is placed on end within another square. In this motif, four stepped triangles are used in the corners of the center square. An additional four triangles are added to the outside of the square for more ornamentation.

151

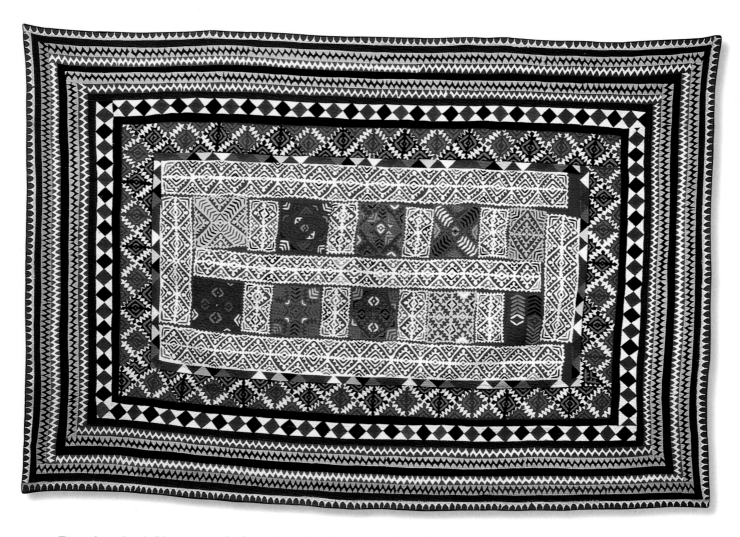

This very fine appliquéd ralli has many examples of stepped squares halved into triangles. In the wider border going around the center field of the quilt, a lozenge shape is made of two triangles with triangular shapes on each edge. The white appliqué border is also composed of lozenges and triangles. This ralli is attributed to a Sayyed family of Sindh, c. 1960, 92" x 65.5", all cotton.

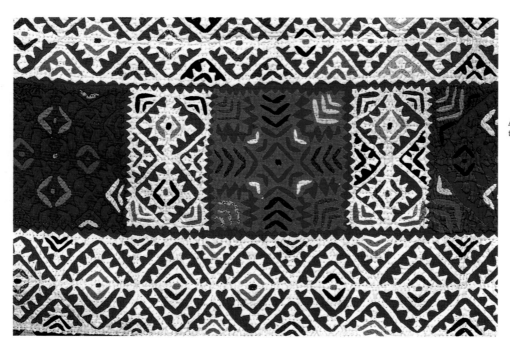

A closer look at the stepped triangles in the Sayyed ralli.

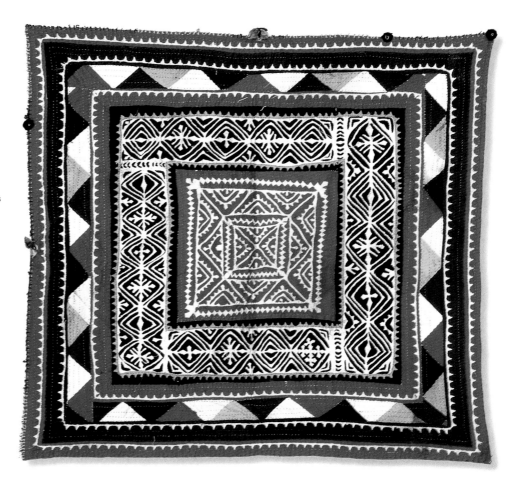

This is an opened bag with two types of stepped squares and triangles in the center field and outer border. Two multi-linear triangles without stepped edges are placed together to form a square or lozenge shape on the border. In the center appliqué block, there are sixteen stepped triangle shapes. The bag is probably from Cholistan, late twentieth century, 26.5" x 26", all cotton.

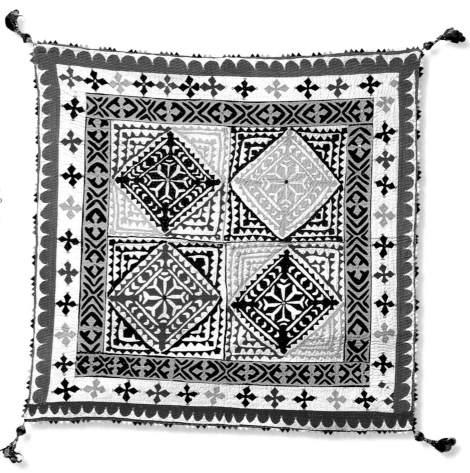

This is probably a baby blanket due to its size and colors. (Rallis for young children usually have brighter colors and generally do not use black.) Intricate stepped triangles are in the four corners of each of the four blocks. This was a special quilt judging by the workmanship, sawtooth edge made of folded fabric and tassels. The quilt is probably from lower Sindh, mid- to late twentieth century, 33.5" x 33", all cotton.

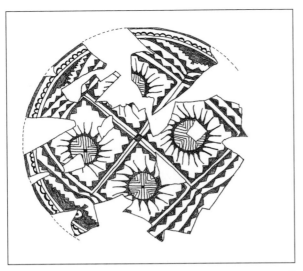

Mehrgarh bowl, Faiz Mohammad gray ware, Period VI (after C. Jarrige et al., 160).

Mehrgarh bowl motif.

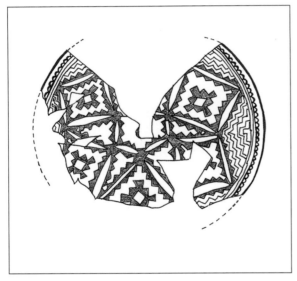

Mehrgarh bowl, Faiz Mohammad gray ware, Period VI (after C. Jarrige et al., 160)

Mehrgarh bowl motif.

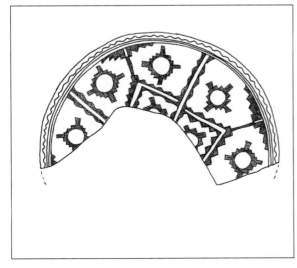

Mehrgarh bowl, Faiz Mohammad gray ware, Period VIIA (after C. Jarrige et al., 442).

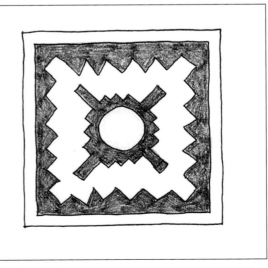

Mehrgarh bowl motif.

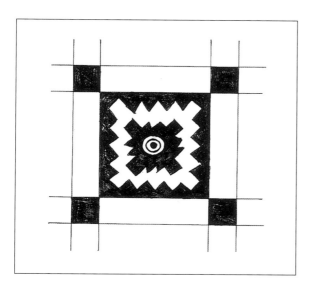

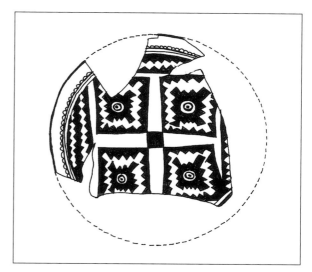

Quetta Valley bowl, Damb Sadaat Phase (After Fairservis, 1956).

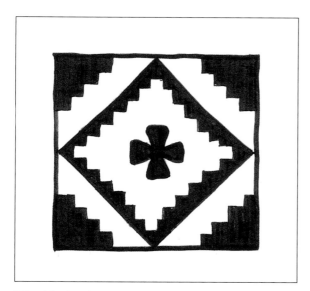

Mehrgarh bowl motif.

Mehrgarh bowl, Faiz Mohammad gray ware, Period VI (after C. Jarrige et al., 124).

Mehrgarh bowl, Faiz Mohammad gray ware, Period VIIA (after C. Jarrige et al., 442).

Mehrgarh bowl motif.

Tribal Tombs of Sindh and Baluchistan

What may be the most visible historic record of geometric patterns used for ralli quilts is found in an unusual place—graveyards. In the deserts of Sindh and Baluchistan are graveyards of stone multi-layered tombs. The largest of these is Chaukhundi Tombs, seventeen miles east of Karachi with hundreds of yellow sandstone rectangular tombs carved with three-dimensional geometric designs. There are more than one hundred sites in Sindh and Baluchistan with over 30,000 graves built by numerous tribal communities, mostly Baluch, between 1468-1843 AD. It is not clear what caused the migration of tribes into the Sindh region. It could have been feuds, the search for new grazing grounds or perhaps a drought in Baluchistan. As was the custom, the tribe migrated with women, children, and flocks. They brought with them a new method of burial, above the ground and away from villages on raised ground or a hill. Tradition says that the tombs were built on migration routes, by temporary tribal settlements or on sites of ancient battles.[86]

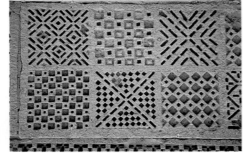

A close up view of six blocks from the side of a Chaukhundi tomb. Each block shows a pattern still used on the ralli quilts.

As with so many of the old crafts and traditions, the tribesmen living now and their folklore offer no explanations of the tombs or their decorations. Interestingly, during the time the tombs were being made and used, almost no mention was made in historical records about the tombs. The tombs themselves give some identification of the makers with carvings and inscriptions of their tribe and culture. The tombs give a picture of the things and symbols that were important to the nomadic tribesmen. The Baluch had been converted to Islam and were therefore forbidden to have aboveground burials and also to depict the image of living beings. However, as illustrated by the carvings of warriors, hunters, horses, camels, and grooms, many of the Baluch retained their pre-Islamic culture and traditions through the time of their tomb building. Images on the tombs include other animals – such as bullocks, deer, birds, goats, fish, and peacocks – and action scenes including hunting animals chasing game and eagles carrying away snakes. The human figures are warriors riding horses, sometimes followed by foot soldiers, armed with swords, and spears, and numerous other weapons. Women's graves have images of jewelry including necklaces, bracelets, rings, earrings, nose pins, and foot jewelry. The jewelry in the same design is worn in Sindh and Baluchistan today, illustrating the endurance of traditional designs among the women of the rural areas.[87] The love of the "hunt" that was illustrated on the men's graves is still seen today. On the hilly roads in Baluchistan, it is said that a Baluch carrying his gun and riding his favorite mare, proceeded by lean hunting greyhounds wearing quilted patchwork coats, can be seen.[88]

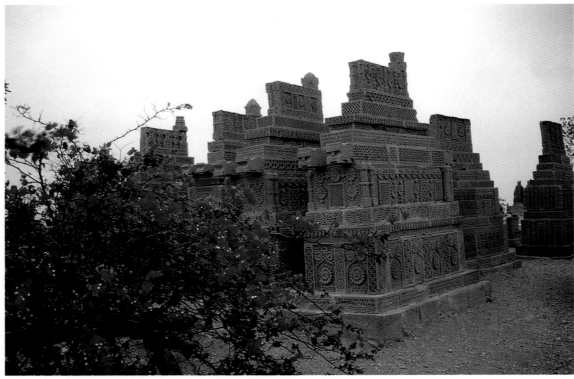

This is a section from the tribal graveyard at Chaukhundi, east of Karachi, where hundreds of carved sandstone tombs survive in the desert.

There is a progression in the appearance and artistic style of the tombs over time. Early graves were crude, low-lying structures with little decoration. Over time, more steps or slabs were added, decorations were added to the whole surface, and the carving became denser and deeper. As the tombs continued, the number of steps rose to four and the width of the steps changed. Geometric patterns became increasingly distinctive as carvers started carving in two and then three depths. With the exception of the depictions of people and objects, arches, chain designs, and screens of punctured stone, most of the tomb designs can be found on the rallis. Most of the geometric patterns could easily be woven in fabric or could have been made by a patchwork method. The idea of bordering a design with a smaller geometric design is seen on the tombs.[89] This framing technique is found in most rallis.

At some point, the structure of the tombs was no longer modified and carvers turned to embellishing the panels. One design that emerged divided each panel into many smaller squares, each carved with a different design. Two later developments, a running broken line (tracery fret) that looks like a sewing stitch and decorative dots between shapes, are reminiscent of textiles and sewing.[90] Specific embroidery stitches, such as interlacing, satin, herringbone, chain, couching, buttonhole, feather stitch, and zigzag are carved in the stone panels. The carvings of horses showing intricate patterned saddle blankets edged with numerous tassels illustrate that patterned textiles were used at the time.[91]

The majority of the surfaces of the tombs are covered by a vast variety of geometric patterns. The patterns carved in the tombs include the same ones found on the prehistoric pottery: grids including checkerboards and triangles, intersecting circles, eight-pointed stars, crosses, zigzags, and lozenges. The geometric patterns are used on textiles including rallis, geometric woven rugs, jewelry, pottery, and woodcarvings in Sindh and Baluchistan.[92] The masons carved in three dimensions, and even showed actual stitches to create the illusions of textile texture. This could be a unique record of textile designs used by the tribal people of Sindh and Baluchistan during that four hundred year period.

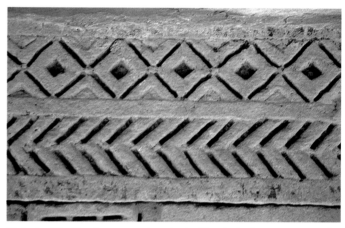

The tombs at Chaukhundi use many carvings as borders. These two borders are common on ralli quilts.

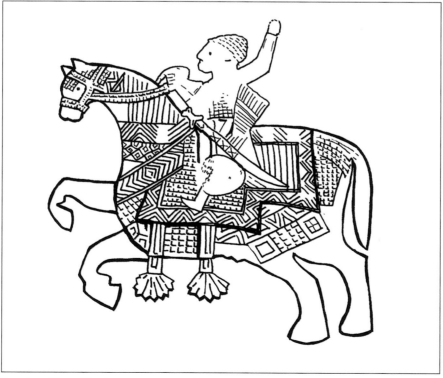

A panel from Mirpur Sakro depicting a warrior on his horse. The large saddle blanket clearly shows many geometric designs used in panels and borders, including chevrons and triangles (after Bunting, 42).

Shared Designs: Pottery, Embroidery, Rallis and Tombs

Strikingly similar to the carvings on the tribal tombs found through the deserts of Sindh and Baluchistan are the geometric designs from Pirak. The compositions from Pirak favor geometric designs; an area where the Pirak artisans excelled. They very carefully and clearly painted exacting geometric designs. One area they paid particular attention to is bordering of the designs. They carefully bordered each block and put multiple borders on the edges. One arrangement seen in several pots from Pirak is a composition of blocks where each block has a different geometric design. Some of the finer ralli quilts have this same composition of equal sized blocks done in different patterns and colors on the same quilt. Some have suggested that the development of similar geometric designs among distant cultures show that they were either shared or they evolved independently.[93] The geometrics from Pirak, however, may warrant special attention as the fine details in the designs are so close to the motifs seen in the fine patchwork rallis today.

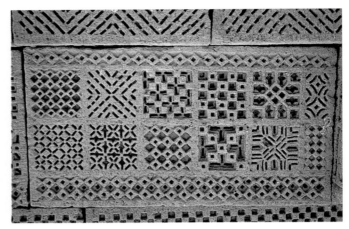

An example of many different geometric designs on a tomb at Chaukhundi.

A segment of a design from a Pirak pot, Period II. The design wraps around the original pot with a variety of "blocks." This segment shows an example of each design (after Enault, fig.55).

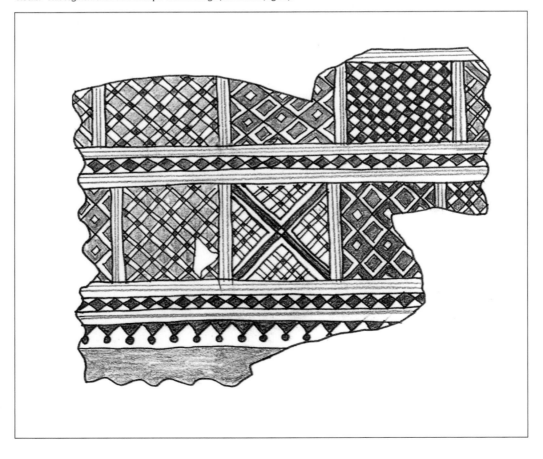

An interesting similarity is found with the embroidery patterns of Baluchistan and the patterns of the rallis, tombs, and ancient pottery. The Baluch women are known for their superior embroidery. It is reported that Sir George Watt in 1903 said that the embroidery of Baluchistan "stands by itself as one of the most strikingly peculiar and beautiful forms of needlework in India."[94] Some of the finest examples of Baluch embroidery are small bags, formed from squares of fabric where three corners are folded to the center and then sewn to form a pocket. Many bags have a similar composition. They are made in a square shape with outside borders and the center field is divided into four quadrants. The borders have multiple rows of decorative stitching. A common style of border is a thin row of plain stitching, next a patterned row of dark and light, completed by another row of plain stitching. This is commonly seen in the pottery of Pirak as well as on the rallis.

One bag pictured has sixteen small squares of geometric designs. The motifs are: checkerboard patterns, zigzag patterns, rows of crosses, rows of triangles, and borders of squares that are seen in quilts, tombs, and pottery as well. A particularly interesting detail is seen in the two bags without mirrors. In the borders are small lozenge shapes with stepped edges. Close examination shows that they are embroidered with spaces between the stitches indicating the lines in the stepped square pattern. All these geometric patterns are seen on the pottery, rallies, and tombs as well in the embroidery.

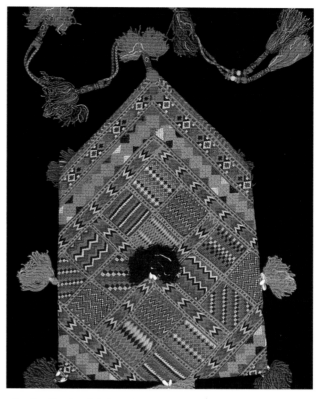

This embroidered bag from Baluchistan has a clear variety of designs including checkerboard designs, zigzag designs, chevrons, and other geometric designs throughout the bag. It is from Baluchistan, mid-twentieth century, 12" x 7.5", cotton and silk.

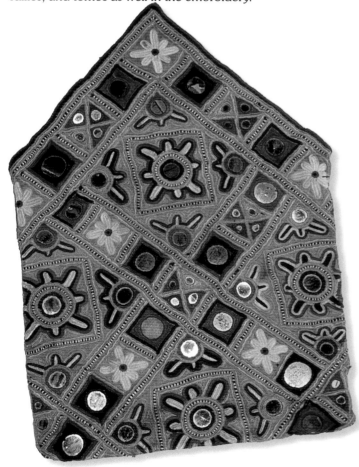

This is a Baluch bag from Kohistan embroidered in yellow with a variety of shapes fit into square blocks. The bag is mid-twentieth century, 15" x 10", cotton and silk.

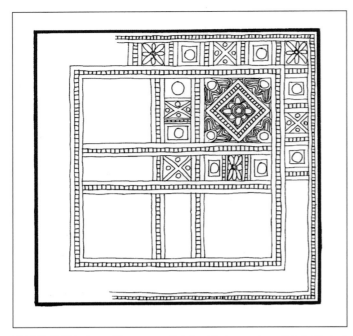

This is the Kohistan bag as if it were opened into its original square shape. Note the blocks of different designs separated by lines of borders.

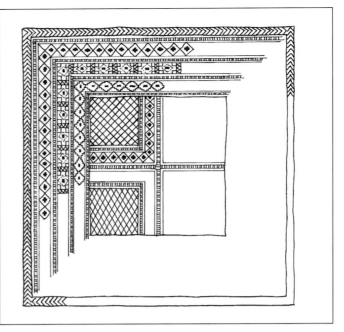

This is a drawing of the Baluch bag as if it were opened to a square shape. The borders include a clear stepped triangle design.

This Quran bag is made by the Baluch in Baluchistan. It is mid-twentieth century, 11.5" x 7", cotton and silk.

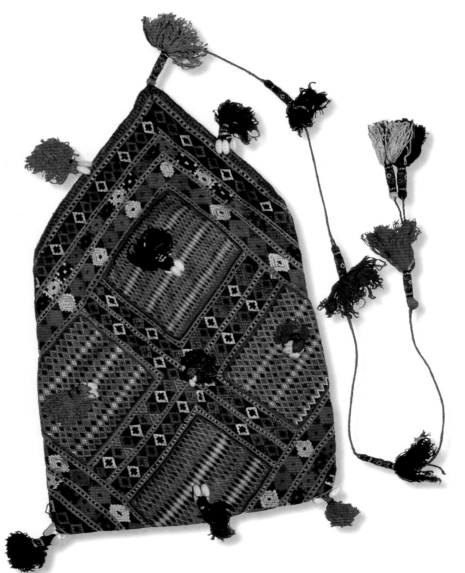

These similarities in motifs in different mediums and times beg us to ask further questions. Is there a common factor spanning over six thousand years and various kinds of art forms? The common factor might be found in the people who made them. In the plains of Baluchistan, two ancient cities, Mehrgarh and Pirak, excelled in geometric representations on pottery and other artifacts. Baluchistan was the settling place of the Baluch tribe when they came into the region. Perhaps they saw and learned the patterns from the indigenous people, the Jats, Meds or Afghans. Later, tombs were built by the Baluch in hundreds of desert sites in Sindh and Baluchistan. They carved on the sides of the tombs the same patterns as the ancient pottery. Today, intricate embroidery in the same geometric patterns is done by the Baluch in Baluchistan. Rallis are made by a variety of people, including the Baluch. Perhaps credit is due to the Baluch for helping to preserve traditional geometric patterns first seen in ancient civilizations.

This is a modern camel from the Puskhar Fair in Rajasthan. The fur has been clipped to form various designs on the body and up the neck (after Nath and Wacziarg, 26-27).

This painted pottery camel from Pirak, Period II, shows different designs on his body and neck. Could this be a representation of the tradition of camel decoration (after Enault, fig. 94)? Two ways used today to beautify camels are to clip the fur or to use a textile cover.

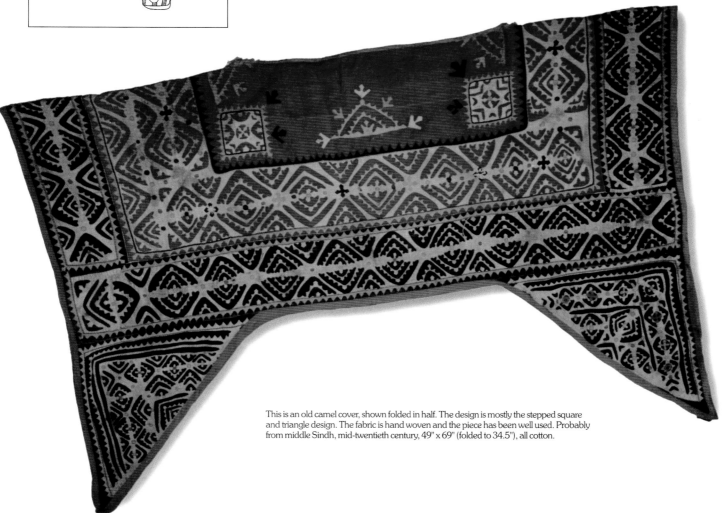

This is an old camel cover, shown folded in half. The design is mostly the stepped square and triangle design. The fabric is hand woven and the piece has been well used. Probably from middle Sindh, mid-twentieth century, 49" x 69" (folded to 34.5"), all cotton.

Age of Ralli and Other Textile Traditions

The age of the ralli tradition cannot be definitely stated given the evidence that is now known. However, there are some records and speculation can be made from the available facts. Starting from the most recent records, the Sindhi poet, Shah Abdul Latif, mentions ralli (calling it gindi) in his mystical poem about Jogis.[95] He lived in the first half of the eighteenth century. Covering the same time period is the record of textile patterns on the tribal tombs of Sindh and Baluchistan covering the 400 years starting from the mid-1400s. The symbols that were incorporated on the tombs were parts of tribal life, warriors, jewelry, and animals. The geometric carvings were so developed compared to the figures that were carved, it stands to reason that the masons had geometric models to follow in their carving, perhaps in rallis or other textiles. Many tombs had large spaces covered with geometric designs that could also be inspired from the look of a charpoy covered with a quilt, as it is used today. The depiction of geometrically patterned textiles in saddle blankets carved on the horses on the tombs is strong evidence that decorative textile were developed at the time of the tomb building.

Traders, starting in the sixteenth century, who traveled to the Indian subcontinent documented many fine fabrics and crafts they found in the area. Quilts from the region were a very popular export item to England and Europe starting in the early sixteenth century. This is evidence that both the materials and the skill were available for making quilts.[96] Looking back from that time is over a thousand years with few records related to rallis except for the continuing references to the fine cloth produced in the Indian subcontinent, particularly the cottons. There is a reference to bandhani fabric, often used on rallis, from the writings of the life of King Harsha, who lived from 606-648 AD.[97]

At Mohenjo-daro, the materials – specifically the fabric, dyes, and needles – for rallis were found. Woven textiles were made at the time of Mohenjo-daro and it can be inferred that the craft was at an advanced stage. In fact, the majority of the remains of the civilizations of Mohenjo-daro and Harappa are relatively undecorated (particularly, the house walls were unpainted), indicating the people had their focus on "things beyond this world" or else they used something perishable such as textiles to decorate their buildings.[98] Evidence of cotton was found at Mehrgarh, two thousand years before Mohenjo-daro. Dozens of pottery designs from that city are also found on rallis. After the demise of Mehrgarh and the complete infusion and demise of the culture of the Indus Valley Civilization came, in the same region, the agricultural settlement of Pirak. The pottery of Pirak returned to many of the traditional designs of Mehrgarh. What kept those patterns alive after about a thousand years? Perhaps textiles were decorated with the ancient patterns and thus became a transmitter of cultural motifs.

There is evidence that a number of traditions in the Indian subcontinent have endured from very early times. A famous bronze statute of a dancing girl from Mohenjo-daro has bangles up her arm from wrist to shoulder. Excavations at Harappa have uncovered many kinds of bangles, made of shell, faience, terracotta, and stoneware. Figurines and burials of women show bangles were worn on both arms with three or four at the wrist and two or more above the elbow. White bangles were found in graves as early as 6500 BC.[99] The wearing of white bangles up the arms continues today among the women of rural Sindh, the Thar Desert, Gujarat, and Rajasthan. It appears that this is a tradition that has remained, with little change, for over 8,000 years! This is evidence that other traditions could have been carried on from ancient times as well.

Some other striking examples of long standing traditions are still seen. Carved drawings of carts and boats from the Indus Civilization's time show them to be very similar to the styles of transportation used today.[100] The techniques used in several kinds of crafts, including pottery, glazemaking, bead making, bronze working, and bone carving, appear, from archaeological findings, to be very similar to the processes used today.[101] Mohenjo-daro had a highly developed drainage system, including manholes, from household baths and privies. The exact drainage system is still used in many towns of Pakistan and north India today.[102] In addition, a site from the fourth millennium near Bannu found that the huts that were excavated were amazingly similar to the modern huts still used by the local people.[103] The rammed earth houses in Rajasthan are also very similar to the ones from the Indus Valley Civilization as well as the local pottery and terracotta sculpture.[104] In Mehrgarh, some graves were found with the bodies covered with red ochre. This tradition is still found among some untouchable groups in south India.[105] Like the jewelry, carts, boats, beads, drainage systems, houses, and burial practices, it is possible that the tradition of quilting and patchwork could have been present in the prehistoric Indus civilizations and continues today.

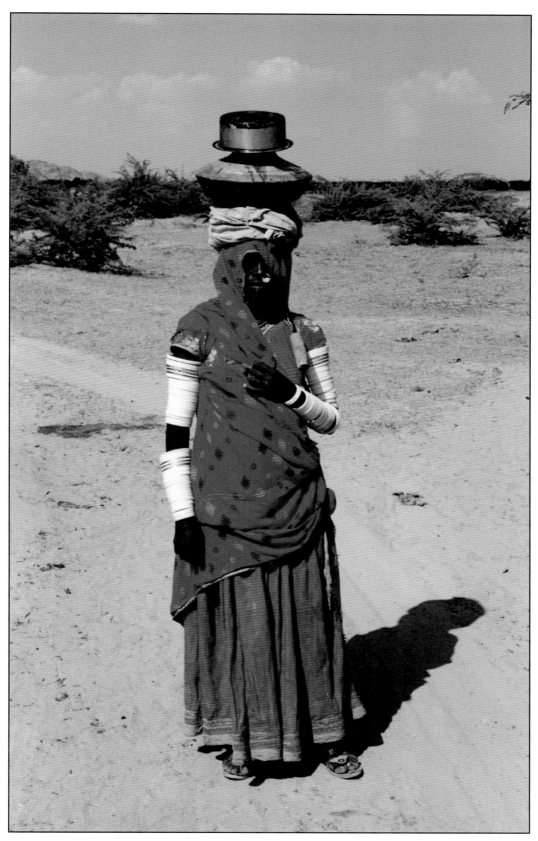

A Hindu woman of Nagar Parkar wearing very traditional white bangles up her arm. *Courtesy of Mehnaz Akber Aziz.*

In a timeless scene, a fishing boat crosses the Indus River. The models of boats found in the ancient remains are very similar to the ones used today, particularly the houseboats.

As has been shown, some of the patterns of rallis are the same patterns found on ancient prehistoric pottery. Painters of ancient pottery had freedom to use curved lines and patterns yet many chose to make geometrically based patterns. Perhaps a source of the inspiration of the painters was familiar textile patterns. Some small fingerprints have been observed on the Pirak pots, made while the paint was still wet. Some archaeologists speculate that women painted the pots with designs that look similar to their embroidery. Baluchistan District Gazetteers from the beginning of this century also mention the important role of women in local pottery production.[106] Marshall reported at the time of his excavation of Mohenjo-daro, the pottery painters in Sindh were women. The pottery being painted was positioned on a wooden pivot on a brick or stone, with a cover on top to help slow the turning of the wheel.[107] (This tradition has since changed in Pakistan but in India, women still paint pottery.) There is evidence that familiar cultural patterns are used in more than one medium. One example is the statute of the famous Priest-King of Mohenjo-daro. He wears a robe with a trefoil design. This same trefoil is found on steatite beads from Harappa.[108] Beads and fabric shared the same motif as could pottery and fabric.

The argument that certain textiles made today were also produced in prehistoric times has been made for both pile rugs and durrie rugs. As today, they were important, useful possessions of the families who produced and owned them.[109] Designs on pottery from the third millenium BC found in southern Turkmenistan are very similar to some nineteenth century pile carpets from the same area. Three designs were similar including a double-sided saw toothed lattice, a tree like figure with saw tooth branches and a variety of unusual crosses not found in other sites, even those close by. In addition, curved cutting knives (similar to those used by present day rug weavers to cut pile yarns) were found in the graves of a large number of village women from the second millennium BC.[110] Spinning wheels (indicating almost every woman spun yarn), knitting, and sewing tools were also found there.[111] Another third millennium BC example is from Bampur in Persian Baluchistan where pottery bore patterns of lozenges, usually halved, in bands. This pattern is still used in their nineteenth and twentieth century textiles.[112] Researchers have also noted that the detailed pottery motifs (particularly concentric circles) found in Halaf beginning 5000 BC signaled the beginning of Mesopotamian textile production later.[113] An example of stone carving following textiles (as the tribal tombs in Pakistan may be) is found in the palaces of

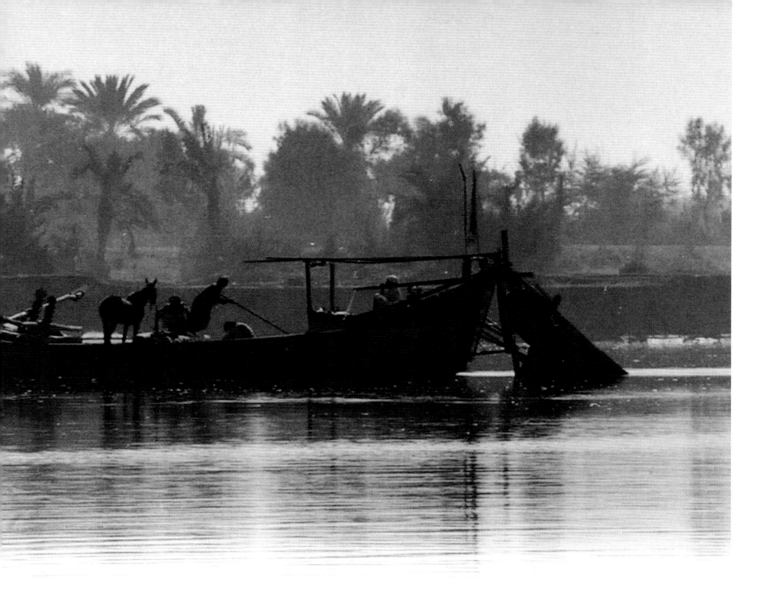

Assyria, Egypt, and Persia during the first millennium BC where thresholds between rooms were carved in carpet patterns. The rooms themselves were probably decorated with carpets and the thresholds were carved to be compatible with the rooms.[114] On the same line, researchers have noted that the designs on the modern carpets in Baluchistan are the same as the pottery.[115] Also, curved cutting knives (possibly used for carpets) have been found in ancient Indus cities.[116]

Researchers studying the woven bridal durrie rugs of northwestern India have found that the designs on the durries reflect life as it is known to the weavers in animals, flowers, boats, and even tea sets. The geometric patterns, however, use ancient symbols found on prehistoric painted pottery of the region (extending to central Asia and the Middle East.) Like rallis, durries are made by women for family use and not generally for sale. There is no written or other evidence of the age of the durrie tradition; however, the extensive use of ancient patterns indicates that durrie making is a very old practice.[117]

Finally, the linkages with the ancient geometric patterns and the Baluch tribe can be made. Baluchistan is the site of the ancient cities of Mehrgarh and Pirak. Even though the Baluch arrived in the region after the tenth century AD, there were indig-enous peoples in the area, perhaps the Jats or others, who appear to have preserved the ancient patterns, probably in textiles.[118] Later, the Baluch built hundreds of carved tribal tombs through the deserts of Sindh and Baluchistan using the same geometric motifs. The Baluch still make embroidered bags that clearly carry the geometric patterning of ancient pottery, particularly from Pirak. And finally, the Baluch living throughout the ralli region still make rallis with the traditional patterns. Through the years, the ralli patterns have been shared among the peoples in the region so that now they are a great cultural symbol for all who live there.

There is not yet certain evidence about the age of the ralli tradition in the subcontinent. However, there are strong indications that perhaps the tradition is thousands of years old, starting in prehistoric times at the time of Mehrgarh. The patterns have continued. They have been passed down from one generation to the next, mother to daughter. If these conclusions are correct, this makes rallis the oldest surviving quilting tradition in the world. In addition to the history of rallis, the beauty of the rallis themselves attest to the great creative talents of the women of the ralli. Hopefully they will continue to create these wonderful textiles and pass the tradition on to untold generations to come.

Glossary

Abochhnai – Large rectangular wedding shawl embroidered in silk or cotton by landowning and merchant castes in Thar Parkar and Kutch. Shawl has floral designs on a red, white or brown fabric.

Ajrak (or ajrakh) – Block printed cotton cloth usually dyed with indigo, red, and black. Mordants and resist techniques are used. Name comes from Arabic word for blue. Used by men as a turban or lungi and by women as a shawl in Sindh, Kutch, and western Rajasthan.

Appliqué – Textile decoration technique where a cut-out fabric shape is sewed on a background fabric.

Baluch – Large group of numerous tribes settled in Pakistan, particularly in Baluchistan and some in India.

Bandhani – Fabric decorated with a pattern of dots created from a tie and dye resist technique process.

Banjara – Group originally from northern India now living mostly in the Deccan plateau. Traditionally they were carters but are now nomads and farmers. Women make fine, intricate embroidery including quilts.

Baro – Literally field of flowers meaning the center field of a quilt.

Bast – Fiber from the stems of woody plants.

Bhagavad-Gita – Sacred Hindu book containing the teachings of Krishna.

Bhujki (bagchi in Kutch or bushkiri in Baluchistan) – Small fabric bag to store valuables made by folding in three corners from a square in Sindh.

Burqa – Cloth over garment used by some women of the region covering face, head, and body when going out in public.

Calico – Originally meaning plain cloth, now used for cotton dress fabric with repeating small designs.

Cemetery H – Large burial place from post-urban Harappan times.

Chaddar – Rectangular or square cloth used as a woman's shawl or a bedcover.

Chapatti – Round flat wheat bread, a staple of the diet in much of Pakistan.

Charpoy – Traditional low woven sleeping cot with wooden legs. Name means four legs in Urdu.

Chauhan – Group of Muslim carters, known for their beautiful rallis.

Chintz – Originally meaning spotted cloth, now used for glazed cotton with large colored floral patterns.

Chopar (or Chopad) – A game played in the region on a cross-shaped fabric with small squares. It is made with a pocket in the middle to hold the playing pieces. The name is also given to a ralli with the same shape design that can also be used as a game board.

Chundari (or chunari or chuni) – A tie-dyed woman's shawl.

Dai – Birth attendant, a position held by women in the rural communities.

Dargah – Tomb and shrine of a Muslim saint.

Dervish – Educated men from a Muslim religious order known for their devotional movements and trances.

Dhadaki (or godadi) – Name for quilts in Kutch.

Dharaniyo – Also called darnia or orchad. A rectangular quilted or embroidered cloth covering a stack of folded quilts in a home in Gujarat.

Dhoti – Four yards of thin muslin used by Hindu men to form loose trousers. Old dhotis are used in the making of kantha quilts.

Dogan – Long running stitch used for basting.

Dupatta – Women's shawl, worn on the shoulders or head with a traditional long shirt, either a kurta or kameez. The name means two parts for two widths of fabric taken to make it.

Durrie – Flat woven rug used for the floor or bed in India and Pakistan.

Faqir – Follower of a deceased holy man, often found begging at the burial place.

Faiz Mohammad gray ware – Named for the ancient site of Faiz Mohammad near Quetta, the ceramic has two firings and uses black decoration on the grey background.

Ghaghara (or gaghra or gaghro) – A full, long skirt worn by some women of Sindh and western India. A gharara is a full length divided skirt.

Ghagarpot – A traditional floral block printed shawl in red, yellow, and green, worn women of farming groups.

Ghi – Clarified butter, a staple for many of the diets in the ralli region.

Ghilim (or gelim or kilim) – Flat woven carpet from western Asia, including Iran and Turkey.

Gindi – A name for ralli used in Cholistan, Baluchistan, and by the Jogis.

Godri (or Godadi) – A quilted square and name for ralli in Gujarat.

Gothro (or kothro or kothlo in Kutch) – A quilted bag made from folding a square in half and sewing two sides together.

Gul – Meaning Flower, is a block in ralli design or motif in knotted carpet.

Hoormutch (or hormutch) – Embroidery stitch used extensively in the ralli region, made from two layers of interlaced herringbone stitch interwoven with two layers of darning stitch.

Jat – Group of cattle breeders from Sindh and Kutch.

Jati – Subclassification of the original major Hindu castes.

Jogi – Group of nomadic snake charmers found in Sindh and Kutch.

Kabiri (khambhiri in Kutch) – Quilts that are embroidered to hold the layers of fabric together as well as to provide decoration, made particularly by the Jogi and Saami castes.

Kanchli – Bodice worn by Bhil women.

Kantha – Type of quilting with embroidery done by women in Bihar, Bengal, and Bangladesh using old saris or dhotis.

Karick – Patchwork pattern of triangles known as "flying geese" in American quilts.

Kathos – Hand loomed rough woolen blanket traditional in Sindh.

Kechi Beg ceramics – Specific style of pottery and design found in numerous sites of ancient Baluchistan near Quetta.

Khaarek – A traditional embroidery of India and Pakistan made of rows of satin stitching.

Khata (Katab in Gujarat, takriali in Kutch) – Appliqué of cut-out shapes.

Khes – Cotton cloth, made plain and twill woven or patterned and bound double-woven in Pakistan and India.

Kothri (or gothri or gothro) – Quilted dowry bag.

Lac – Type of red dye.

Laih – Middle layer of stuffing in a ralli.

Lasi – Buttermilk, a common drink in the ralli region.

Lharti (or laharan) – V-shaped or large zigzag textile pattern named for waves.

Lungi – Cotton, or cotton mixed with silk used by men as a sarong, turban cloth or sash and sometimes by women as a sarong.

Mandherro – literally a milk churn. The head of the churn is cross shaped and the name is used for a cross-shaped border pattern and also a ralli design with a large cross in the middle.

Mashru – literally meaning permitted. A fabric made with a silk or synthetic warp and cotton weft.

Meghwar (or Meghwal) – Leather worker Hindu caste of Sindh, Kutch, and western Rajasthan.

Mehndi – Designs made from henna paste on the hands of participants in a wedding ceremony.

Mordant – A metallic salt used as part of the dying process that reacts to set the dye permanently.

Murshid – A disciple or follower of a holy man who is considered a spiritual guide.

Nanghar – Patchwork zigzag pattern named for a snake.

Odhani (or odni) – A woman's shawl or head cover.

Palampore – Large cotton panel used for decorating beds or walls made in India and exported starting in the sixteenth century.

Pero – Patchwork pattern of squares circled by other squares.

Pir – Holy man or religious leader.

Purdah – Meaning curtain, is the custom of seclusion of women practiced primarily by Muslims.

Purr – Upper and lower layers on a ralli.

Putti (or pati) – Borders in ralli quilts.

Quran (or Koran) – Sacred book of Muslims composed of revelations to the Prophet Muhammad by Allah.

Ralli – Quilt with patchwork, appliqué or embroidery decoration made in Sindh, parts of Baluchistan, Punjab, and western parts of India.

Rallee-vijhanu – Name of the process of "laying" or sewing together a ralli by a group of women.

Reverse appliqué – Appliqué technique where the top fabric is cut to form the design created by the bottom fabric showing through.

Rig Veda – First of the four books of sacred Hindu hymns brought by the Aryans to the subcontinent about 1000 BC, memorized and recited for many years until they were written about 1000 AD.

Rumal – Small square cloth, often quilted and used as a cover for gifts or food. It is also the name of a kerchief worn on the head or shoulders.

Shalwar kameez – Costume worn by both men and women consisting of a long, loose shirt and baggy trousers. Women also wear a head cover called a dupatta and men wear a wrapped turban or hat. Shalwar kameez is considered the national dress of Pakistan and is also worn in India.

Shamiana – Colorful cloth tent with patchwork designs or printed fabric.

Sitara – Meaning stars, are sequins used in embroidery.

Shisha (abhla in Gujurat) – Indian name for small mirrors in embroidery.

Sufi – A follower of a mystical part of Islam.

Sujani – Quilting from north Bijar similar to kantha quilting.

Toukri (katab in Kutch) – Patchwork in textiles.

Topi – A traditional Sindhi men's round embroidered cap.

Note: There are many languages and spelling variations in the ralli regions. The terms defined here have other names and definitions in the various communities. Spellings are taken from reference sources.

Endnotes

Chapter 1.

1. Frater, *The Artisan Reflected in Embroideries of Western India*, 1993, 77.

2. Brohi, *History on Tombstones in Sind and Baluchistan*, (no date), 111-112.

3. Baloch, *The Traditional Arts and Crafts of the Hyderabad Region*, 1966, 12. For centuries the various crafts had organizations (kasbnamahs) that unified the craftsmen through common ideals, purposes, and practices. These organizations disappeared in the mid-1800s with the competition from manufactured goods from Britain and Europe.

4. Duarte, *The Crafts and Textiles of Sind and Baluchistan*, 1982, 10.

5. Askari and Crill, *Colours of the Indus*, 1997, 15, 65, 87. Many people divide Sindh into only Upper and Lower regions. (Lambrick, *Sind, a General Introduction*, 1964, 4.)

6. Gillow and Bernard, *Traditional Indian Textiles*, 1991, 57.

7. English, *Urbanites, Peasants and Nomads*, 1967, 54. Three general descriptions of lifestyles are: desert nomads, peasant villager, and urbanite.

8. Robertson, *Snake Charmers*, 1998, 6.

9. Possehl, *Indus Age*, 1999, 158-159.

10. Imperial Gazetteer of Baluchistan, 1908, 45.

11. Lambrick, 1964, 216.

12. Berlund, *No Five Fingers Are Alike*, 1982, 60; Tarlo, *Clothing Matters*, 1996.

13. Ajwani, *History of Sindhi Literature*, 1991, 28, 41.

14. Quoted by Duarte, 1982, 48.

15. Elson, *Dowries from Kutch*, 1979, 14; Huyler, *Village Indian*, 1985, 40.

16. Graham, *Traditional Textiles from Gujarat, Rajasthan and Sind*, 1982, Introduction.

17. Nazimani, *Socio-Religio-Cultural Patterns in Thar with Special Emphasis on Food Distribution*, 1994, 37-38.

18. Gillow and Bernard, 1991, 58, 60.

19. Nazimani, *Rehli*, 1997, 114-115.

20. Jain, *Folk Art & Culture of Gujarat*, 1980, 147.

21. Elson, 1979, 16-18.

22. Frater, *Traditional Embroideries of Sindh & Kutch, Vol. 2*, 1998, 1.

23. Lambrick, 1964, 12-13.

24. Nazimani, 1994, 18-29, 45.

25. Due to the age of this research there may be changes, but hopefully this gives a context for rallis made in this period. Honigmann, *Three Pakistan Villages*, 1958, 1-24.

26. Possehl, 1999, 160-161.

27. Imperial Gazetteer of Baluchistan, 1908, 89.

28. Honigmann, 1958, 1-24.

29. Rulers of the area in the medieval period were the Rajputs, some originally from Sindh and Rajasthan. They had a strong cultural impact on the entire area. The Kathi, called plunderers, controlled some territories also. Over time, they adopted Rajput surnames and customs and are known for their original and beautiful arts and crafts in Gujarat today. The Kathi women take great effort in beautifying their homes and also do embroidery, appliqué, beadwork, and quilting. (Jain, 1980, 1, 6.)

30. Huyler, 1985, 235.

31. Elson, 1979, 11-16.

32. Jain, 1980, 147-151.

33. Elson, 1979, 61, 69, 72; Jain, 1980, 88.

34. Jain, 1980, 87-90.

35. Frater, *Threads of Identity*, 1995, 38-39; Jain, 1980, 47-52.

36. There are many, perhaps several thousand, groups or castes of people living in the region where ralli quilts are made. The following are examples of some groups known for making rallis. They are differentiated by both religion and type of work done. (They are listed alphabetically.) Information is from the Kumar family of Umarkot. The groups are all located in Sindh and some other locations as noted.

Muslim Groups: Chauhan (Carters-Badin); Halepota (Landlords/Farmers); Jat (Cattle Breeders- Kutch); Jokhria or Johkria (Pottery makers); Junejo (Landlords/Farmers); Khaskeli (Farmers); Langha (Musicians- Cholistan); Mehar (Landlords/Farmers-Cholistan); Noorhia or Numria (Landlords/Farmers); Odheja (Landlords/Farmers); Saand (Landlords/Farmers); Samma (Landlords/rulers); Sangrasi (Farmers- Thar Desert); Sayyed (Religious leaders/landlords).

Hindu Castes: Bhil (Farmers- Cholistan, Rajasthan); Lohana (Merchants- Kutch); Jogis (Snake Collectors-Badin); Meghwar (Leather Workers-Banni Kutch, Rajasthan); Rabari (Pastorialists-Gujarat); Saami (Nomads/Beggars- Gujarat, Rajasthan).

37. Lambrick, 1964, 219.

38. Lambrick, 1964, 211.

39. Ahmed, *Puktun Economy and Society*, 1980, 161.

40. Lambrick, 1964, 211.

41. This example comes from a town north of Hyderabad, Pakistan.

42. The Baluch include various groups (alphabetically): Bugtis, Buledis, Burdis, Dombkis, Jamalis, Jatois, Karmatis, Korais, Lagharis, Lasharis, Magsis, Marris, Mazaris, Rinds, and Umranis. Askari and Crill, 1997, 65.

43. Nyrop, 1983, 93, 96.

44. Pastner and Pastner, *Clients, Camps and Crews*, 1982, 61; Nyrop, 1983, 93.

45. Gazetteer of Sindh, 1907, 169, cited in Bunting, *Sindhi Tombs and Textiles*, 1980, 6, is the Baluchi story that they came through Baghdad, from Aleppo, along the Persian Gulf to Makran before moving to the Indus Valley. During this journey, they were sent away by Yazid, the second Umayid Caliph between 680-684 AD.

46. Brohi, (no date), 140.

47. Pastner and Pastner, 1982, 61.

48. Bunting, 1980, 39.

49. Brohi, (no date), 139-140.

50. Aitken, 1907, 156. A Sindh census of 1907 lists the major group of non-Sindhis as Baluch followed by people from Rajasthan, Kutch, and the Punjab.

51. Lambrick, 1964, 212.

52. Pastner and Pastner, 1982, 62.

53. Nysop, 1983, 94-95; Pastner and Pastner, 1982, 62-71.

54. Imperial Gazetteer of Baluchistan, 1908, 27.

55. Lambrick, 1964, 209, 213-214.

56. Brohi, (no date), 145-147.

57. Lambrick, 1964, 213-214.

58. Elson, 1979, 41; Jain, 1980, 87-88; Westphal-Hellbusch and Westphal, *The Jat of Pakistan*, 1964, 36-37.

59. Kumar, *The Bhils*, 1997, 65-67, 169, 219-224.

60. Robertson, 1998, 1-17, 153-156.

Chapter 2.

1. Nazimani, 1997, 105.

2. Frater, correspondence, 2002. There are at least two pronouncations of ralli from different languages. One is raali (with a long "a" as in father) and the other is ralli (with a short "a" as the u in but).

3. Jatoi, *Ralle-making*, 1966, 26; Yacopino, *Threadlines Pakistan*, 1977, 38; Rashdi, *Ralli Work in Pakistan*, 1987, 45; Askari

and Crill, 1997, 46; Hassan and Fuller, *Folk Craft of Baluchistan and Sind*, 1968, 25. Other possible sources for the name ralli include the Sindhi words rallial, millial, which mean to spread, to mix or match and the word giddial, which means to be together. (Rashdi, 1987, 41.) It is also suggested that the name comes from the Sindi word "rill mill," which means to come close, to mix up or to become one. (Nazimani, 1997, 104.)

4. Jain, 1980, 91, 95-6, 150.

5. Nazimani, 1997,106-117.

6. Askari and Arthur, *Uncut Cloth*, 1999, 84.

7. Nazimani, 1997, 115-117.

8. Jatoi, 1966, 27; Nazimani, correspondence.

9. Jatoi, 1966, 26.

10. Huyler, 1985, 45.

11. Nazimani, 1997, 107, 110.

12. Sindh Museum. The lower layer is also called the taihe. Other names are upper purr (mathiyoon taho) and lower purr (hethiyoon taho) (Nazimani, 1997, 107) and filling is called gabh (Rashdi, 1987,43) or lihu (Jatoi, 1966, 26).

13. Rashdi, 1987, 43.

14. Also called "ralli wijhan" or the setting of the ralli.

15. Nazimani, 1997, 108; Rashdi, 1987, 46.

16. Elson, 1991, 69.

17. Askari and Crill, 1997, 46-47.

18. Rashdi, 1987, 43-45.

19. Baloch, *GEECHA*, 1964: songs from pages 64, 65, 74, 102.

20. Nazimani, 1997, 109.

21. Babree, *Culture of Pakistan*, 1997, 52.

22. Nazimani, 1997, 111.

23. Allana, *Art of Sind*, (no date), 25.

24. Allana,(no date), 24; Yacopino, 1977, 9.

25. Paine, *Embroidered Textiles*, 1995, 148-149; Grewal, *The Needle Lore*, 1998, 98.

26. Grewal, 1998, 98.

27. Paine, 1990, 132, 140-143, 148-149.

28. Sindh Museum, 1997.

29. Hassan and Fuller, 1968, 25. There are various names for the categories of quilts. The names change but the categories remain consistent as the indigenous, traditional way to define the style of rallis.

1. Patchwork – Tourki (Hassan and Fuller, 1968, 25), Tukrin Jo Kammu (Abassi, *Popular Types of Sindhi Embroidery*, 1966, 38), Chutkinwari (Askari and Crill, 1997, 46), Tukran or Tukrate Ware Ralli (Rashdi, 1987, 43), Tukrian-Wari-Rallee (Sindh Museum), Katab (in Kutch, Frater, correspondence).

2. Appliqué – Khata (Hassan and Fuller, 1968, 25), Katah Jo Kammu (Abassi, 1966, 38), Tukwari (Askari and Crill, 1997, 46), Tukk or Katta (Rashdi, 1987, 43), Tuk-Jo-Kam (Sindh Museum), Takriali (in Kutch, Frater, correspondence).

3. Embroidered – Kanbiri (Askari and Crill,1997, 46; Graham, 2), Kanbeeree (Hassan and Fuller, 1968, 25), Khambhiri (in Kutch, Frater, correspondence).

30. England and Johnson, *Quilt Inspirations from Africa*, 2000, 46.

31. Graham, 1982, 1.

32. Other researchers have found similar situations. When asking about a vine with flowers on a bridal durrie, they were told that the design was actually the small colored electric string lights that are used to decorate buildings for weddings and other special events (Shankar and Housego, *Bridal Durries of India*, 1997, 132).

33. Bunting, 1980, 64.

34. England and Johnson, 2000, 33; Spooner, *Weavers and Dealers*, 1986, 219.

35. Rashdi, 1987, 43-44.

36. Gillow and Sentance, *World Textiles*, 1999, 150-153.

37. The Sindi poem is:
Muhunjee rilli ja nau sitara
Wah tan ja noori nizara
Disan pya tan khe sabh jag wara
Sharmayin pye chan, sitara.

38. Rashdi, 43-45.

39. Graham, 1982, 2.

40. Bunting, 1980, 55-56. The history of decorative embroidery is very old in the subcontinent. The oldest example may be the statute of the Priest King from Mohenjo-daro who is wearing a garment with a trefoil design. This design was somehow affixed to the fabric by stamping, painting or embroidery. Buddhist sculptures during the time of Asoka (273-236 BC) were figures wearing clothing with embroidery on the bands and hems. During the sixteenth and seventeenth centuries, the Baluch tribes embroidered with gold thread on heavy cloth such as wool and velvet.

41. Nana, *Sindhi Embroideries and Blocks*, 1990.

42. Gazetteer of Baluchistan, 1908, 49.

43. Yacopino, 1977, 33.

44. Frater, 1998, 7.

45. Yacopino, 1977, 38; Rashdi,1987, 45; Jatoi, 1966, 27.

46. Askari and Crill, 1997, 47-50.

47. Nath and Wacziarg, *Arts and Crafts of Rajasthan*, 1994, 39.

48. Grewal, 1998, 72-75.

49. Nath and Wacziarg, 1994, 53.

50. Elson, 1979, 63.

51. Jain, 1980, fig. 148-150.

52. Frater, correspondence, 2002.

53. Gwinner, *The History of the Patchwork Quilt*, 1988, 34.

54. Morrell, *The Techniques of Indian Embroidery*, 1994, 46; Huyler, 1985, 188.

55. Morrell,1994, 47.

56. Fisher, *Mud, Mirror and Thread*, 1993,136-171, 227; Gillow and Bernard, 1991, 136.

57. Davidson, *Desert Places*, 1996, 158.

58. Askari and Crill, 1997, 61-63; Bilgrami, *Sindh Jo Ajrak*, 1990; Gillow and Bernard, 1991, 39-40; Nath and Wacziarg, 1994, 53; Yacopino, 1977, 84.

59. Murphy and Crill, *Tie-Dyed Textiles of India*, 1991, 9.

60. Patolas and Resist-Dyed Fabrics of India, 1988, 15.

61. Census of India, 1961 as quoted by Murphy and Crill, 1991, 25.

62. Askari and Crill, 1997, 58; Gillow and Bernard, 1991, 92; Nath and Wacziarg, 1994, 39-43; Patolas and Resist-Dyed Fabrics of India, 15, 42; Yacopino, 1977, 92.

63. Askari and Crill, 1997, 58; Gillow and Bernard, 1991, 89; Murphy and Crill, 1991, 61; Nath and Wacziarg, 1994, 43-51; Yacopino, 1977, 82.

64. Yacopino, 1977, 92, 95.

65. Gillow and Sentance, 1999, 212, 215.

66. Bunting, 1980, 58-61.

67. Morrell, 1994, 75-79. Glossary of Indian Embroidery Stitches. Perhaps the tradition of mirrorwork is even older than tradition says. Small pieces of mica have been found throughout the remains of the ancient Indus Valley cities. It was used in the clay and is also a tempering agent. On many painted pottery pieces are small circles with "fuzzy" edges, reminiscent of mirrors sewed on fabric.

Chapter 3.

1. Yacopino, 1977, 8.

2. Jarrige, *Mehrgarh*, 1991, 34, 36-38.

3. Jarrige, 1991, 41-44, 46; Samzun, *The Early Chalcolithic: Mehrgarh Period III*, 1991, 69.

4. Jarrige, 1991, 47.

5. Lamberg-Karlovsky and Sabloff, *Ancient Civilizations*, 1995, 195, 212; Allchin, *The Rise of Civilization in Pakistan and India*, 1982, 169, 243.

6. Kenoyer, *Ancient Cities of the Indus Valley Civilization*, 1998, 42-45.

7. Lambrick, 1964, 206-7.

8. Jarrige, *The Cultural Complex of Mehrgarh and Sibri*, 1991, 101-102.

9. Tosi, *The Indus Civilization Beyond the Indian Subcontinent*, 1991, 116-123.

10. Kenoyer, 1998, 82-83.

11. Tosi, 1991, 127-128.

12. Jarrige and Santoni, *Fouilles De Pirak, Vol. I*, 1979, 407-408.

13. Jarrige and Santoni, 1979, 392-394.

14. Ajwani, 1991, 1.

15. Possehl, 1999, 6-7.

16. Ajwani, 1991, 2, 4.

17. Lambrick, 1964, 3, 24, 73.

18. Postans, 1843, 18.

19. Ajwani, 1991, 2-3.

20. Lambrick, 1964, 135, 148-9.

21. Huyler, 1985, 63.

22. Ajwani, 1991, 5.

23. Huyler, 1985, 65-66.

24. Yacopino, 1977, 15.

25. Shankar and Housego, 1997, 132-133, 141.

26. Yacopino, 1977, 16.

27. Yacopino, 1977, 18, 21.

28. Huyler, 1985, 81.

29. Huyler, 1985, 85-88.

30. Meadow, *The Domestication and Exploitation of Plants and Animals in the Greater Indus Valley, 7th-2nd Millennium BC*, 1991, 56-57.

31. Gillow and Barnard, 1991, 7; Gittinger, *Master Dyers to the World*, 1982, 16.

32. Marshall, 1931, (1973), 33; Barber, *Prehistoric Textiles*, 1991, 32; Gittinger, 1982, 16 citing Watson, Meadow, 1991, 54.

33. Mackay, *Further Excavations at Mohenjo-daro*, 1937-38, 441 cited in Possehl, 1999, 250.

34. Lamberg-Karlovsky and Sabloff, 1995, 21.

35. Kenoyer, 1998, 41, 159.

36. Possehl, 1999, 250.

37. Allchin, 1969, 325.

38. Barber, 1991, 67.

39. Hochberg, *Handspindles*, 1980, 18.

40. Duarte, 1982, 13.

41. Gillow and Bernard, 1991, 7.

42. Bilgrami,1990, 19; Marshall, *Mahenjo-Daro and Indus Civilization*, 1931, (1973), 33.

43. Possehl, 1999, 249-250.

44. Huyler, 1985, 67.

45. Huntingford, *Periplus of the Erythraean Sea*, 1980, 42-48,130.

46. Gittinger, 1982, 16.

47. Marshall, 1931, 1973, 33, 585.

48. Bilgrami, 1990, 19; Vats, *Excavations at Harappa*, 1940 (1975), Plate CXXXIII. This "cloud" pattern also reportedly came to Thatta from China in the fifteenth century when Thatta was a great center of learning (Bunting, 1980, 62).

49. Bilgrami, 1990, 20.

50. Gittinger, 1982, 16.

51. Possehl, 1999, 251.

52. Duarte, 1982, 7.

53. Barber, 1991, 4; Barber, 1994.

54. Gwinner, 1988, 12-23.

55. Barber, *The Mummies of Urumchi*, 1999, 20-21.

56. Bishop, Bresenham, and Leman, *Hands All Around*, 1987, 4; Gwinner, 1988, 19.

57. Gwinner, 1988, 22.

58. Bishop, Bresenhan, and Leman, 1987, 4-5; Gwinner, 1988, 12.

59. Pires, *The Suma Oriental of Tomé Pires*, 1944, 269-270 cited in Gittenger, 1982, 13.

60. Adamson, *Calico and Chintz*, 1997, 15, 44. Some of the patterns found in early American quilts: Ohio Star, Pinwheels, Flying Geese, Strips, Nine-Patch, and Four-Patch patterns as well as whole cloth quilts are also seen in ralli quilts.

61. Innes, *Rags to Rainbows*, 1992, 51.

62. Rashdi, 1987, 47-48; Huyler, 1985, 81.
The original text of the saying in old Sindhi is:
Dah Darvesh
Dar gile may
Bakhus pand
Wa do baadshah
Dar do akley may no Gun jand.

63. Ajwani, 1991, 1.

64. Gwinner,1988, 23, 49.

65. Yacopino, 1977, 38; Rashdi, 1987, 45.

66. England and Johnson, 2000, 44, 123.

67. Gwinner, 1988, 38.

68. Gwinner, 1988, 28.

69. Gillow and Bernard, 1991, 62-63. Gillow mentions the earliest surviving example of appliqué in Gujarat comes from the late nineteenth century. Some think that the tradition of appliqué in the Indian subcontinent came through trade contacts with Europe or the Middle East.

70. Shankar and Housego, 1997, 107.

71. Starr, *Indus Valley Painted Pottery*, 1941, 16.

72. Yacopino, 1977, 8-9.

73. Starr, 1941, 57. The only other culture using this pattern is Halaf (5000-4700 BC) now part of Syria, Iraq, and Turkey.

74. Shankar and Housego, 1997, 136-137. Another ancient use of parallel lines is the combination of four triangles separated by a cross and a square in the middle. Some of the earliest pottery examples had animal forms or serrated edges on the outside edges of the triangles starting as far back as the sixth or fifth millennium BC in Iraq and Syria. The serrated edge could be a representation of a woven textile pattern that produces a broken edge. The cross and triangle pattern is not common in the Indus pottery but there is an example from west Haryana (early second millennium BC).

75. Kenoyer, 1998, 178.

76. Mahdihassan, *Cross as a Symbol of the Soul*, 1974-1986, 287-292, referring to George Dales.

77. Shankar and Housego, 1997, 152. Triangles were also very common decorations on the pottery from Iran and Mesopotamia from the fourth and third millennia BC.

78. Starr, 1941, 58-59.

79. Starr, 1941, 59-60; Shankar and Housego, 1997, 147.

80. Shankar and Housego, 1997, 140.

81. Frater, correspondence, 2002.

82. Shankar and Housego, 1997, 121-125. The intersecting circles pattern first appeared on pottery from Halaf (5000-4700 BC). Even though the design was often used in their pottery, the design appears to have disappeared in succeeding levels of their civilization. Intersecting circles are still seen in a variety of places, including in architecture and furniture in the Indian subcontinent.

83. Possehl, 1999, 676-9. The similarity between artifacts of Quetta and Central Asia has raised the possibilities of either a developer-receiver relationship between the areas or a mutual interaction where ideas were shared.

Related Bibliography

Agrawala, V.S. *India as known to Panini*. London, 1953.

Burton, Richard F. *Sind and the Races that Inhabit the Valley of the Indus*. London, 1951.

Dales, George F. and Jonathan Mark Kenoyer. *Excavations at Mohenjo daro, Pakistan: The Pottery*. The University Museum, University of Pennsylvania, University Museum Monograph 53, 1986.

Khan, Dr. F. A. *The Indus Valley and Early Iran*. The Department of Archaeology and Museums, the Ministry of Education, Government of Pakistan, Karachi, 1964.

Mackay, Ernest J.H. *Chanhu-Daro Excavations 1935-36*. Delhi: Bharatiya Publishing House, 1976.

Mughal, Muhammad Rafique. "Excavations at Tulamba, West Pakistan." *Pakistan Archaeology*, Dept of Archaeology, Ministry of Education, Government of Pakistan, Karachi, No. 4, 1967, pp. 11-152.

Shimmel, Annemarie. "People and Places on the Indus." In Jansen, Michael, Maire Mulloy and Gunter Urban (eds.) *Forgotten Cities on the Indus*. Mainz, Germany: Verlag Philipp Von Zabern, 1991, pp. 1-17.

Wheeler, Mortimer. *The Indus Civilization*. Cambridge: Cambridge University Press, 1972, p. 86-106.

Index